SEXTOPIA

SEXTOPIA
STORIES OF SEX AND SOCIETY

EDITED BY CECILIA TAN

CIRCLET PRESS, INC.
CAMBRIDGE, MA

Contents

INTRODUCTION
CECILIA TAN

Some people are just not content with reality. I'm not talking about your general-purpose malcontents, nutcases, or dreamers, I'm referring specifically to writers. There are any number of reasons why the real world isn't satisfactory for some fiction writers. Perhaps our thesis requires an exterior point of view or that a contrast be made to the current state of humankind. Perhaps we have a brilliant idea that can't be shoehorned into the shapes of "normal" life. Perhaps we want to be humorous, or cautionary, or shocking.

Perhaps we have a desire that can't be expressed in the "real" world.

For whatever reason, writers have been dreaming up not only their own people and their own plots, but their own places, since before the creation of the novel as a modern literary form. Some of these places are meant to be better than our world, others merely different. Sir Thomas More may have crafted one of the punniest titles in the history of literature when he christened his epic work of political and socio-religious commentary "Utopia." His literate audience would have heard "eu-topia" or "good place," when the actual translation of "u-topia" is "no place." Because, of course, the society that More dreamed up exists nowhere at all.

These days when an author invents a new world or society, we call

it science fiction, or fantasy, or "speculative" fiction—the scholarly way to say "What If?" What if technology enabled us to be free of totalitarianism? (Or enslaved us?) What if the religious conflicts in the world could be solved? What if one single culture came to dominate the entire population?

What if the thing that I desire can't be had in my mundane world?

It may seem like there is no place other than in our imaginations for certain kinds of desire, but as we have seen in the recent history of twentieth century America, more places are being carved out all the time. People are creating places for themselves, fighting for gay marriage, against infant genital mutilation, for the choice to change gender, for the right to freedom of sexual expression. Sex is one of the necessities of life, but erotic desire is a necessity of being human, and tremendous energy goes into codifying, controlling, and channelling that desire in each and every culture and society in the world.

What I have asked the writers in this volume to do is to give me stories exploring the intersections of desire with society, where erotic needs and a society's rules conflict or interact. I wanted them to look at not only where lust and love unravel the order of things, but to create worlds where they are a part of it.

This latter idea excites me because it is counter to the way of things in the real world that I know: in the world I live in, the "powers that be" view freedom of sexual expression as part of the decline of civilization. Lust is a force of disorder that is constantly under attack, being repressed, regulated, and legislated. The government in the United States (and Canada) is a moral arbiter that too often derives its morals from the attitudes of our Puritan founders rather than from the ideals of freedom and tolerance put forth in the Constitution. So I dream of a world, a country, a society, where honoring sexual desire is a part of the foundation upon which it is built, where celebrating eroticism and diversity of desire adds to the order of things.

Several authors here gave me stories exploring these possibilities. Eric Del Carlo's "To Love and Riot" was the first story I acquired for this volume and the first story that convinced me more would follow. Renée M. Charles's "The Delectation Debates" took my ideals to an extreme, and I've made a note to myself to read the story again in the next election year. In Jennifer Stevenson's "Something for Everyone," desire isn't just a feeling, it's a natural resource, like coal or water. In Saskia Walker's "Delfidian" and A.R. Morlan's "Stone Still," their societies regulate relationships even more strictly than ours, and yet sometimes joy and hap-

piness can result.

Other authors came at the interplay between erotic needs and rules from a different direction, looking at where people need to cross from one set of rules to another. In Raven Kaldera's "Anthem to the Sun," the protagonist finds himself caught between the desires and expectations of two different cultures, while in Zoe Bloom's "Dinner" he is between two subcultures, each with their own rules and taboos, both spoken and unspoken. Yes, a secret society is a society . . . In Catherine Asaro's "Soul of Light" a young artist takes a peek into military life, and finds it different from his expectations. In M. Christian's "The Hope of Cinammon" the main character's occupation is to bring his brethren into their sexually-free utopia, but he finds that what seems so perfect and beautiful for him is not as easy to accept for those he rescues.

Then there is what happens at the end of civilization, when society begins to fray, and how desire can be let loose, for good, as in Reina Delacroix's "Blue Sky," or for ill, as in Suzy McKee Charnas' "Oak and Ash."

Books are such a civilized medium, don't you think? But the next thing you know, your imagination goes wild. At least, I hope it will. These stories may arouse, startle, or provoke thought. In a perfect world, it would be all three.

CECILIA TAN
Cambridge, MA

TO LOVE AND RIOT

ERIC DEL CARLO

Queen's Bishop 3 of the gridded city winks red to the aria-wailing of the antediluvian air raid siren, and we scramble out of our neutrality. Gear tumbles from storage bays, and we make armor of it—jumpboots, foamed bodysuits, wetgloves, helmets (a reckless scroll of alphanumerics lighting translucent faceplates) and all the tools of the trade. Clacking and clicking, locking and loading, we take on our arsenals.

Blitzkrieg: and we're the shock troops of the flesh.

"Eros, Aphrodite, Astarte, Priapus, Venus, Freya, Baal," we chant the timeworn mythologies.

My unit spills out of the cold faceless neutrality of the garrison where we lie and wait—patient and dispassionate—during those long stretches when the city doesn't need us, when all is calm, when the pot merely simmers and doesn't boil.

But this instant Queen's Bishop 3 riots, and out we come.

We mobilize, the air raid siren dwindling away below.

The skyboat slings itself into the clouds above the obelisk of our garrison that stands on King's Rook 1, banking, climbing, gathering speed, twirling toward the city square of winking red. Surrounding me in the 'boat's hold are the flushed faces of my fellow warriors—teeth glinting from lips behind translucent faceplates, wide eyes gobbling the

alphanumerics that tell us the severity of the disturbance, this red alert, this Queen's Bishop 3 riot. Gloved hands twitch. Groins roll. Our armored bodysuits are injecting us with potent sequenced stimulants, pumping, priming, inciting. My cock is fantastically hard within the shell of my metaplastic codpiece. We leer; we salivate; we desire.

How long—how very long—since we've last been turned loose, since last the city needed us?

Below our flinging skyboat the city lies, orderly and magnificent, cascading marvels of architecture, crochet patterns of color fanning artfully, spires, mazes, fields. It seems absurd that the tranquility could be disturbed, the harmony gone discordant. The lives lived down among those flawlessly balanced city squares are rewarding, gratifying, sublime. Individual and societal needs are all met. Nothing can go wrong.

Yet the alphanumerics surging down my faceplate tell a different story.

"Ah, Lieutenant," mewls Mictosh, my sergeant, her white foamed bodysuit rubbing mine. Her juices are drooling within her pliable but solid armor. "I'm burning. . . ."

I smile. "Soon enough, Sergeant. Soon enough."

We're banking again, downward now, and there's Queen's Bishop 3; and the intel on our faceplates becomes reality. I see smoke. I see anthill bodies boiling in the square. A hundred thirty-three rioters are rampaging down there. My unit is made up of twenty-one soldiers.

Deliny, the pilot of our skyboat, slides us at a sharp decline, a forest of delicately poised towers rising around the craft, and we get a good look.

Berserk, violent, feral, frenzied, frantic—tremendous destruction, mindless ferocity . . . and these poor fuckers (ancient, pointless and grossly erroneous profanity) don't even understand why they're acting this out. Mass insanity. A collective instinct to devastate.

We lift at a mild angle (Deliny just wanted to give us all a preview) and bank tightly, pirouetting and coming down finally onto a rectangle of once-manicured hedgework that's already been trampled and burned in several places.

In the hold of the 'boat we quiver and twitch and ache.

I give deployment commands. Our helmets are all wired together, and we hear each other breathe, every needful moan, every ratcheting pant.

"Eros, Aphrodite, Astarte, Priapus—-" we chant, and out of the hold we swarm.

The turmoil has already passed this rectangle of scintillating hedge-work, but we see the rioters, further away, tearing apart the black glass front of a building. They throw ornamental stones, and great shards rain down. There's some blood. There's screaming.

I match the chaos to the alphanumerics scrolling my faceplate and deploy the unit. My soldiers spread out at a fast trot, crack troops, proficient, earnest, my grunts—Pedrzin, Taler, Delcroy, Maxwil, all the others, my sergeants—Mictosh and Biglo . . . away we go, dispersing across Queen's Bishop 3.

Mictosh and a few others are grouped about me as we rush the rioters.

They're in frenzy, and now we can taste the sweat, feel the E string quiver of the violence. They boil. Their clothing— their elegant gowns, their comfortable embroidered robes—are shredded. They make violence on the surrounding architecture. They uproot gardens. They smash. They howl. They writhe on the mosaic floorings. They have no understanding of their own actions, the collectively unconscious motivations, the teeming emotional underpinnings. They choose violence as surrogate, as substitute, as pitiable proxy for needs they possess no other means to fill.

So we come to them.

Amid the shrieking, amid the stone-throwing, amid the raining black glass, they see us. And turn. And blast us with their primal rage.

A rounded stone flings out of the mass and punches my faceplate, dead square, but doesn't flicker my alphanumerics as my helmet absorbs the shock. Chatter fills my ears. The other soldiers of my unit are engaging the rioters all about the square.

They hurl themselves at us—our physical forms surely more intriguing targets than the surrounding unresponsive architecture—these civilized citizens of the city that live artfully balanced lives, that are intellectuals, craftspeople, thinkers, that are cared for, that are educated, that achieve, that make art and commerce, that are the pinnacle of the species. They come at us like hyenas. More stones strike us; and it's a good thing we're wearing our armor.

I bring my heels together, and my jumpboots spring me upward; in mid-arc I unfasten a nozzle from my belt and spray. A lavender mist sprinkles down. I land on the glorious mosaic stones behind the mob.

Momentum has carried one of the rioters forward and into Mictosh, his weight knocking her white foamed bodysuited figure flat.

The lavender mist will see to most of them—to the hangers on of

the riot, to those who've merely been swept up in the hysteria, who've gone along out of vague instinct. But still there will be the core instigators, the truly angry ones, the berserkers that touched off this tumult. We will weed them out.

Already the timbre of the frenzied energy is changing. I can smell it, even through the faceplate. The yowls of rage are flagging.

I look across the throng (we've probably got sixty of the one hundred thirty-three rioters cornered here by our tiny contingent) and see Mictosh, still underneath the male body that sprawled her but no longer pinned, the man going slack, shaking his head as if to clear it, confused. His gown is torn into streamers, trailing from his shoulders, and he's bare below the waist. Mictosh's hand is already working. Her self-lubricating glove moves between his legs, and I watch his backbone tighten.

The grunts of my unit are moving into the crowd, the rioters tottering, dropping their stones.

The pitch of the energy that produced the violence remains the same—powerful, urgent, primal—but the key rapidly changes from minor to major. The frenzy is transmogrified.

Mictosh springs the latch that frees the metaplastic groinguard from her foamed bodysuit and guides the male rioter's erect cock into her streaming cleft.

My own cock screams for release.

Delcroy bares a woman's breasts, opened palms sliding over the nipples, then fingers cupping the rounded flesh. The woman—emerging from the transmuting effect of the lavender mist—stares down in wonder at the fondling. She begins to respond, lips parting, spine arching. Delcroy pushes more of her robe aside, slipping gloves down her firm naked belly, sliding a pliably armored leg between hers. The woman, race memory instinct taking hold (as it must, as it always does, despite generations atop generations of social engineering and gene splicing), grinds her thatched triangle against the leg. Delcroy presses her bodysuited breasts against the woman's.

Grifth frees a swiftly hardening cock from the folds of an erstwhile rioter's gown and pumps it skillfully in his lubricated wetglove.

Quinzi has unlocked his codpiece to release a long reddened member which he teases against the vaginal lips of the woman lying beneath him, her hips bucking helplessly upward, the dismay draining quickly from her face, to be replaced by leering want.

The chatter of my other troops deployed throughout Queen's

Bishop 3 tell me similar engagements are under way.

My bodysuit continues to pump merciless stimulants into me. I wade out into the crowd. My eyes and the scrolling alphanumerics tell me all violence has desisted. My soldiers and their carnal frays create foci of attention. None of these rioters, these citizens, these refined and Vat-procreated people, has ever witnessed such acts, has even the mythic lingering knowledge that once the species indulged in just such activities routinely, relentlessly, obsessively. Carnality has been bred out, owing to the advent of the Vat where the cast and substance and health of a human being can be coded by the engineers and made perfect. No more the wild and perilous and messy crapshoot of spermatozoon and ovum. No more the unstable and contradictory impulses of sexuality that can only unbalance the ordered society. So eroticism has no place in Utopia. But somewhere, deeply, on the molecular level, the fundamental instincts abide and evade the scalpels of the geneticists' micromillimeter knives . . . and need (undefinable, elusive, gnawing) wells up sporadically amongst these people. And they know of nothing else to do but lash out, make war not love, give free rein to the hysterical energy. So they riot. And out we come from the cold neutrality of our garrison. To quell. To alleviate.

The lapsed rioters are collecting about my soldiers, about myself. I spread my arms to gather flesh into them. I grope genitals, and there are responding groans. We have the ancient knowledge of physical pleasuring; we possess the training; we can satiate.

I catch a glimpse of the male rioter atop Mictosh as his body bucks recklessly, hips pounding hers, then the spasming as he loses final control and comes disengaged from her moist passage, rampant cock spraying gouts of semen across her white foamed bodysuit, his limbs locked in an agony of pleasure— simplistic, base, primal bliss, such as he's never known in his civilized, conscientiously balanced lifetime. Another man takes his place atop Mictosh.

I loose my needful cock, discarding the metaplastic groinguard, and an eager hand grabs it up immediately. Bodies crowd inward on me. My gloves dribble their oils, and I finger enthusiastic vaginas and rectums. The tatters of robes and gowns fall away.

Another flashing crowd-glimpse: This time I see Delcroy unsheathing gear from her belt, drawing out a hefty phallus that she swiftly and skillfully inserts into the woman who is inexpertly but ardently fumbling at her breasts through the bodysuit.

Bodies rub and roll against mine.

We work the crowd.

They crush in on us, fascinated, needing, the strength of violence transformed into lust. But they are ignorant; and we must show them how it's done.

The Vat-grown bodies are sublime, living sculpture, bearing all the benefits of physical programming. How I want them. How I want them all. I swipe a lubricated glove into the valley of a male ass, then press my stone-hard cock to the ring. I impale slowly, and the man gasps. A woman—her hands blackened from smoke—grinds against my side, and I reach fingers into her vaginal fissure. She bites the shoulder of my foamed bodysuit, whimpering.

I thrust my cock deeply, and the man grunts pleasurably. My free hand slides around his hip and rolls and squeezes his aching testicles; then I find the raised shaft. I pump twice, and he bursts in my fingers, just as I unleash a furious stream of semen into his ass. My cock slithers out, and I wipe it clean. But the injections my bodysuit continues to pump won't let me rest, flag, wilt. I don't pause. I'm instantly erect again.

I brush the side of my helmet, and my translucent faceplate disappears—along with all the alphanumerics that tell me all is going according to strategy in Queen's Bishop 3. The riot is quelled, and the carnality has ignited. I remove my helmet and no longer hear the intermittent reports from my troopers.

More than a dozen hungry shapes converge on me. I drop to my knees and jam my face into the fragrant curls that spread at the joining of one woman's thighs. My tongue jabs, and her knees buckle; but the weight and urgency of the mob hold her upright while I taste between her heated lips, then dart toward her clitoris, hardening my tongue, lapping mercilessly, finally bringing my teeth to the ultrasensitive nub, nibbling delicately. She shrieks, and fingers clutch my hair.

As she falls away, a supple young male body replaces her, and I take the lengthy cock fearlessly into my mouth, lips tight, tongue making a bed for the shaft. The ballooned head meets the back of my throat, and I scrape my nose into his wiry coils. Legs and arms press around me. Two sets of hands are exploring my cock and balls.

He ejaculates gloriously across my tongue, and not a drop escapes my lips. I swallow the acrid warmth. The young man is replaced by another yearning cock.

I roll to the ground, onto my back, and drag this one down on top of me, forcing him to straddle my chest, the cock deep in my mouth.

The man pumps himself instinctively. I feel bare breasts rubbing my own cock now. A tentative hand ventures beneath my bloated testicles and fingers my rectum.

The man comes in my mouth, across my chin and throat.

I remove my wetgloves.

I undo the central catch of my bodysuit, and the riot armor falls away in pieces, baring my arms, torso, legs.

A woman throws herself across my chest, and I sink my teeth into her full breast. A mouth—mimicking my demonstration—drops courageously onto my cock. The sucking is initially awkward; but the skills are learned in a matter of seconds. The hot lips and tongue consume me. Another mouth seeks out my sac. The finger is still probing my ass.

I come explosively as the woman writhes herself off my chest, and I see I've deluged the two faces—one male, one female—devouring my genitals. They stare at me, then at each other, astounded. Impulse—powerful, irresistible—brings their mouths together, and they share my taste on their eager tongues, licking my juice off their respective lips and cheeks.

Mictosh, Delcroy, Grifth, Quinzi, the handful of other troopers and myself orchestrate the orgy. And now we turn the rioters on each other.

A man and woman lie on either side of me, pressing urgent groins against my hips. I sit up, turn and gently roll the two together. I take up the cock in one hand, spread the woman's folds with my other. I guide the head inward, and—incredulity on the two faces—the man slams his member homeward. The couple buck and writhe together, finding mutual rhythm, harmony.

Hands and mouths still seek my cock and balls as I link others to each other. I spread one woman atop another, bodies reversed, reciprocal mouths discovering sweetly drizzling vaginas.

A frantic tongue is delving my ass while I lock two males into mutual masturbation, bringing in a third to distend a waiting rectum with his cock.

So we match up the bodies, there in the ruin of Queen's Bishop 3.

I come in several more holes, the stimulants still racing my bloodstream, but the carnal frenzy moves now under its own power. I stagger to my feet.

Mictosh, naked, perspiring, even bruised in a few places, wades through the sea of contorting bodies to me. We sag against one another; we kiss, wearily; she idly fondles my abused cock. My other soldiers

are rousing themselves out of the erupting heaps of flesh. There will be no more rioting today. Utopia is restored.

Then I catch sight of the lone dark-haired man. . . .

He's disengaged from the erotic delirium. He stands apart from the squirming mob. His hands clench and unclench.

"Sergeant," I say to Mictosh, "with me."

We leave the rest of the troopers behind and plod toward him. A stray arc of semen spatters my leg. A disembodied hand reaches upward to claw Mictosh's buttock. The dark-haired man backs a few steps, seeing our approach. His eyes still burn with violence, primal, fierce. He is surely one of the (perhaps the single) core instigators of the riot.

"Why don't you join in?" I ask, Mictosh and I halting a few meters away.

Insolence darkens his features. He gazes about at the spasming bodies. "I want more," he says softly.

He flinches slightly as we cross the last of the intervening space. Mictosh and I stand near him. I can smell her juices and my own. I am growing rapidly hard. Her face flushes.

I lean in and press my lips to the side of his throat, languidly extending my tongue to lick up to his earlobe. Mictosh's fingers find his nipple and slowly tantalize. His sleek sculpted body quivers. How I want him. I nip his ear with my teeth. Mictosh's hand descends, and I watch him come erect in her palm. I graze the head of my cock against his.

I can feel the strength of him—the willfulness, the rebellion, the rage. What place has he in this utopian city?

His instincts are potent. He grasps my cock. He grips Mictosh's breast. We have him.

We have him.

Mictosh laps his dangling sac while I pump him in my fist. I guide the dark-haired man on top of her, set his cock into her cleft. I feed my own cock into his mouth. We thrash about on the mosaic stones. We shift. Mictosh takes us both at once into her gaping mouth. I gnaw the tiny stiff nubs of his nipples. He feeds voraciously at her vagina. I position myself on hands and knees, and the dark-haired man mounts me while Mictosh slavers his ass. I feel his length pistoning inside me; and that's where he comes, convulsively, explosively. My own cock empties itself onto the ground of Queen's Bishop 3.

The dark-haired man rocks back on his haunches. He closes his eyes, slowly shakes his head.

"I still want more," he murmurs sorrowfully.

"What's your name?" I ask, Mictosh and I wrapping arms about him.

"Melin."

We gather him onto his feet. I press my lips to his ear. "Come with us, Melin." And we lead him through the twisting rioters, this riot transmuted to orgy, the violence and destruction past; and when it's done, when the last antediluvian orgasm is reached, these people, these good citizens of the city, will wander home, and automated repair units will restore the square, and they will remember little or nothing of what transpired here. It will be out of their systems. The urges will be satisfied and forgotten. The equilibrium of their utopian lives will reassert itself.

It will not be so for Melin.

My soldiers rendezvous at the skyboat. We reek of sweat, of prurient drippings. Everyone is accounted for, and it's time to return to King's Rook 1, to the cold neutrality of our garrison, where we will wait in stasis until the next occasion when our city needs us . . . we who can't fit into the non-carnal scheme, who are throwbacks, who still bear the need.

"This is Melin," I say to my troopers. Hands reach out to caress the dark-haired man, welcoming, embracing. Deliny powers up the 'boat, my arm tight about my new soldier, and we move into the hold. "Let's take him home."

THE DELECTATION DEBATES

RENÉE M. CHARLES

Good evening, ladies and gentlemen, and welcome to the first round of this year's Delectation Debates. Since this is an election year, the results of tonight's debates will determine the two candidates for this fall's election: The task of judging each potential candidate's performance will be up to you, the viewing audience. For those of your who have just reached the age of majority, I'd like to go over the voting proceedure: By using your remote, press FORWARD for a YEA vote, and REWIND for a NAY—all you have to do is aim the remote at the center of your viewscreen. Please wait until each candidate has completed his or her time on the podium before making your decision. And remember, only those of you aged eighteen or older are allowed to vote, according to the census report filed for each household. There are, however, no restrictions for those viewers who have registered under more than one sexual category, i.e. heterosexual/transvestite, or gay-lesbian/transsexual, provided all additional taxes have been paid accordingly.

That said, I'd like to introduce tonight's first candidate, a Ms. Letje Cuvier from New Rochelle. Ms. Cuvier is a registered Lesbian, as well

as a graduate of the University of Standford, with dual degrees in Sexual Anthropology and Feminist Philosophy, who is currently the director of admissions for the East Coast branch of the Gay/Lesbian Technical Colleges System. Ms. Cuvier, welcome to the Delectation Debates.

Thank you.

Before we begin, Ms. Cuvier, could you please uncross your legs? The audience prefers an open field of vision for all potential Leaders— thank you. And may I add, your muscle tone and overall tautness is exceptional—

I do try to stay physically as well as sexually fit. As a matter of fact, I haven't needed to wear a bra since I was a teen-ager . . . but I digress. Before the questions begin, I'd like to say that I feel that what this nation needs is a Leader with a life-long commitment to an alternative lifestyle, in order to better understand the needs of our many transgendered and non-heterosexual citizens—

But not at the risk of alienating the heterosexual minority?

Oh no, not at all . . . many of my friends are heteros.

As are some of mine . . . however, since time is limited to a quarter hour per candidate, I'd like to begin with the questions, before the actual demonstration. First off, please describe in detail the manner in which you would go about establishing diplomatic relations with a member of the hetero minority who represents a foreign nation.

Male or female?

Good point . . . let's say . . . male.

Well . . . since so much of the human body is similar rather than dissimilar, I'd con-centrate on the parts we have in common, to better establish a sense of mutual rapport . . . I'd start by massaging his chest, concentrating on the nipples . . . a circular motion, enough to make them hard—and I'd ask him to do the same with mine. Once they were taut, I'd lick them just enough to moisten them, before applying light pressure with my teeth . . . then work my way down his chest, stopping short of his waist, alternately kissing then sucking deeply enough to create a line of fiery-hot flesh down his middle.

And as I did that, I'd work my hands around his torso, still massaging his skin light-ly, then slide them down, to grasp both his cheeks—

Not to interrupt, but what would you encourage the diplomat to do to you at this point?

To me . . . I would assume that he'd be mirroring my actions, given my stated sexual preferences—

But remember, the hetero minority can occasionally consider their way to be . . . the only way. Per their adherence to certain Biblical ref-erences—

True . . . I suppose that under the circumstances, I would need to make myself sexually . . . available to him, per his differing beliefs.

Available as in allowing penetration?

Orally, or vaginally, or anally?

Given the mindset of the minority, perhaps the first two options?

That makes it easier . . . I would continue working my lips and tongue down his torso, past his abdomen, and treat his penis and scrotum as an engorged clit and labia, adjusting my pattern of sucking and licking accordingly . . . this would enable me to stay within my stated preference while satisfying the needs of a potential diplomatic ally. Aside from the matter of dealing with his orgasm—and, given my vast experience with my own sex, including varying degrees of post-orgasmic lubrication, I feel that I would be able to cope with his eventual emissions—

But how do you feel about swallowing versus allowing the ejaculate to cover you—

Cover as in—

Colloquially, a pearl necklace. Given the need for sexual dominance in the typical hetero male, which option would you choose?

Covering . . . it allows for an added measure of visual stimulation, which is all-important in the male.

Excellent point. Once his needs were satisfied, would you permit him to reciprocate?

I'd encourage it . . . albeit orally. Quid pro quo. Again, this would better establish an equal diplomatic footing.

I believe that covers the question portion of your segment . . . to make the demonstration portion more meaningful for the audience, we'll need to zoom in with cameras two and three—now, Ms. Cuvier, would you show the audience how you, as Leader, would be willing to provide a role model for your fellow citizens who may be lacking the initiative to pursue solitary pleasuring as a means of enhancing their sexual well-being and increasing their capacity to better function in the workplace?

With pleasure . . . as I stated earlier, the human body is more universal than diverse . . . all breast tissue, especially the nipples, is sensitive to first a light, then a more intense touch . . . alternately circling then grasping the nipples tightly creates a balance between pleasure and anticipatory pain . . . and once the nipples harden, the possibilities for self-pleasuring are endless. I prefer using ice cubes at this point, but any intense sensory stimuli will do.

Then, once the nipples and breasts are engorged, I like to work my way down to my pubis and outer labia—for men, the scrotum would work as well—and by hooking my middle finger in the natural cleft above the clit, I pull my pubis upward, then lightly mash down on the plumpest part over the pubic bone, while lightly stroking my inner labia with

my other hand, just brushing the fingertips along the outside, until the moisture begins . . .
only then do I touch my clit, with just the . . . tip of my middle finger . . . as it peeks in
and out of the sides of my labia . . . as you can . . . see, there's . . . no need for actual vagi-
nal contact at all . . . so . . . this basic method would work for . . . all sexes—

Ladies and gentlemen, there you have tonight's first candidate, Ms.
Letje Cuvier . . . the camera will stay with her throughout her orgasm,
as all majority-age and above members of the audience vote . . . and as
you can see, Ms. Cuvier has climaxed, and is now winding down with
a gentle massaging motion—

YEA—4,562,937,711,942 votes NAY—3,648,972,350,793 votes.

That was a close one, but Ms. Cuvier has made it to the final round.
Congratulations, Ms. Cuvier—

Thank you—and thank you, voting audience.

You're welcome . . . and now, let us welcome our second candidate,
a Mr. Mario Klimas, from Indianapolis. Mr. Klimas is a member of the
heterosexual minority, and a graduate of the University of Wisconsin,
La Crosse, where he graduated Cum Laude with a degree in Applied
Behavioral Sciences. He is currently on leave from his job with the
National Sexual Aptitude Council. Welcome to the Delectation Debates,
Mr. Klimas.

Glad to be here.

You realize, Mr. Klimas, that being a member of a minority, you are
somewhat at a disadvantage with the majority of the viewing and vot-
ing audience—how does that make you feel in terms of your potenti-
nal for assuming the position of Leader?

While I am a heterosexual, and proud of my sexual and psychological heritage, I am
also aware that the rights of the majority should be respected; they've fought hard for said
rights, but I doubt that their current position as a sexual majority would blind them to the
rights of those not currently in the majority. Nor would it allow them to ignore the phys-
ical ease and natural superiority of the heterosexual lifestyle—

When using the terms "ease" and "superiority," I assume you are
referring to the traditional biological aspect of copulation versus mutu-
al pleasure regardless of sexual orientation?

Yes, yes . . . as the entire viewing audience is aware, biologically, the human race is still
dependant on the heterosexual minority for a continuance of the species as we know it—
granted, artificial insemination, pseudo wombs and other manmade devices and procedures
do allow virtually anyone to "give birth" so to speak, but for the natural method of copu-
lation, insemination, and birth, only heterosexual coupling will produce a child without the

need for medical intervention.

But what does that say about heterosexual minority couples who are infertile? Are they in some way inferior, or non-minority, because they too need to rely on medical advances in child—

Not at all . . . I am merely saying that the heterosexual minority will always have a place in any society. A necessary place—

I see . . . but getting back to my original question, how will you relate to your potential consitituency?

As one human being to another—or to many—human beings.

Good point, and a universal one. Given that stance, how would you react in the following situation: You need to convince the Leader of one of the other Nations that your intentions in regard to a human~ rights treaty are honorable, and that you have the best interests of his people as well as your own in mind. If this other Leader is a male homosexual—an avowed homosexual since childhood—how would you go about persuading him that you're on his side?

Well, even though I've never had any gay experiences, I know what I enjoy, as a human male, so I'd naturally assume that this other human male would want me to kneel before him, and tongue his penis—Oh, may I ask a question?

Uhm, yes, certainly—

Is he a top or a bottom?

Why . . . that question wasn't considered during the formulation of—

Never mind . . . I'll assume that since he's his nation's Leader, he's probably a top man. So my kneeling down before him will intensify his pleasure and his sense of being ahead of the game. No matter how long he is, I'll take him into my mouth, lashing his shaft with my tongue while kneading his testicles, until all of him is within me—only then will I bite down, lightly at first, then with a sense of . . . purposefulness, just to let him know that we're actually on equal footing. And when he comes, I'll swallow it, to simultaneously show humility and a sense of duty to others. Once I've serviced him, I'll offer him whichever orifice or organ he desires on my body—if it means bending over for the good of our mutual cause, I will do it. And if he takes me in his mouth, I will surrender to the ministrations of his lips, his tongue, his hands . . . just as I surrender myself to my own wife. For the sake of that human rights treaty, I would do what he wished, just as I would hope that he would in turn do what I wished to be done to me.

Well put, Mr. Klimas . . . and in that spirit of self-surrender, how would you encourage the citizens to surrender to their own greater sexual needs?

Since I'm only one person, I'd have to start with what makes me feel good, but then again, each person out there should know their own needs and wants well enough to adapt

their masturbatory techniques accordingly . . . as for me, my penis is my staff of life. I start with the underside, where the base of the shaft meets the scrotum, and use long, steady strokes to . . . just ease my cupped palm from bottom to top, then once . . . it's up . . . use my thumb to tease the glans, and push back my foreskin . . . one of the benefits to not being cut . . . and as soon as the first drop beads on the tip . . . rub it over the tip, until it's lubricated . . . then cup the other hand around my balls and give them a firm but gentle squeeze . . . while encircling the penis with the other hand—

Camera two, be ready to pull back—sorry, too late. Audience members can vote now . . . Mr. Klimas has climaxed, and camera two will again be operational shortly. But the full-body view in camera one is exceptional—

YEA 4,202,286,791,734 NAY 4,009,623,271,001.

The voting is exceptionally close tonight, but again, we have another candidate advancing to the final round. Congratulations, Mr. Klimas . . . and may I say, that was an *exceptional* ejaculation—

Thank you . . . I trust that camera will still work?

It should . . . yes, the monitor indicates that the lens is undamaged. Again, congratulations on making it into the final round, Mr. Klimas.

The pleasure was all mine—and, I hope, all of yours, too.

I'm sure it was . . . and finally, our third and final candidate, Ms. Adonia Caeneus from Newport Rhode Island. Ms. Caeneus is currently undergoing sex-change surgery—uhm, would you prefer to be addressed in the masculine?—from female to male and—

I am still registered with the Social Census as a female as of this date, but I will be changing my name to Adonis quite soon—

Thank you. Now where was I . . . roll telescreen back a bit, thanks . . . from female to male, and is currently on sabbatical from a post at the San Francisco Municipal Library of Sexual History. And let us be the first to welcome Mr. Caeneus to the Delectation Debates—

It is my deepest pleasure.

Thanks to the recent changes in the Sexual Registry, you do realize that as a voting, mature citizen, you are one of the seven percent of the population qualifying for double-vote status due to your gender-change decision. How do you think this qualifies you for a term as Leader?

Aside from the obvious fact that I will have lived a life as a member of not only both sexes, but also as a practicing bisexual and as a sexually responsible member of the mature sexual community, I feel I am best qualified for the position of Leader due to my thorough

understanding and empathy for all mature sexual beings, of any and all genders and orientations. Plus, I feel capable of expressing genuine, uninhibited sexual congress with anyone whom the service of my country might deem it important to approach sexually. Just as I have literally experienced life by coloring inside and outside the lines, to use an ancient analogy, I feel that I can best empathize with and adapt to any person and/or situation presented to me as Leader.

Well put . . . however, might you run the risk of not being able to focus on the needs of a specific person or group, due to your transgender life experiences?

On the contrary, I have literally lived many types of lives, and have full emotional and sensory memory of all the stages of my life, and therefore can relate to those people who choose to remain "as-is" sexually, as well as to those individuals who choose to explore their sexual potential and possibilities.

Since you've brought up your multi-sexual life, perhaps you'd like to show the audience how that understanding might apply to this scenario: A government intern assigned to work closely with you on an important sexual devices trade agreement is frigid; she is a hetero female, only recently of the mature age, and wholly inexperienced. How might you initiate a better understanding of the nature of her work in her?

Well, as you can see, while I've had my breasts reduced with liposuction and laser surgery, they're still quite whole in the nipple area . . . and if you'll aim that camera there at my pelvis, I'm currently in the initial stages of hormone enhancement, so my clitoris is quite enlarged, as are my outer labia—prior to the surgical reassessment of my organs—so you can see that physically, I'm between specific genders, which I would use to show this intern that no matter what she looks like, or how little her body has been touched either by herself or by others, she is still a precious sexual being, one whose body still holds many surprises for whoever beholds her. I'd show her how tender and responsive my nipples are, despite the changes in my breasts, and I'd let her stroke me along my clit and on the outsides of my labia, to show her how she might feel to others. But even if I were fully male by that time, I'd have her stroke herself, then touch me wherever she wished, just to allow her the pleasure of contrasting self-excitement with exciting others. Once we'd finished foreplay, I'd first tongue her to orgasm, getting her used to the feeling of being entered with the tip of my tongue, then a fingertip, then . . . should I be wholly male by then . . . with my penis. But not hard thrusts, just teasing, shallow penetration, until she could relax fully, and enjoy it all the more. Or, if I'm still like this, I'd rub her quim with my own, making sure that the enlarged clit slid along her own inner lips . . . and all the while, I'd watch her eyes, specifically the lids. As soon as they were completely flushed dark pink, I'd ease into her, or press what genitalia I do have all the more tightly into her oily-wet center, until we were mutually satisfied—

A most absorbing scenario . . . and I'm sure that the audience is eager for a demonstration of how you bring yourself to solo satisfaction . . . even if it is a temporary manner of masturbation for you under the circumstances—

I doubt things will change too much . . . my nipples have always been so hypersenstive, just brushing a forearm or an inner wrist against their very tips makes them go raisin-hard, as you can see . . . while running a finger very lightly from breastbone to the top of my mons makes me almost immediately wet—I hope this will translate into a semi-instantaneous erection later on—which I currently help along with a figure-eight motion along my inner labia, making only the briefest contact with my clit before moving back down along the double loop. And as I do this, I feel my ass tighten and throb—when I'm alone at home, I use sexual toys, but right now, since the cameras are aimed at my quim, I'll just make do with my fingers . . . once I've been completely changed over, a simple rolled finger motion should do it.

But until then, I'm still quite sensitive . . . still quite . . . aroused . . . almost as if I'm fingering someone else, someone totally female

And as the viewing audience can see from the inset from camera one, Mr. Caeneus's eyelids are quite deeply flushed . . . and the audience can register their votes now

YEA 4,110,140,031,522 NAY 4,101,500,031,413

Ladies and gentlemen, we have our first-ever three-way tie for the Leadership primary . . . congratulations on your extraordinary efforts—

I was just being myself . . . and I thank the voters out there for their open-mindedness for the ultimate sexual minority, but not the only sexual minority.

Thank you, Mr. Caeneus, and best of luck with the remainder of your transformation—

You're welcome, and I look forward to returning to the primary this fall—

We'll be looking forward to seeing you, and your new organs.

I'll be looking forward to showing them off to the nation.

And ladies and gentlemen, we'll be looking forward to seeing all of you come the primaries . . . this year marks not only the first three-way Leader race of the Sexually Awakened Period in our history, but it also marks the beginning of fully interactive voting. As you are aware, voting in the final election traditionally takes place in official polling areas, where each person votes in private . . . but now, thanks to a new fully interactive telescreen system, our potential Leaders can see all of the citizens making their vote, however each person wishes to make it— this way, our Leader-to-be can benefit from a virtual one-to-one "meet-

ing" with each of his or her fellow sexually mature countrymen, so that no voter is a mere nameless face and body to our Leader, but a real, individual *person* in all of his or her unique glory.

Even though your vote will remain anonymous, *you* will no longer be a mere statistic, but a true sexual individual, just as your Leader is much more than what used to be known as a "dark suit" up behind some podium. Just as all of us fully know and treasure our Leader, so shall he or she fully know and value each of *you*.

And so, on behalf of our current Leader, and our soon-to-be-elected new Leader, I hope to be seeing you all at the polls

Oak and Ash

Suzy McKee Charnas

"Brought you something," Paul said.

Karen, arms crossed over her breasts, watched from the doorway as he unloaded an enormous baulk of timber from the back of his truck. It wouldn't cost him at the plug-in to recover all the charge it took to drag that weight from wherever. Paul had a secret stash somewhere Out that he used to run his gas-powered truck. Which meant she would be that much more indebted to him.

Say no, she thought. But the wood was splendid. You didn't often find that kind of thing lying around these days. The local Scroungers left her bits and pieces, the remains of abandoned furniture and fallen house frames, nothing like this.

Paul grunted with effort, wiry muscle braiding under the thin cloth of his tee shirt. Showing off. He never stopped trying And he was strong, for a piebald. Like most Outsiders—like Karen herself—he didn't bother with shielded clothing. His skin—like hers—was blotched with old cancers.

Karen leaned against her doorframe, secure in knowing that he knew that there was a loaded shotgun within easy reach of her hand. The day he'd first dropped by and seen it he'd nodded approvingly and said she was smart, she already knew the prime rule of living Out: keep a gun.

She'd returned tight-lipped thanks and not mentioned the automatic pistol she kept in a drawer of the table. He didn't need to know about that. You live Out alone in a crack-walled old adobe house you can't really secure, you have this strong and oh-so-helpful neighbor, and you won't keep dogs and watch them sicken—you have two guns.

"Where do you want it?" he panted.

She started again to deny that she wanted it anywhere; but said nothing. It looked bleached and caked with dirt. Where she could see the grain it gleamed silvery-tight, and there was a twist to the shape of the baulk that had already anchored itself in her imagination. This one wouldn't become a small, fine carving of a tree, a bonsai entirely of wood, for the bubbleheads to keep as a reminder of what real trees had looked like when there had been an ozone layer to protect them.

She indicated a sheltered corner of the yard.

Paul said. "You sure? You'll have to wrestle this rascal inside by yourself later, if you change your mind."

I can always call you, she thought; words from another life, life in the bubbles, life before Jason (still the inward flinch, the echoing cry of rage and hurt and disbelief). Not likely. She didn't want this man or any man setting foot in her house, now or ever.

"I'm sure," she said.

He half-dragged, half-carried the timber across the bare earth and propped it on end under the tarp stretched from the eaves of the old tin roof and out to the fence enclosing the yard.

"It's oak," he said, brushing his palms together and breathing deeply. "From the old Holman place; one of about a dozen timbers Joe Holman had shipped all the way from Europe after the big hurricane. I heard he was going to build an underground house instead of going into the bubbles—independent old cuss. I thought you might like to have it, for your work and all."

How could she get rid of him? "Thanks," she said. "How much do I owe you?"

He grinned—*gotcha*—and shrugged. "Nothing, it's just scrounge, Mizz Raeburn."

"For the haulage," she insisted. In the end he accepted a mostly-used tube of Cansuppress and a good steel rasp, the passage of goods taking the place of the handshake Karen wanted to avoid. Then he was rattling away down the hill toward the wheel-track and hardtop remains of the road out of the canyon. The sharp gas and oil stink of his truck hung in the hot, dry air.

Karen inspected the wood. The surface drank oil from her fingertips, darkening as if her touch burned. The whole baulk rocked when she tugged it forward, then settled upright on its flat-sawn end—a pillar as high as her shoulder, with a twisted narrows in the middle.

No hurry, she thought. Let it sit.

The rest of the afternoon she worked on a two-foot high chunk of mahogany, roughing out the form of a wind-gnarled California cypress, one of her most popular designs. Maybe later the intricacies of branch and foliage would be painted brown and green by somebody in the bubbles; things had a way of being passed around and embellished Inside. Karen preferred the bare wood, but as long as she got her minimum of food supplies and energy charge in return, she didn't object to changes in her work once she was done with it.

Some work she kept, and on days when her pain (ungentle nudges from the slowed but steady progress of cancer) required heavy doping to survive, or days when her energy simply gave out, she rested surrounded by early efforts that she told herself weren't good enough to trade. She loved their company: her own forest, made by her own hands, tree by tree.

Carefully driving her blade along the ropey form of the cypress, she didn't give the oak baulk a thought. If she didn't concentrate utterly on the work at hand, nothing was achievable at all.

Later, forcing herself to eat some bubble-grown greentack and jerky while she sat on the front doorsill to watch the sun set, she was drawn to the corner of the yard again. The wood attracted her hand like the hide of some big, docile animal. It even felt a little warm to her fingers—an illusion of friction, of course.

She dreamed of Jason that night, shoving her down hard and swarming on top of her, his contorted face dropping stinging sweat into her own wide, terrified eyes.

The dream woke her. She pulled on her robe—it was cool enough for that after midnight—and padded around the one large room she lived in: bed, kitchen-corner, and workspace enclosed in thick earth-brick walls all crazed with cracks and patches where the white plaster had fallen off. Using up precious energy she needed for her work, using up precious waking hours, but she couldn't be still. She unlocked and relocked the door, unloaded and reloaded the shotgun, settling at last at the table to clean the automatic by lamplight with the ragged curtains drawn.

They had fined Jason. Rape was a commonplace in the bubbles, a

product of compression on all fronts. She was lucky not to have been murdered too. She had fled.

Without the shelter of the bubbles you died pretty soon even with Cansupress to quell the skin lesions when they came. But you didn't get bothered much, and you had some space to live in. She wished she had come Out a long time ago. Even her work had changed when she had decided on the caustic rain and lethal sun instead of the subdued frenzy of bubbled life.

She was something special now: not just a boringly, violated and betrayed bubblehead but a romantically doomed artist braving the bitter Outside to bring back life-giving images of how it used to be. There were perks. They let her draw a modest energy ration for her skate, pain-killers and Cansupress, oil for her lamp, cleaned water to drink, from bubble stock. It was a short term arrangement they could afford.

Watching her fingers laced with cancer scars and shiny with gun-oil as they faultlessly reassembled the weapon, she had a vision of herself as a sunken-eyed crone, her cloud of springy red hair thinned to gray, going through these same rituals next year and maybe the year after. *Like a ghost*, she thought. *Jason did kill me, he killed me into a ghost. A ghost sculptor, carving the ghosts of the dead forests.*

Her forearms rang with leftover shock from using the mallet all afternoon. Even without the added fragility brought by the inward destruction of her body, she was too fine-boned for this kind of work. She'd been a jewelry maker in the bubbles. She was a small woman, with freckled celtic skin, a pointy-chinned, pixie face, and lean, sinewy limbs. Her ribs showed, her collarbones stood at the opening of her shirt like barbaric jewelry from some long-since dried up and blown away African country. Small, neat, light even before the cancer had begun to shrink her; an easy mark for an angry man afraid to fight other men but not afraid to fight a woman, on whom he could inflict the ultimate, the inexpungeable defeat.

She cleaned the automatic and visualized her hands tapping, tapping, driving a number 5 chisel into Jason's head, just above the right ear. Not too fast, either.

Hot tears burned the scarred skin of her hands.

In the morning she set wooden braces around the oak. Then she put a gauge to the curved place at the center and tapped tentatively. Wood curled neatly back, split off with a tiny dry sound, and fell. And again. I don't know what I'm doing, she thought. I'll ruin it, messing

blindly around like this. All she had ever made Outside was miniature trees copied from photographs in travel brochures she had taken from a ruined office building.

This oak had been a tree already, it wanted to be something else now. The wood directed her. It would only cut in certain directions, which seemed to have nothing to do with the plain oak grain. Knots underneath? Something. Something hidden. Tap, curl, break.

The light was going. She sat back on her heels, her sweat-filmed body trembled from sustained effort. She'd been day-dreaming about planting vegetables, a useless task Outside. While she'd dreamed, her blades had cleared an oval space on the side of the pillar. The sunken surface was smooth, inside the shaggier ring of the outer layer of oak, faintly undulating in a pattern she almost recognized.

For two days she worked on her carved bonsais, but she kept going out into the yard to look at the oak. The space she had cleared on it was golden now from her handling. She touched it whenever she was there, trying to get a better sense of the shape within.

That Friday she delivered a sixteen inch high olive tree to Becky at the bubble that called itself Gaia, outlying from the main cluster.

Karen had put the trip off as long as she could. She hated the grimy, straggling look of the bubble-chain that lay glistening slightly, like greasy eggs laid by some gigantic insect in sloppy coils over the charred and collapsed ruins of the old city. This stale-looking mess occupied the center of a once-fertile river valley, now —not jungle, too high for that—red, gullied desert. The whole valley pulsated endlessly with the sound of the pumps, sucking water from the deep aquifer that justified the survival of that portion of the city that had been bubbled. When the water-mine dried up, the bubbles would be dismantled and moved elsewhere.

The Gaia women fussed over her. They flattered her and praised her work which, bartered through their coop, helped to support them. She wasn't interested in living in their grouping, which had compression blues—batterings, destructive drunkenness, fads and addictions—just like those of the other bubbles.

She had planned to stay for tea and baked treats and gossip as usual on delivery days, but she found herself heading the skate back into the hills almost at once, trundling along as fast as it would go. Sometimes bummers and snappers lurked around the bubble-locks, daring each other to take a few minutes exposure to earn rank in one or another of their secret societies. They could be ugly with Outsiders.

At home she rested a while, then went into the yard, trying unsuccessfully to reenter the dream-state of her first attack on the oak. Exasperated, she set to work anyway; let the chips fall where they may. What difference if she spoiled the fool thing? It was just junk Paul had unloaded on her in hopes of getting something back. At worst, she could cut the ruined timber into several pieces and make carved trees of them.

She worked, panting and barely in control of the exhausted quivering of her arms and fingers, until the gauge she was using turned under a crooked blow and jumped from her hand, landing tip down in the dirt like a pocket-knife flipped in a game of mumbledy-peg. She dropped her maple mallet and fell back a wobbly step, sweeping the grimy safety goggles up onto her forehead with her wrist.

She had carved the lower part of a man's torso, naked, the ridged belly and the lower left rib-cage stretched in a half-turn away from her.

I don't do figures, she thought blankly.

Hadn't done this one either. It had done itself using her thin, freckled hands, as if recalling in them the school-drawings she had done years ago, nude studies in art school. She hadn't been much good at that, though.

And this was beautiful.

She set her palm gently on the hollow between the floating rib and the still-hidden hip-joint. Only if she pressed hard did it feel unyielding, like—like wood. Just resting her hand there, lightly, she could have sworn she touched the flank of a living body.

Her heart pounding erratically. A man in the wood, a prisoner—except to the degree that she let him out. She knew instantly that she would do the hands and the feet last, keeping him long in the stocks, at her mercy. And she didn't have any of that.

A truck rattled past on the road below. She swore. If that was Paul, he would stop by to see what she had done with his gift.

The truck didn't stop—it was red, not green, she could see it even at this distance over the naked earth—and there was no gas stink. An official vehicle from the bubbles, then, making one of their periodic surveys to keep track of changes in the stripped, sliced landscape. Busy work. But what work wasn't?

Paul would come sometime. She didn't want him to see this strange emergence from the oak. She decided to call Becky and ask her to bring up the truck with the winch in it. The Gaia women did heavy equipment work. It was their skills more than their arsenal and willingness

to use it that kept them relatively unmolested. They would move the baulk inside for her.

They talked about bubble politics, and news of weather patterns up north and developments in storm-proofing windmills for electricity generation. Karen made an erosion report, giving the kind of information she was expected to offer for the use of the phone line into the bubble. There were always new landslips off the stony sides of the mountains.

Then she said, "Listen, you read, you'll know about this—"

"Or Jane will," Becky said.

"Or Jane. You know any stories of men trapped in trees?"

"David and Jonathan, I think," Becky said. "Wasn't it one of them that got caught by his hair in the branches of a tree during a battle, of all things—"

"No," Karen said. "Inside the trunk, caught in the trunk of a tree. I know I've read something like that somewhere." She didn't read any more, had taken no books Outside with her, and had many gaps in her memory.

"Ariel, in the cloven pine," Becky said. "That's in The Tempest; punishment for disobedience, I think."

"Who else?" Karen said restlessly. She didn't like talking to people any more. She wished she had never called.

"Well, there's Merlin the magician," Becky said. "He's supposed to have missed the final Arthurian battle because his girl-friend, Nimue or Viviane—"

There was a murmur in the background. Becky added, "Or Niniane, Jane says, there's no agreement on the name. She might or might not have been the Lady of the Lake, though mostly she's described as a wood-nymph."

"I thought wizards didn't have girlfriends," Karen said, frowning, "like priests."

"You bet." Becky laughed. "They lose their magic with their precious bodily fluids, you know. She's supposed to have beguiled poor doting old Merlin so she could get him to tell her the secrets of his magic, such as trapping an enemy in a tree. Then she lured him into a forest in Brittany and sure enough, stuck him into a hawthorn bush."

Murmur.

"Or an oak tree," Becky ammended, "Jane says. Or a cave, or a castle in the air, depends on your source."

An oak.

"Why?" Karen said.

Becky snorted. "Because he was too old for her and she was bored with him, and she'd learned all he had to teach her. Typical female treachery. It's a tale of the patriarchy, Karen, what do you expect?"

"Any others?" Karen asked, looking out the window at the oak. "Trapped in trees, I mean."

"Oh, tons of Greek myths, of course. Every time some panting god goes to rape a local village girl, a helpful other god comes along and turns the victim into a myrtle tree or a laurel or whatever—somebody's idea of a rescue."

Karen stood dry-mouthed, her consciousnes caroming around the inside of her skull like a bullet. Becky knew, of course. Everybody in the bubbles knew everybody else's business, and Gaia, where many rape victims retreated, was bound to contain more knowledge of who'd been raped by whom than any others in the chain. Becky was no doubt administering what she thought of as real-world therapy: Treat the victim just like anybody else.

Right, Karen told herself forcefully. She took a deep breath. "Well, you could do worse."

Becky said, "So what's doing, do you have some figures turning up in one of your bonsai pieces?"

"Something like that," Karen said. She didn't say anything about the winch, or the oak.

The figure was shorter than she was, she discovered over the next few days. The frame was that of a smallish, slightly built man standing in a defensive crouch. His knees were bent and one arm was raised and crooked over his head, giving him the posture of a wispy caryatid sinking under a pediment too heavy for its strength. The other arm was clamped across the torso. The face was partly hidden in the crook of the upraised arm, which angered her: how dare he—it—conceal anything from her?

"We'll see, we'll see," she muttered to herself, limping around the figure from side to side in a wide arc, studying it. There would be a profile at least, pressed up against the inner surface of the raised arm.

She dreamed that night that a man stepped out of one of her carved trees and attacked her. He had Jason's weight and strength, but it wasn't him, it was someone else.

The next morning she went out and studied the figure narrowly, searching for any resemblance to Jason. "You'd better not," she said through her teeth. "If you come up looking one little bit like that son

of a bitch I will burn you and toast my food in the flames."

His body was worn as if with use, with a seam-like scar running down one lean ham and another scar, perhaps of an animal-bite, crossing the left forearm just below the elbow. She ran her fingers down the chest, across one nipple, and then along the forearm where the veins stood high—a grown man's arm, not that of some Classical youth.

She felt her own nipples go suddenly sensitive against the fabric of her shirt.

She stood as still as he stood, her mind fluttering wildly between shock and a faint, glowing pleasure. She'd had moments of arousal since the rape, odd moments, shocking and disorienting. This was different. She was, after all, alone; and the cause—the cause?—of her inward warmth wasn't some image or waft of scent designed by some one else to elicit exactly this response.

This was something she had made for herself out in the poisoned world, and it was in her power utterly.

She put her hand on the as-yet undifferentiated bulge of wood between the wooden thighs and smiled.

A bed of chips and curls made creeping, cracking noises under her shoes as she moved around the figure. She thought sometimes it—he—shuddered with more than simple vibration under her probing blades, her inquiring hand, the pressure of the smoothing rasps and sandpapers.

His helplessness incited her. One night she took a cracked old leather belt and lashed the figure under the dim gray sky until her arm was tired and she tasted blood on her lips—her own blood, of course. The way she had tasted her own blood the night Jason had attacked her. Only this time it was *her* will that was brutally unleashed on another, an experience both sickening and intensely satisfying to her.

She phoned Becky again and this time they made arrangements, and Becky came out with the winch.

"Who's the model?" she said, after they had hoisted the figure in through the skylight and set it in the middle of the room.

Karen smiled nervously. "Damned if I know."

Becky had taken off her heavy work gloves and stood with her hands at her sides. Karen wanted to invite her to touch the carving, but couldn't bring herself to say the words.

"I didn't know you did this kind of work," Becky said with admiration.

The wood man looked so naked. Karen was glad that the face was still hidden and the genitals no more than roughed in yet.

"It would make a hell of a centerpiece for a show," Becky said. "What else are you working on?"

What did it matter? Karen showed her some tree carvings draped in oiled rags to keep the wood from cracking.

"Nice," Becky said. "You're not going to stop doing these, I hope? There are way too many people still, and not nearly enough trees."

"I don't make trees," Karen said. "I make mummies of trees out of the corpses of trees."

Becky murmured, "These days, that's a lot."

She pulled on her bulky Sunsuit and they went outside. "I don't know how you take it, alone in all this barrenness," Becky said in a voice distorted by her face mask. "Any problems with Mighty Stud down the road?"

Karen said, "Nothing I can't handle."

Becky climbed into her truck. "If he bothers you, call. You can always stay with us for a while. We've got room."

Someone must have died.

"I like the new piece," she said again over the purr of the truck's electric motor. "Nice that you're making him mature instead of a pretty boy."

Old, Karen thought, waving as Becky drove away. *I'm not making him anything, but he is old. Not Ariel; Merlin.*

"Too old," she murmured later, prowling around the figure. "Merlin the wise. Too old for Nimue. Did she hate you, run from you? Bet she did."

In the flickering lamplight she circled closer to him, whispering. "Bet she didn't even know you. Why are you cowering and hiding your face? Shut up in oak all these centuries—for what? What did you do to her, to earn yourself this living coffin?"

She peered at the hidden face. "What else?" she breathed, "The usual thing, right? Or anyway you tried. Of course you tried. And she made you pay, and you're still paying. Good."

The quiet amplified her thoughts and sped them up. She sat on a long-legged stool and studied the figure, drawing knowledge from it.

"She was young, a girl," she said, hearing her voice take something of the singsong lilt of her own mother's voice from long ago, telling some old, old story. "Full of the power that girls have until it's crushed out of them And she was a wood nymph, she had more forest-magic

than you did, didn't she? She was the one who knew how to lock a person into a tree, and you were the one who wanted to know how, to help defend your protégé. What were you, forty, maybe fifty, even? The big battle was coming up that you could glimpse from the corner of your prophetic eye, and you needed to help Arthur. But how could you, with an old man's failing powers?"

From the figure nothing, of course.

"Man-magic failed you," she said. "So you tried to seize some fresh magic from that girl. What was she, someone dedicated to a woodland goddess? Or just a young local with a talent for finding helpful herbs in the forest? And she was too much for you after all. She shut you in a tree, where you've been thinking it over ever since; while the story gets told and retold, with you as the victim of course."

There was no sound but the wind outside, and someplace distant a faint rumbling—some denuded, wind-cut hillside slumping down into a dry creek-bed.

"Should I leave you where you are?" Karen mused, tapping her iron-bound mallet handle lightly on her thigh. "Or chop you to bits and burn you? Or just roll you down onto the old road and let you lie there and rot in the sun? I would, if I were afraid of you; but I'm not. You're the one who should be afraid of me."

The statue acquired a rich patina from the oil of her skin. She rubbed it and stroked it. She knew every plane of the wooden body, every angle and sloping curve.

She worked on the back, smoothing the small-stepped stair of the spine and the flat palms of muscle arrowing down into the buttocks. Sitting on a stool and lightly sanding the wood with fine grade paper, she felt heat build in her hand and flow through her to unite with heat in her body, and when she got up to stretch and drink water, there was a sudden coil of sweetness in her crotch.

She laughed. Paul should know—Becky should know—what she was doing for company here in her refuge in the dry hills above the bubbles.

What she was doing for power.

She lived on greentack soup and withered apples. Surrounded by miniature trees in various stages of completion, she worked, in the hours when she had strength to work, on the wood man.

One foot came free, callused heel and splayed, bent toes. Now the arm, the one clamped across his torso, the hand turned outward, fin-

gers spread—slim, clever fingers, a stage-magician's hand—vainly fending away the magic of the abused wood nymph, her anger and her curse.

She touched his open, out-turned palm, and touched herself, exercising the only woman's magic that she had in the lamplight and the silence of her earthen house. Sweet and liquid heat flashed in her groin, dissipating so quickly her knees hardly had time to weaken.

"How about that," she asked him fiercely "for a change?"

She went to bed feeling embarrassed, which made no sense. But she was. *Shouldn't have done that*, she thought.

Which didn't stop her from doing it again.

She spent all her time with her hands on the wood, on her own body; danced ferociously around him, naked and barefoot; taunted him, whispering and humming while she sat in front of him easing miniscule threads of wood off the curving column of his penis as she freed it from its bedding of chipped-in hair.

"Nobody ever had one like this, you can bet on it," she said, rubbing her cheek on his belly while she worked the mallet and small scoop with taps no louder than the tick of a watch. "Skin doesn't come as fine as the surface you'll have."

The face she worked on silently for a long time. One eye showed, shut tightly. The nose was longish and bent at the tip where it was pressed against the inner arm, the mouth and stubbled cheek stretched in a rictus of extreme emotion. The other hand was just as she had imagined it, clenched in the flat, thinning hair.

She went to bed facing him every night. She would spit on her finger and slip it into the parting of her sex and stroke slowly while she stared at him until his dark image, a shadow in moonlight, blurred. The only sound in the house was her own sharpened breathing.

He, of course, said nothing, did nothing. In his way he was perfect. She, however, was starving; and she stank from wearing the same shorts and t-shirt and being continually re-coated in sawdust and sweat.

She had forgotten to put out supplies on the porch for the Scroungers. They sometimes left wood they'd scavenged in exchange for whatever food and medicine she could spare. They had come and gone and left her nothing, and she had never noticed and didn't care now that she had.

The handle of her big v-scoop had split and had to be bound again with iron rings. She cared about that. So she threw her stinking clothes in the corner, sponged off in water from the supply tank, dressed in

clean clothes and rode her skate to the bubbles.

She got her scoop fixed and the edges of two nicked gauges reground. Credit for her latest sales bought her a new shirt and a bloc of 600 grade sandpaper.

One of her bonsais was on exhibit in a shop window behind protective metal mesh, an elm incongruously hung with miniature Christmas ornaments. People were lined up to look at it. It was close to that time of year again. She was lucky, she had no one left to give things to. She stopped at Becky's for some coffee. Whatever was in it, it tasted delicious.

"You don't look so great," Jane said with her usual tact. "Sure you don't want to come back In?"

Becky added "It might not be such a bad idea. For what it's worth, by the way that shit Jason has moved down-corridor to the Border bubbles; defense work."

Jane snorted. "With any luck the Machos will wipe him before the year's over."

"Really," Becky said, setting out cookies with precise movements of her stubby hands, "I hate to think of you Out all alone. Having that Paul around 'keeping an eye' on you sounds almost worse to me than being completely solitary, if you know what I mean."

"What?" Karen said.

"He came inside last week for some specialty items," Becky said, "and made a point of stopping by to tell us he's been going to your place now and then just to make sure you're okay. As if you needed—"

"Thanks for the coffee. I better go." Karen set her cup down carefully on the table.

She drove back as fast as she could push the skate, through the broken grid of deserted streets baking in the December sun and up into the hills. By the time she got well into the canyon it was dusk. There was a light in the window of the big A-frame Paul had taken over, but no truck in the yard, just the rusted hulks of a dozen dead cars.

His dogs came clamoring hoarsely, tumorous and slow-moving. She accelerated and lost them in her dust.

The truck was there, in her yard. Gasoline vapors stung her nostrils before she was close enough to see it. Paul sat at her butcher-block table with his hands wrapped around a mug of something that steamed— hot chocolate, by the fragrance. He must have brought it with him. Specialty items, Becky had said; the tough Outsider liked his luxuries.

"Hey," he said easily, "how you doing? Thought I'd babysit your

place while you were out, in case of bad-eyed Scroungers coming around. I seen a gang of them down the north side last week."

Lies. He had Jason's look, all greasy-eyed with expectation. She recoiled as he stood up and she would have run; but he could run her down with his truck. And this was her place, her things were here. The trees, her work. The wood man.

"Got things to carry in?" Paul said. "Glad to help. Your cupboard is sure bare." He jerked his thumb over his shoulder at the wooden fig-ure under the skylight. "Been feeding all your stuff to him?"

"Go home, Paul," she said.

He raised his hands to shoulder level, palms out.

"Hey," he said, "what's wrong? Look, you must be beat. Couple hours in the bubbles wears hell out of me; I bet you feel it the same way. Relax, I'll cook us up some supper. I got mushrooms picked fresh from this place I know, gila eggs, couple of onions out of my own growing patch. You didn't know I'm a farmer, did you? Even the way things are now. A good man can do okay Outside. Sit down, uncoil, start getting used to having old Paul hulking around in here."

Was that how he thought of himself, this stringy, scar-slicked snake of a man—hulking? She stared at him. No words came, only scorching anger, obliterating weariness.

He shrugged. "Well, I'm sure better company than that cigar-store Indian you made. Though I know you like him, Karen."

"What did you say?" she whispered.

He said, "I've seen how you like him. You know what I mean. Hell, if you can get hot over a goddamn statue, you must be ready for fun with a live man."

That was why she hadn't seen anything of him for weeks. He had been watching her secretly, sneaking up on foot to peer in at her while she worked. And danced. And.

The shotgun was gone, of course. His smile widened as he saw her look for it, and he shook his head very slightly, no. He was standing between her and the drawer with the automatic in it.

"Go," she said hoarsely, backing up quickly and throwing open the door. Her tongue was an unwieldy leaden lump in her mouth. She could hardly speak human language. "Get out of here."

"Wait a minute," he said, "I'm not passing judgment, I'm just offer-ing something better. What's wrong with that? We're two of a kind, Outsiders, tough and smart. We could help each other all kinds of ways."

"Out!" she barked.

"That's no way to treat your friends," he chided. "And I am a friend of yours, Karen. I'm worried about you. Everybody's worried about you. You're a valuable person, doing what you do. Why do you think they make it so easy for you to get what you need Inside? There's bubbleheads making fortunes, trading those pretty carvings you make. There's people with a stake in you, and everybody knows this is no life for a woman, Outside all alone. Even old Becky was relieved when I told her I was keeping an eye on you. So what are you hollering about? All I'm saying—"

"I know what you're saying," she hissed, her throat suddenly open again and seared with venom. "And I don't want it, and I don't want to hear it, and I don't want you. If you come sneaking around here again I will blast you to Hell."

"What with?" he said. "Looks like your big old shotgun is gone."

Her jaw burned with tension. "Get. Out."

He showed his palms again, conciliating. "Okay, okay, if you feel that strong about it. I'm going."

But as he stepped past her toward the door, he lunged and pulled her into a crushing hug, pinning her face to his hard chest with one hand.

"There," he murmured into her hair—she could feel the heat of his breath on her scalp and smell chocolate. "Just stay there a minute and see if you don't feel different."

He moved his hips against her, prodding. She smelled Jason's sweat and felt Jason's eager heartbeat under her cheek. She twisted, trying to bite him through his shirt.

"Hey," he panted, "take it easy. We can do this friendly or unfriendly, it's up to you. I won't complain either way." He kept her face turned aside so she couldn't get hold of him with her teeth, and her feet, in her soft-soled shoes cushioned for hours of standing work, made no impression when she kicked.

"Aw," he said, his voice going gruff, "come on, honey. I'm better than wood." He began to work one hand into the waistband of her pants.

She convulsed, screaming into his body, trying to tear him and herself apart with the wrenching of her rage and terror; but he was like steel cable to her bird-boned frame.

Suddenly he slammed against her with a huge expulsion of breath, and his arms sprang wide. She reeled backward as he turned away from

her, his hands thrown up to block the next blow from the figure behind him.

Lamplight danced on the polished skin of the wood man and shadowed his raw, splintered cheek. He had torn his right arm free from the side of his face and lashed Paul across the shoulders. With a splitting sound his other arm pulled away from his chest and snapped out, catching Paul in the belly with a thick, meaty sound.

Paul doubled over and stumbled, wheezing, past Karen, his eyes bulging and spittle hanging from his lips. He bounced off the door-frame as he passed through so that his trajectory across the yard toward his truck became a shaky parabola, like an ungainly top wobbling to the end of its spin.

Karen shrank against the wall as the wood man approached her. He swayed precariously from step to step: his left foot, the one she had left imprisoned in the wood, was a shapeless, splintery lump. The worn boards of the floor shivered with each thumping impact.

He's coming for me, she thought in numb terror, remembering what she had said to him, how she had treated him and taunted him and punished him.

But he brushed past her and clumped out onto the porch, where he stopped as if stunned by the line of bare, dark hills under the blurred night sky.

The truck door slammed shut. The engine caught, the lights came on, gravel ground under the old tires. The truck lurched around drunkenly and accelerated toward the house. The front bumper was part of a steel beam that Paul had welded on.

Whatever the wood man was and whatever his intentions, Karen had made him and his unmaking was not for the likes of Paul. She dragged the wood man back by his lean bicep that was warm and faintly vibrant to her touch. He rocked in an unsteady circle and came inside with her. The door wouldn't lock—Paul had broken it.

She jerked the wood man back from the door just as the truck hit the house with a shuddering crash. The floor jarred underfoot and she heard the splintering of two of the porch beams and the tearing sound of the porch roof collapsing; then the grind of gears and the roar of the engine withdrawing, and revving for another assault.

She pulled open the table drawer. The automatic was where she had left it. She checked the load with shaking hands, clicked the safety off, waited.

The wood man stood beside her, faintly odorous of sunlight in a for-

est, one leg cocked over his misshapen foot. He looked not at the door but at her. When she returned his stare, time slowed to his rate, tree-time. Shadow pocked and stained his ragged cheek and forehead like the charring of a dreadful burn, and a swathe of splinters crossed his body where his arm had rested.

There was blood, too, Paul's blood, dark and clotting on his right hand and forearm. As she watched, the wood man lifted his hand and put it to the clean-cut side of his mouth. He smeared the blood on his lips, and on his good eye, and then he let his hand fall; and his chest shuddered and stirred with something like breath.

The surface of his eye was dark and slightly sticky-looking as if coated with sap, and he stared at her with a wide, quiet, pupilless gaze.

"Merlin," she breathed.

The truck engine idled now, and there was a scuffling sound and then Paul's voice, very close outside—"Bitch!" he bawled, or perhaps "witch," or both. "I'll get you, you and that monster you made, I'll get you both."

There was the slap of liquid splashing the broken timbers of the porch, and she smelled gasoline.

"He'll burn us," she whispered, filled with dread; Paul always carried a can full of gas in the truck. The walls of her house were adobe, but the window-frames, the tie beams and the ceiling, the old wooden floor would all burn.

She whirled and ran to the back, clawing open the window over her bed. Not big enough, not nearly, not even for her small frame; and what about the wood man?

He was turning slowly in the middle of the room, looking with his single formed eye at the rough table with her tools and Paul's abandoned chocolate mug on it, and at the finished and unfinished pieces here and there on shelves and boxes, trees, small and perfect, many of them with their rag-drapes pulled off them. The carvings cast wild shadows on the walls in the flickering lamp flame.

From outside came the fat whoom of fire catching, and Paul shouted exultantly.

The wood man limped to the back wall and placed his stiffly extended fingers in the cracks the truck's impact had widened. He pressed, driving steadily into the adobe, and the cracks opened and spread. With a whisper the wall slumped into a dusty heap half in and half out of the room.

Cool air rushed in, and flames answered from the front door, lick-

ing in around the doorframe. The wood man took Karen's hand in his
smooth left hand and drew her toward the gap in the wall.

Emerging into the warm night, he checked so suddenly that she col-
lided with him. He turned his face from side to side his nostrils flared
as if tasting the breeze, bent his head back to scan the dim, milky sky.
A low sound came from him, a thrumming vibration almost below the
threshold of her hearing. He let her hand slip from his grasp and with-
out turning limped away up the hill behind the house toward the
mountain slopes.

Karen hung back, dancing fearfully from one foot to the other.
Through the hole in the wall she saw the door burst inward. The high-
beam lights of Paul's truck struck blindingly through the smoke. Fire
gulped a rag draped over a stylized pine done in cherry wood, and the
carving went up. An apple tree, gnarled in miniature, leaped to frag-
ments with a roar before the flames reached it: Paul had fired her shot-
gun from the cab of the truck.

The automatic, heavy in her hand, was absurd in this glaring, smoky
chaos. Against the shotgun it was a joke. The guns were Paul's way, all
this was Paul's way. Better the wood man's way, if he had one—what-
ever it was. Better any way at all or no way.

With a sob of rage she hurled the gun—it clanged off the hood of
the truck—and ran. The shotgun's second blast drove her stumbling
uphill before its irresistible fist of terror. Moments later, a physical
shock wave streamed past her and she turned, tottering. Below, the torn
walls of her earthen house dropped heavily out of the air around the
charred truck that squatted crookedly now in a crude star of settling
rubble.

Divested of everything, a weightless and transparent woman, she
followed the wood man away from the quietly crackling wreckage.

He led her up a boulder-choked stream bed. The footing was treach-
erous with gullies and rocks. He reeled awkwardly sometimes on his
misshapen foot so that she was afraid he would fall. She stalked him,
not close enough to touch but not far enough away to lose him, up
bare bosses of rock where her feet curled in her shoes, trying to cling
right through the soft soles. Sunkilled brush broke around her legs.

In her mind ran tales of princesses following magic foxes into the
woods, knights pursuing enchanted harts.

The wood man found the old hiking trail that switched back and
forth for seven miles to the summit. Karen knew she had no strength
to make it to the top. She scrambled to catch him, try to turn him.

But he angled off the end of one of the switchbacks, picking his way above the heads of the deep canyons that slashed the lower slopes. Karen crouched to keep better balance, sometimes grabbing at the loose soil and stones so that she went more on all fours than on her two feet. Below, she saw the dull gleam of the bubbled town beside the dry river bed, and, much nearer, the fitful match-flame of her own house, burning with the carcass of the exploded truck half in and half out of it.

A rock flicked out from under her foot and vanished into darkness.

I will never be able to get down from here. She wished she were younger, stronger, not slowed by the exposure sickness that had eaten away at her during her years Outside, as the weather of centuries had eaten away at the wood man. But all that time he had been drawing nurture from the earth that fed his prison-tree. Her earth was barren and ungiving, as men had made it. It had nothing to give.

Her legs ached and trembled with weariness.

The moon rose full behind the haze of cloud, revealing what looked like scattered figures ahead, frozen here and there on a shallow saddle between two gullies. They were trees, few and small and twisted, but alive: she could smell the green of them. This had always been hard country, colonized precariously by tough, drought-enduring pines and cedars. Some still lived.

Bemused by the tortuous shapes of the scattered trees, measuring them against her own lost creations back in the workroom, she gathered herself to follow him—but where was he? A small bleat of panic escaped her. Then she saw him stepping back from a pinion tree which he had embraced and merged with into immobility.

He turned from the stunted tree and sank slowly onto his knees. He dug his fingers into the harsh ground and scooped it into his hands and poured the dirt over his head.

Karen stared. There was no sound but the distant throb of the water pumps and the whisper of the dry earth sliding down the wood man's skin: the faint ping and click of pebbles bouncing off him, the tiny, thready explosions of dead root-clumps tearing as the wood man's fingers raked up the soil.

Rent his garments, came a memory of words, *and poured ashes over his head.*

People of the Old Testament were always rending their garments (but Merlin had no garments, or perhaps the enclosing oak had been his garment, already rent). Grieving, they poured ashes over their heads.

She sat down near him, her arms propped loosely on her upraised knees. "Did you think the forests would last forever?" she said scornfully. "Do you remember being human, a busy, greedy little jumped-up primate, tearing everything apart to get ahead? God, I hope you remember. It was your kind that did all this, with my kind trotting meekly along one step behind, grabbing for whatever crumbs we could snag for ourselves."

He rocked slowly backward and forward, scrubbing the pebbly dirt on his scalp and forehead with both hands. The scrape of pebbles over wood set her teeth on edge.

"Quit that," she snapped, slapping his arm. "I didn't sand my damn fingertips off just so you could go wreck your finish."

She shook her stinging fingers and began to laugh, a helpless giggle at first, then a succession of soblike whoops that echoed in the canyons below.

"God, that feels good," she gasped, wiping her eyes. She wondered if he heard her voice, how he heard it, whether her words—surely not the same words that had made up his language ages ago—made any sense to him at all.

She reached out to brush the dust from his sound cheek, rubbing with her palm to oil the wood and bring up its luster again. He pulled away, rising and turning—and halted, lurching. She heard the soft, thick tearing sound as he lifted his unmade foot. He froze, staring down; lifted the other foot with a smaller but similar sound.

Roots. The wood of him was seeking downward for the hidden spring that must feed this thin scattering of trees.

He turned toward her, mouth open, eye staring wildly.

Karen jumped up and stumbled backward. "Keep away!"

He stayed where he was but shifted his feet, breaking the new roots, keeping himself—free? Alive, in whatever human sense he was alive? If he became rooted, what would happen to his memory of being a man?

Diffuse moonlight gleaming on his skinny chest and on the long, light muscles of the leg that was slightly advanced toward her. The sinews of his throat ran strongly beneath the wrinkles that she had discovered with her scoops and gauges. The right side of his face was a formless mass of splinters and rough grain. His left eye blinked, fathomless, its slightly drooping lid giving it a sad and knowing aspect. She thought she saw the arched nostrils quiver.

The night wind licked coolly at Karen's sweaty neck and throat and chilled her back where her shirt clung.

Another tearing sound: she saw the clenching of his jaw as he ripped his shapeless foot free of the soil again. It must hurt, to break the rootlets that kept threading their way out of his skin to burrow into the ground. Good, let him suffer.

But the thought of him escaping back into his insensible, inaccessible tree form so simply and so easily incensed her.

"Fuck you!" she snarled, shaking her fist at him. She grabbed up a rock and flung it. It shied off his ribs with a hard thud and bounded down the slope to silence.

The wood man hugged his splintery arm to his side but made no other move.

Karen scrabbled up another stone and advanced on him, driven by the rage drumming in her blood. A growl ground out of her throat past her clenched teeth. She raised the stone, menacing his face. He drew his head back slightly but stood his ground.

She reached toward his face, not with the stone but with her extended forefinger. Her fingertip rested on the surface of his eye, which felt tense and resistant and slightly tacky, like half-dry paint. She snatched her hand back. If her fingerprint were impressed on the surface of his eye, would it stay there forever? He had no tears to wash it away.

He stood still under her fierce scrutiny. His hands fell to his sides, the palms turned slightly outward, the fingers slack: one hand rough and torn, the other smooth and shapely, the hands not of Jason or Paul or of anyone but the man she had cut from the tree. His posture spoke with the eloquence of sculpture: Here I am, as I am, complex and entire—man and tree, whole and torn, made and marred.

Do your will.

Karen whirled and flung the stone down into the canyon. "Shit!" she screamed. "I am so tired of being so—damn—angry!"

Her eyes stung. She closed out the sight of the wood man and the warm, filmy sky behind him and the ugly glowing worm of the city below. In the weary privacy behind her closed lids, she thought about falling into the canyon, just tipping over into darkness.

She felt fingers slide lightly up the inside of her arm. His unblemished hand came to rest along her ribs, the palm and thumb pointed delicately as the pointing of a fallen leaf up the side of her breast. In the instant before her eyes flashed open, a flame of hunger made her catch her breath in a sharp hiss of startlement and want.

His other arm slipped around her waist.

"Wait," she gasped.

A ripple of intention willfully transformed shuddered through him. She felt him choose stillness and become still, with the unquestioning patience of the tree of which he had become heartwood and tireless essence.

But *he wants*, she thought, leaning slowly back onto the support of his encircling arm. *He wants but waits, and what have we all come to if that in itself can bring tears to a woman's eyes?* Moisture cooled her cheeks, and she tasted salt at the corner of her mouth.

In her mind's eye she saw herself dancing in the moonlit workroom, taunting; saw Jason's sweaty and contorted face, Paul's arms gripping the oak baulk as he dragged it across the yard, fire leaping among the miniature trees in her house, saw herself sanding the curve of the wood man's back with dreamy, sensuous movements of her hands—

She felt the tremor of flight in her legs, and in her belly and groin a terrified clench of rejection. A scream like a needle darted through her, arrowing toward utterance in a blast that would shake the mountains down. But that scream had already happened once without effect, it hadn't even made Jason flinch.

And this that held her was not Jason, or Paul, or any of them, but was Merlin of the tree; Merlin with his sentence served, his pride chastened, his patience the patience of oak; Merlin with his magic humbled, called back to life by her and remade unpredictable in a wasted world that Merlin's own vision had surely never predicted.

She fixed her eyes on the wood man's dual face, the smooth, shaped side and the raw side.

I am thirty-two (she declared silently in her mind because these things are not said aloud and with Merlin need not be) *and bound to die soon; and everything is gone but you are here, and the green, damp scent of you intoxicates. And I want, I want, I want to be intoxicated, and I want to embrace and be embraced outside of anger and outside of the time that has bred my anger.*

The beseeching tone and color of this thought drew more water from her eyes. Yet all she had to do was release the tortuous knots within and let an answer come.

All!

But it was already done.

I, Karen, she thought, *being of some kind of mind and body, far from sound but it's all I have—but I am not just scars and anger, I refuse to be only that. I am Karen, and I in my entirety will do this because I wish to.*

A wave of horror at her own decision rushed over her. Somewhere in it she glimpsed a core of simple vanity that made her snort with

laughter: her skin was only animal skin, rough and dimpled where the hairs stood from it with chill and fear. What a hide it was even at thirty-two, slicked with old scars, sagging where age and illness had already marked it. She was deeply shamed and reluctant for him to discover her imperfections.

As she had so painstakingly discovered his.

"We're even," she announced. "And even if we're not, really, I say we goddamn are."

She unbuttoned her shirt with shaking fingers and pulled it off, for once not moved to hide her small breasts. The wood man held her steady on their ledge of earth above the world while she stripped off her pants and shoes and kicked them away behind her into the dark.

She could see his sex, that she had given him and lovingly, loathingly shaped and detailed, bob slightly against the inside of his thigh as he shifted his footing with another burst of ripping sounds. How much time had they? His good foot was sunk deep into the soil.

Trees are strong though slow, and who knows what happens in the mind of a tree?

"Are you my death?" she whispered, looking into his face that was level with hers, and shivering with a new onset of sweaty dread. "I'm afraid."

A note of something much larger than fear sounded through her body as his hands moved, one to the small of her back, drawing her closer with a pressure so slight that she was barely aware of the needle-pointed splinters denting her skin. His left hand slipped downward and nuzzled between her legs, which shuddered apart and settled their joining into his polished wooden palm.

She felt blind and boneless with terror, and yet it was so easy to raise her leg, curving her back over his encircling arm, and tip her pelvis and slide, with a low cry of release, onto the gleaming staff that she herself had carved.

Her moisture drank him in. She felt heat and honey blooming in her belly as he drew back and swayed in again. His arms slid up and across her bare back, his mouth opened to her open lips. She floated, half-sitting on his thigh and spreading herself, her raised leg arching around his back, to take him deeper in.

Her veins throbbed with a thick elixir glowing sweet like the memory of maple-sap, made in the slow pulsing advance of his body into hers and driven through a dense vascular system that fed them both. His verdant breath poured into her mouth, tangy fluid coated her

tongue. The burning of her midriff where his broken flesh pricked her spread like the tickle of kisses on some defenselessly tender place.

A low rushing sound like a far wind in a forest swirled from deep in the wood man's body and drummed into hers, surging with his surges, roaring in her trunk and limbs. She felt the softening of his bones (and hers) as he twined around her, torso encurling torso, and his mouth and face twisted to enclose her mouth and face in a caress as close as cells one to another. Her own frame writhed and coiled, braiding with his, penetrating and encasing, bending and being bent.

Shock waves rose, shuddering, stretching her body (and his) massively upward and pressing the hairs out of her head (and his) in a reaching mass of branches already sprouting eager leaves; and raced downward through their joined legs, driving from their feet swift roots that shot like lightning through the solid rock and split and moved it, rucking up the overlying earth into rolling, thunderous new chains of mountains.

Her consciousness encompassed (as it spread to the thinness of molecules that have no consciousness) that the planet's skin steadily shrugged itself into new configurations on the outwelling force of their union. The sky was scraped clean and infused with the life-giving exhalations of a universe of leaves, the land was made new, raw and tumbled, both below and above the thrashing seas.

The great ash stood again, joining all the levels of the ripe green earth and the many blazing rings of heaven.

THE HOPE OF CINNAMON

M. CHRISTIAN

The Rescued had a smell about them. Even after daily cleansing, a week of rest, hours of medical attention, clean sheets, and plenty of food, the smell—the bitter taint still lingered. It was subtle, almost an afterthought. The Medicos said they couldn't smell it, though the Helpers discounted them because they were too focused on the Rescued's more physical needs: too busy making sure their muscle mass reformed correctly, their bones absorbed new calcium at a good rate to notice that they smelled.

Most of the Helpers said they smelled of the past—a dusty aroma of years. Gen, though, knew exactly what Bissou smelled of. Sitting on a shape-couch across from him—obviously uncomfortable with the intelligent polymer intimacy of the furniture—the small man had that soft but noticeable aroma. Gen didn't think it was age. He thought it was cyanide: the smell of death's wings.

"You seem to be improving."

Bissou smiled, moved his hands in a gentle ballet: "It's a great place to be," he said. His German, native and not injected from synthesized

RNA like Gen's, was high and piping, musical—his inflections precise and orchestrated.

Still, Gen caught the hesitation, the phlegmatic pause. Helpers were trained to detect such subtlety, the difference between words meaning one thing in *language* and having whole books in that word's *speaking*.

Gen was an intuitive. He couldn't begin to explain the intricacies of the comm plates, the recycling system, or even the orbital magic that the Stonewall station used to keep from crashing down onto the Earth or spinning off into space. His world wasn't material, it was emotional. His universe wasn't filled with matter—it was populated by personalities. He didn't know the details of what had brought Bissou to him, but he did know that a shadow was obscuring the small man, covering his eyes with a heavy weight. It was Gen's job to make sure that weight didn't crush him, reduce him to ash and memories. Gen was there give him new life and walk him, happily, into his new world—and new life.

"I can tell you've had fun playing with the synthesizer," Gen said, smiling as he sat down next to him.

"Have some," Bissou said, passing Gen a plate of misshapen cookies. "It's not an iron oven but I think it did a pretty good job."

Gen took one, feeling the crumbs skate under his fingers. The sugary bite of the dough was strong in his nose. "I wish we could, but fire is one of those things we don't feel comfortable with."

It was a leading question, one Bissou was supposed to answer. He didn't disappoint: "Because of the air, right? Too much something in it?"

Gen smiled and patted his tiny, almost skeletal hand. "Oxygen. We have a high oxygen content here—that and the corrolis effect makes it harder to control open flame. A fire would be disastrous."

Bissou took his hand away, folded both of them in his narrow lap. "It's one of those things I'll miss."

Gen sampled the spiced cookie, not because he was uncomfortable but because his training told him that the young German needed to say something and the act would put him at ease—show that Gen was there for him, and respected him.

Bissou didn't physically sigh, but his body seemed to radiate the signature all the same: a muscular wave of building and relaxing. His eyes were turned away from Gen, staring down at the plate of ugly cookies.

The silence stretched. Gen put his hand on Bissou's knee, feeling the sharp planes of his bones through the thin material of his coverall. On their second day together Gen had relented to wear something similar, even though it grated on him more than he was willing to admit. It

itched—it tickled the backs of his knees, and it pulled, much too hard, on the back of his neck. Nudity was far better. Nudity was *natural*. But in the name of Acclimation he had started wearing it. Despite his discomfort, seeing the relaxation it brought Bissou had made it worth the irritation—though the instant he left the Therapy Suite the coverall would end up down the nearest recycling chute.

He wished Bissou would relax, drop some of the tension from his body and just *be* with Gen—but there was something brittle and hard in the young man, something that seemed frightened of the freedom and luxury that Gen was holding out to him. On their third day together Gen had offered Bissou sex—his reaction still puzzled and disturbed Gen: he couldn't recall seeing the young German's eyes, wide and quivering with liquid panic, without feeling an almost physical pain for him. After then he hadn't offered again, but he had moved to touch Bissou as often as possible. Touch was important: without overcoming his fear he could never be able to Acclimate.

"Have you been cruising channels?" Gen asked, absently stroking the irritating fabric covering Bissou's thigh.

"You mean that machine?" he said, indicating the flatscreen with a small tilt of his head. "I spent an hour with it last night. It was interesting but confusing. I didn't know what I was looking at most of the time."

"You will, don't worry. Much of it would be probably familiar to you—if you understood the basic concepts. That much hasn't changed."

"I'm sure. But there just seems to be so much . . . sex."

Gen laughed, but not with a scathing, mean-edge to it. It was a teacher's laugh when his student makes an observation close to truth: "Ours is a very sexual culture. It always has been. It's how, after all, we define ourselves. I'm sure that's what it was for you."

Bissou picked up a cookie, studied it, took a tentative bite, and frowned. "Not enough cinnamon. Too much sugar. I'll never get it right."

Gen kissed him on the cheek and despite the shock that echoed through the young man's body, he said: "You will. You will."

Paisley was waiting for him when he got home. The trip from the Rescued's Compound to his own apartment near Spoke Four had been too quick—much too quick: Elevator up Spoke Two, ten minutes of uncomfortable zero gravity, down Spoke Four then a ten minute walk

to his front door. He could have walked it, Gen realized as he walked up the pseudowood steps leading to his front door. Walking it would have taken an hour, maybe an hour and a half. It would have given him more time to think, to pinpoint the tension that seemed to ride somewhere just inside his breastbone, next to his heart.

Unfortunately he hadn't, and so walked in with the ache throbbing deep inside. It would make him tense and irritable, bitchy. Paisley didn't react well when Gen was bitchy.

As the door slid aside the strong smell of liquid plastics made Gen's nose burn. The coffee table had been stripped and moved to one side. In its place was a giant easel—and on that was a splash of eye-biting color. A diagonal of yellow. A handprint of black. A crimson slash that could have been the letter "s"—but since Paisley was illiterate Gen knew it couldn't have been intentional.

In front of the painting was Paisley. There, then, looking at his lover-partner of four months, Gen felt the pain in his chest lift, vanish in the power of his appreciation for him. Many people went too far, allowing Cosmetians too much leeway—trying to top one kind of iconic beauty over another. At least the skilled technician that Paisley had allowed to sculpt him had shown some restraint, a sense of refinement. Paisley wasn't a Tom of Finland God or some deep-African jungle king. He was a slender man, stepping just from boyhood: downy cheeks, golden long hair, a strong chest with just a hint of babyfat.

"Oh, you're home," Paisley said without an ounce of emotion, wiping his brushes on a rag that Gen recognized as one of his old t-shirts.

"Trying again?" Gen said, moving towards the sensormat, hoping that Paisley wouldn't want to talk—would give him a few minutes to breathe, relax, try and diminish the ache he'd brought with him.

"The artistic process isn't an on or off kind of thing," Paisley said as Gen dialed up a mild sophoritic followed by a quick chaser of Dull Satisfaction. "It's an on-going process of extension and release, of relaxation and endeavor. It's not a linear, logical thing—it's an emotional act, a spiritual act. It's something that comes when you least expect it, seizing control of your spirit. When that happens it takes ultimate precedent."

Seeing that Paisley's "precedent" had left their ceiling flecked with minute dots of yellow, red, and black paint and that a large crimson smear arced across the carpet, Gen reselected a Pure White Light and slapped the two tiny capsules against his upper arm.

"As long as it makes you happy," Gen said, feeling the precise phar-

maceuticals start to work. He walked around the couch and sat down with a heavy release of too-tight muscles.

"It's not about happiness. It's about being at the mercy of an unstoppable muse, a divine light that descends on the artist like a form of madness. When it comes you can't do anything but release yourself to its power, the vision," his lover said, enthusiastically flicking paint across his canvas, additionally spotting Gen's bare legs.

Last week it had been music—and the apartment ringing with Paisley's experiments with . . . not so much notes, chords, and melody as much with the percussive quality of banging away without rhyme or reason on a pair of sound decks.

As the drug started to inflate his mind, warble at his perceptions, Gen wandered through his fragmenting thoughts towards Paisley—the idea of Paisley. He loved him, certainly, but it was an intangible kind of love—glued together with a physical affection. When he looked at him, however, it was like he was seeing an impression, an outline of a person. He made Gen laugh. He was a glowing, foxfire sprite in bed—all tongue, kisses, and cock.

Winds, though, blew through him—distorting him. Smoke, tissue, and glass. There was nothing stone or steel in him. Music last week, painting this week, Tantra next week.

The drug? Rock dust bit suddenly at Gen's nostrils. He'd lived in Stonewall all his life. He'd never lived, or visited anywhere else. He'd never seen rocks. Lunar soil, of course: it filled the planters on the deck outside, but never earthly stone. But, still, he could swear that he could sense its aroma—even feel a rough surface with his tingly hands, the weight of rock against his muscles.

Bissou was shattered, almost broken. Considering what had happened to him—a previous life in dim history summoned into the present: a chance to live, granted at the barest seconds before death. He should have broken, fissured. Instead he was attempting to learn, to live.

But, still—cracks were there. Gen could see with his carefully tailored perceptions: the collapse was working its way through him, one break at a time.

Getting up was difficult—the drug wanted him to be fascinated with the minute pattern of dots on the rug, the walls, the ceiling. Walking to the sensormat was an EVA, a zero-G stroll. It seemed to take forever. Carefully, he dialed up Clear Resolution and Sharpened Reasoning and snapped the capsules, again, against his upper arm.

Clarity, like waking, roared through him. Without looking back Gen moved, each step becoming more and more certain, more and more stable till he was in the bedroom.

"Aren't you going to watch me be creative?" he heard Paisley say, little wounds in his musical voice.

Gen put on a firm smile. "Be right back. Go ahead and be creative with yourself for a while."

In the small bedroom he stretched out on their unmade bed. The ceiling was spotless, a uniform white expanse. Emptiness. Outside, their sundeck was slowly slipping into shade, what passed for night on Stonewall. *Bissou.* The thought of the little German man brought a new dose of tightness to his chest. He wished, not for the first time, that he could find the right cord to pull, the right words to say, to make him unwind—drop out of his fear and shock into the life that Gen and the Helpers were offering him. *It's a beautiful place*, he thought to the wry little man, *can't you see that?*

Gen had been a Helper for three years. Two clients in those three years. The first had been a older man named Goer. Uncomfortable and clumsy, the ex-jeweler had accepted his Rescue with hope. Yes, there had been fear—Gen remembered one night in particular when he had collapsed—as if the life had drained out of him in one giant sob. Gen had held him, quaking with his own fear as the big man shook with tears. He remembered their last day together, sitting on the balcony looking out at the wondrous interior of Stonewall. It was a moment of acceptance, a step into his new existence.

The other had been a young Pole named Markowsi. He had been harder. Much harder. So hard that Gen thought that he would crack, break up into tiny pieces along with the rusty-haired farmhand. Nothing was familiar to him—nothing. Not even the sexuality that had gotten him arrested and sent to the camps. He was a stranger even among the friends who had rescued him.

It had been hard. Terribly. But, still, Gen didn't feel the same way for the Pole as he did for Bissou. He tried to examine his feelings, bring them out of his unconsciousness and into the light of his present mind. He had walked Markowsi not only into the Stonewall "sunlight" but also into a whole new world. Gen had been his first lover, his first love. Gen had taken his hand, put it on his hard cock. "It's okay to want. There is no one here but us. Just the two of us and love." Markowsi had cried as well—but it was a source of deeper tears: nothing was familiar to him. No friends. No home. No earth. No animals

(not counting cats and dogs). No crops to pull from the resistant earth.

Still, Gen remembered their last time together—a passionate embrace on the tubeway as Markowsi's train pulled in. The love that had been between them, the bonding that had glued Markowsi not only to the love of men but also to the new age that was to be his home.

Thinking of him, Gen moved to the flatscreen and called up his old notes. Reading his younger-self's words, he felt caught up in the fear, the hope he'd had as he'd tried to Acclimate him. Nothing like Bissou, though. It had been deep, loving and special—but there hadn't been anything else. Markowsi hadn't been a ghost, a transparent boy-man— but he hadn't held something deep and close as Bissou seemed to, something aching and magical. Something that Gen suspected was lurking just under the pale surface of his chest—something he was slowly bringing out to show Gen.

Absently, he called up the current records for Markowsi.

DECEASED—flashed the screen. A chill ran through Gen. He read the worlds again, hoping the drugs hadn't completely left his system. The word stayed. Heart pounding a fistfight in his chest he read on. A year ago, eight months after kisses and tears on the tubeway. He'd jumped from the roof of his apartment block. Dead instantly.

Why wasn't I told?

Separation was part of Acclimation—he understood that: put them on their feet and kick them out into the world, make them create their own relationships, their own lovers. But they *had been* close, they had been lovers—a kind of Helper-Rescued love but the ache was there nonetheless. There was pain, seeing that word, reading the details: A pounding pain. Markowsi's hands, rough and hard around his cock. Markowsi's lips, full and soft kissing him, gently washing his cock in hot spit. Markowsi's asshole, pink and pretty as it swallowed Gen's cock. Markowsi's eyes, dancing with wonder the morning after—seeing possibilities. Markowsi was dead. Dead.

He called up Goer's file. The fat little jeweler had suffered some kind of breakdown six months ago. A model, a perfect job, he remembered some of the other Helpers telling him with pride. Stonewall offered Goer so much—genetic retailoring to give him the body he'd always wanted, a world free from hate and war. A world full of men who loved men. It was paradise. It was a utopia for Goer.

He'd broken, nonetheless—his cracks might not have been visible, gaping, but they'd been there nonetheless. They'd grown as he'd tried

to Acclimate, to live in the strange world he'd found himself in—
grown till there wasn't anything holding him together and he'd simply
fallen apart.

Bissou. The face of the young German hovered in front of Gen's
wide, frightened eyes. His beautiful hands. His face, planed and ele-
gant—nose long and thin, lips wide and soft. His hair, black as starless
space. His eyes, opals—alive with flicking blue. He was thin and nar-
row, and walked like a dancer, with beauty singing from each step, each
gesture. Refined and elegant.

Where would he be in six months? What would happen to debonair
Bissou and his cinnamon cookies?

Gen took a stuttering deep breath, squeezing his eyes against the hot
tears that had already started to slowly roll down his cheeks. Getting
himself together, he started calling all the Helpers he knew.

"It's the little things you remember most, isn't it? You don't know
much about your part of the world, your life, but you remember the
tiny things the best."

It was against the rules to let them talk about their past too much.
That part is gone, the philosophy went, *it's time to move on*. But Gen didn't
stop him, didn't step on the usual course of trying to get Bissou to
watch the flatscreen more often, or encourage him to remove his cloth-
ing, have sex. He sat next to him, not even touching the slim young
man, and listened to his words.

"I had a little place near the train station. Small and dirty, but it was
mine. The Concierge was a little widow who'd lost her husband in the
first war. She had a shrine to him: dusty glass, a fading photograph, and
two medals. I always saw it when I paid my rent. He looked like a God,
a Yoden, staring down at me from that wall. His eyes were big and glar-
ing, as if his anger at the photographer still beamed out of his eyes at
me, and anyone else who came into his widow's apartment."

"Did you like living there?" Gen said, watching Bissou pacing back
and forth—from one cream-colored wall to the other. It was week six
of his Acclimation and the flatscreen was on all the time: *cultural exposure*.
Get them used to their new world. Gen, though, had turned the sound
down till it was nothing but a mumbling whisper. Even though the
chaotic fragments of Stonewall's media flashed and pulsed with vivid
entertainment Gen's eyes were only on Bissou.

And Bissou's eyes were back in his tiny apartment near the univer-
sity.

"I hated that place. I hated that portrait. I hated the words that followed me down the street." He stopped—his walking, his talking, and turned to the brilliant pulses coming from the screen. Gen noted, unconsciously, that the screen had stopped on a bout of the Sexual Olympics: bronzed gods with mammoth phalluses wrestling each other to the orgasmic delights of an immense crowd.

Bissou turned away. Gen noticed his eyes were closed tight. "I was beaten twice when I lived there. One time so badly I couldn't see out of my left eye for three days. I was scared of going blind—but more so of going to a doctor."

"It must have been frightening," Gen said, feeling the emotion himself, or at least a personal version.

Bissou became quiet. Turning back to the flatscreen he said to the flickering images of giant, oily torsos and dicks like battering clubs, he finally whispered, "You don't have any idea.

"The place smelled of cinnamon from the bakery next door. It smelled safe, like my mother's kitchen. Warm and safe. When I was in bed at night that smell meant hope, that it would be there in the morning, the next day. That I would be there to smell it."

Gen listened, washing himself in Bissou's words. He was him, his crossed arms and memory-glazed eyes. *Seventy percent Failure rate*, he also saw. The eyes of the other Helpers he'd talked to, red-ringed with the surprising, and too-hard emotions that'd come from discovering all of their failures. Seventy percent of the Rescued didn't make it. Madness. Stepping onto a high fall. No one understood it. Many were frightened. Why, they had no idea.

"I wish I could make you understand. I don't think you can. It was bad. Everyone I knew was frightened, in pain. But sometimes we found each other, reached out into the night and found a warm body, a smiling face."

"My first kiss," he said, turning back and speaking with surprising volume, "was a model named Heinz. He was so pretty. So pretty. Eyes like the sun—full of light. His skin was gold. Not bronzed like a farmer's but gold. I sketched him for many weeks but it was just an excuse to be close to him, to warm myself in his glow."

"One day I noticed him watching me. Staring down at me from the soap box he was posing on. His face didn't change but I felt it did: I could feel something about him, something that saw into me, beyond the student, the painter: something deep down. It frightened me—to be known that well, that quickly. I guess it also scared me that he

accepted it, acknowledged it. I didn't return to that class for days, pretending to be ill in bed."

"He visited me, all warmth and gold. He brought cookies from next door—cinnamon. That first kiss was like the welcoming embrace of my room. Cinnamon. We didn't do anything. Nothing at all. We just kissed and held each other. Sometimes the best Heaven is a pause in Hell.

"We stayed together, warm bodies on cold mornings. Slowly I noticed others, like Heinz and I." He waved his still-thin, still-malnourished looking arms at the cream-colored walls, the shape-couch, the wallscreen, at Gen. "There was a kind of shame over everything we did, even if it was just talking out of doors. But my heart was exploding every day, bursting when I thought of them all—of Heinz and my friends."

Bissou came and sat down next to Gen. He seemed light, almost insubstantial, the light having drained out of him. "It meant something. Everything had a priceless value to it. Our kisses, our bodies—everything was more precious than anything I had ever known. Even when they came and made us wear the triangles, we made it a uniform—a badge among us all. It was stupid, and childish, but it was a time when any amount of love, every kiss, was worth more than anything on earth.

"Here everything is cheap, easy. Nothing means anything. Nothing is special. You don't understand. No one here does."

Gen put him arm around him, held him close. For a long time they didn't say anything, then Bissou turned his head and kissed Gen's cheek: it was a distant flock of birds, almost invisible except when they passed between the sun and the earth and the shadows they cast hit the earth. A ghostly kiss. For Gen it felt like a kiss good-bye.

No! A part of Gen screamed, and a surge of anger and passion rushed up his body, making his head swim. Turning fast he grabbed Bissou by the shoulders, tilted his head and kissed him *hard! Passion!* Bissou struggled at first, a kind of shocked retreat but then he slowly began to melt. Together their tongues rolled and tugged against one another's. A fire started somewhere within both of them.

Startled by his own ferocity, Gen dropped his hands away—and his left grazed the tiny man's lap, feeling a strong, hard cock there.

A image swelled in Gen's mind, the thought of Bissou, alone in a place with dazzling beauty and too-common sensuous joy, where nothing has value and everything is too easily acquired. He thought of him fading away, lost against the vacuum he felt all around him.

Again the anger boiled in Gen, again the *No!* was a mad bell in his head. With a powerful tug he parted the thin material of Bissou's coverall. His cock was crimson, brilliant red with strength. It wasn't half-hard, or even just-hard, it was screaming life, lust, and passion.

Putting a hand, hard, around the thin man's cock, Gen hung on. He didn't care if he was holding on too tight, because he was holding on—keeping Bissou there with him, keeping him close.

Pulsing with the beat of his rapid heart, Bissou's cock in Gen's hand felt like steel wrapped in velvet. It was life, it was the present.

Gen was almost shocked at the strength of it—the image of Bissou as a ghost of a man, someone fading off to sometime in the past slipped a little bit. He felt like he wasn't just hanging on to his cock, he was hanging on to the one thing, the anchor, that would keep the thin little man from falling—falling down and away from him.

Bissou responded by breathing deep and pulling slightly back, eyes wide with pleasant shock—his arms filled with tension—but didn't move to stop or break Gen's grip.

I might lose you, Gen thought, his mind remarkably clear, *but I have you here, now.*

Climbing down, Gen knelt in front of Bissou. Before his eyes, Bissou's cock was straight and narrow—not as long as many cocks Gen had seen, sampled, but then Gen's age was one where beauty was affordable and genitals were whatever you wanted them to be. Possibly because of that—that Bissou's cock, balls and body were what he had lived in, dealt with, and enjoyed—he was beautiful to Gen. More beautiful than any store-bought body, more divine than any artistically enhanced cock. He was just flesh, blood, memory, experience, and desire.

Bissou's cock was proud and strong because he had made it so.

Gently, being the Helper that he was, Gen kissed the satiny-smooth head of Bissou's cock. He tasted the rich flavor of hot skin and the sharp tang of bitter salt from a tiny dollop of pre-cum that had gently oozed out. Above him, he was dimly aware that Bissou had leaned back into the shape-couch and was breathing, raspily, in and out.

After the kiss, Gen slowly eased Bissou's cock into his mouth, inching into the blast furnace that Gen felt himself becoming. Breathing around the fat head, Gen bathed Bissou in his own hot air. When he brought his lips around it again he felt much more salt, much more bitter come taste—and Bissou's cock, impossibly, was even harder.

Then Gen started to make love to Bissou with his mouth. Stonewall

was proud of its tradition of teaching, of educating young men in the arts of love. Gen always prided himself on his artistic flair regarding sex and sex play. He'd received high marks from every teacher he'd studied with and had even mastered some of the more arcane arts of erotic pleasure. But that afternoon, with the tiny man from the twentieth century, Gen was just a man, his lover, and his lover's cock. The perfect artistry of simplicity.

Rhythmically, Gen lowered and raised his mouth around Bissou's cock—relishing the taste and the feel of his member. Dimly, distantly, he was aware that he was also hard—an ache in his crotch against the confining clothing—but he didn't dare even stroke himself because it might take his mind, and mouth, off of Bissou.

Distantly, but not dimly, he was also aware of the sounds deliciously emanating from Bissou. Like a mantra, he moaned "Jesus, God, Jesus, God—" in his native German.

Gen didn't know those words, at least not clearly, but he took it as a good sign and kept on sucking Bissou's pretty, pretty cock. Gen felt himself becoming nothing but the excitement and joy of what he was doing—it wasn't so much just sex as breathing life into someone who had come so close to death. He was washing away the stink of cyanide from the gas chamber, the smell of death's wings. He was trying his best to obliterate years of pain and suffering, remove with just a blowjob words like *Dachau, Auchwitz, Relocation, Undesirables*.

Bissou's cock was strong, a grounding rod into the earth. Gen knew he couldn't wipe away the pain of Bissou's life—but he could, at least, hold him here, there, now for a little while more.

Sudden salt, shocking wetness in Gen's mouth. Above and beyond him Bissou moaned, deep and guttural: a feral, primitive burst of joy as he came in Gen's mouth.

Carefully cleaning Bissou with his tongue, Gen stroked and fondled him—worshipping the shape and strength of his cock, the shape and strength of his forged soul.

When he was clean and oh-so-hard again, Gen stood, quickly tossing aside the coverall that he hated. Naked and also achingly hard, he stood in front of Bissou and didn't say anything—though he thought: this is life, take it.

Bissou hesitated then elegantly kissed the head of Gen's cock. With his lips he learned the shape of the Helper's—felt the softness, the hardness, the silk, the satin, the velvet, the iron. Slowly, methodically—as if he was memorizing Gen's member so he wouldn't ever forget it—

Bissou worked his way up and around Gen.

Watching, hypnotized, to Gen it felt like someone unwrapping a precious gift—luxuriating in its beauty. For many minutes, this went on—the meticulous adoration of Gen—then, so slowly that Gen wasn't even quite sure that it was happening Bissou swallowed Gen's cock.

The sensation scared Gen at first, its overwhelming feeling of warmth, wetness, firmness was so perfect, so ideal that the reality that it was being performed by a Rescued shocked him. But soon the sensation won out over his prejudice over who was performing it—and Gen was awash in the beauty of Bissou's worship.

Lips, tongue, hint of teeth, roof of mouth, down the throat, Gen was consumed by Bissou, feasted on—he was eaten so that life could flow into Bissou.

When the orgasm came it was a rumbling earthquake, something that Gen didn't, at first, recognize—a shimmering wave of physicality that raced from his thighs and chest up through his neck into his face and brain. His body responded on its own, bucking slightly into Bissou's mouth, face. Then he exploded—a burst of thrilling sensation that made his knees weak and his breath labored.

Sitting back down on the shape-couch, they held each other for a long time and fell asleep—till the shadow of "night" passed by the window and another great panel of sunlight started to arrive.

Gen had somewhere to go. Carefully, he got up. When Bissou was awake enough he kissed him, took his hands and stared into his face.

"I'm going away for a little while. For you just a few days. You must promise me you don't do anything. Wait for me."

Bissou looked scared and confused: "Where are you going?"

"I'm going to try and understand."

The shuttlepod docked with a deep shudder of impact. Gen closed the flatscreen he'd been studying since they'd set out for the Anomaly—washing himself in details: customs, history, maps, economics, the dry facts of a long-dead age. He'd received a new dosage of German, a heavy layering of the language over his own: Gen would be able to speak it like a native. The injection had been so large that he had to think twice before speaking—he'd confused most of the crew on the trip out by speaking the old, dead tongue.

It had taken some persuading but in the end the Helpers had all agreed—seventy percent failure. They had to know why. They had to understand.

The details of what was planned refused to stick in his mind, the techniques and the concepts puzzling—but he understood the basics. He'd have ten years. He was going to 1930. Ten years of walking their streets, eating their food, speaking their language, knowing their life. Gen, too, would know the Triangles, the guns, the trains, the camps, the ovens. He, too, would be Rescued—but hopefully he might know, understand, what he was being Rescued from, being brought to.

Wait for me, Gen thought, thinking of Bissou, as the hatch opened and he floated out into the Anomaly, the gateway back.

I'll be back—and when I do maybe I'll know a priceless kiss, the hopeful smell of cinnamon.

BLUE SKY

REINA DELACROIX

". . . and the only answer at the Miranda residence was the dead man's voice on an answering machine."

I stretched out a cramp in my back as I leaned back from the Winbook keyboard and saved my work. Strained to see the clock . . . geez, 5:23 P.M.? I'd been writing too long this stretch, but—miracle of miracles—I'd finished the last chapter.

Now I needed to take a break before I wrote the epilogue, to get the proper valedictory feeling to it.

I looked out the window, at the dark yellow sky, and shuddered at the billows of heavy smoke. So the chemical plant was still on fire, then. The rioters hadn't come this far into the city (yet) but they were sure doing a lot of damage upwind. I'd closed and locked the windows, and switched the automatic air recirc on the day before, to cut off the outside air until it cleared some, but still the lingering smells from the initial explosions had tainted the curtains and the furniture. I wondered if I'd never get them clean. . . .

Oh, who was I kidding? I'd never get the chance. A loner by nature and a writer by trade, I'd isolated myself from the world just a little too well; by the time I knew the uprising had started, it was too late for me to run even if I'd been willing to. The TV news, before they destroyed

the transmitter, had showed the roads choked with the cars, and slaughtered bodies, of those who had not left soon enough.

I figured I had a couple of days, at most, until either the rioters came or one of the fires they delighted in setting at random took my town-house along with everything around it. Or maybe I'd be destroyed in a counterattack by the fragment of the army still in existence.

Either way, I would stay with my house. There was no getting around the fact that I was trapped, so I just accepted it and waited for the future to arrive.

And I was sitting here, still writing words, words that no one would ever read, because I had nothing else better to do. I had no husband, no lover, no friend to huddle with against the dark days ahead. No chil-dren to protect. Not even a pet to occupy my mind with worry for its safety.

Being alone, in the face of the end of the world, was not a whole lot of fun.

Still, the book was all but finished, and strangely that feeling of near-completion made me just as happy as it ever had. A futile gesture, to write away dutifully in the face of oblivion, but it was all I had to offer.

As I got up from my chair and strode around the dining room, try-ing to swing the stiffness out of my shoulders and walk it out of my legs, I looked out the window again and froze.

There was someone standing in the street, looking up at me.

One lone man, looking up at the lit window uncertainly, as if trying to decide whether a fugitive had merely left a lamp burning, or if there was really still someone living inside the house.

What the hell was he doing, standing out there? I had thought everyone was gone. Everyone with any sense, anyway.

I ducked out of sight, unsure if he'd spotted me moving around or if I had hidden in time. Then I crept along the near wall until I could raise up to a more invisible vantage point to look out, and slowly, very slowly, I unbent my aching knees until I could just peer over the sill.

No one there.

Had I imagined him?

I looked again. Nothing, just a small city street full of abandoned cars and abandoned houses, and the faithful streetlights popping on as the dim daylight began to fail completely. When they did finally hit the substation, they'd be too close. . . .

The pounding on the door was far too loud in the dead silence; I jerked around—and rammed my forehead right into the table corner.

I yelled, "Shit—!" and then I realized what a mistake that was, but the hand I clapped over my mouth was a little too late. He knew for certain there was someone in here now.

The pounding stopped for a moment and then renewed even louder. "Please, let me in! Please!" he shouted.

I ran to the door, willing my head to stop pounding with pain. My head was hard, but the table was harder. "Shut up, dammit! Someone might hear you!"

When his voice came next, it held the nervous calm of someone trying hard not to be hysterical. "Please, let me in. I'm all alone out here."

What, open the door? To a total stranger, in the middle of the Apocalypse? He had the wrong house.

"No." I said flatly. "How do I know you're not one of them? Or just a free-lance looter, looking for an easy target on your way out of the city? You've gotta be kidding."

A moment of silence, and then a not-quite-sob. "Please, lady, let me in . . . I don't want to be out here by myself anymore."

"Forget it."

Another moment of silence, longer this time. Yeah, he really did sound scared, but I reminded myself sternly that he could just be a very good actor.

And anyway, what would I do with someone else in the house? I was barely able to take care of myself, and if the rioters did get this far, it would be much harder to hide two people than one.

"Please. . . ." His voice was very soft, and I could tell only by the swallowed sound of it that he was crying, or near it. "What can I do to prove I'm okay?"

"Nothing. And even if you could, there's really only room for one in this hidey hole. Sorry. Look, find somewhere else, okay? Go east, there should still be places to hide there. Maybe other people, too." I put my hand up to my aching forehead, and winced when it came down streaked with blood.

"I just came from the east," he said. Pause. "The army shelled it last night. Everything from four miles onward is . . . rubble, or worse."

So that hadn't been distant thunder, as I'd hoped. "I can't let you in," I repeated.

He sighed. "I guess I can't blame you. You're right, you don't know me. I guess . . ." Another sigh.

"I'm sorry." And part of me really was . . . but all I could focus on was the danger involved.

I could hear him pulling himself together as he spoke next. "Okay, I'm sorry I bothered you. Bye."

Footsteps started to walk away . . . then stopped and returned. "Lady?"

"Yes?" I snapped. The rush of adrenalin I'd felt was fading, the blood on my forehead had now trickled down over my eyebrow, and I was starting to feel a bit lightheaded and tired.

"Well, it's cold out here, and I haven't had any hot food since . . . well, since It started." I knew what he mean by It; I nodded, then winced at the renewed pain in my head. Three days, then, since he'd been inside.

"Do you have any soup or something you could make, and just put it out on the doorstep? I mean, I'll go stand across the street where you can see me from the window, so you'll know it's safe to open the door and leave it out there. Could you do that much, at least? And I'll go."

I thought about it for a moment. I still had a little food upstairs, and heck, soup wasn't such a bad idea; I was feeling a bit chilly myself. "Okay, I can do that. I'll use the microwave, so it won't take very long." I went to the window to watch as he walked away, to stand patiently in front of 710 opposite, huddled in his ski jacket.

I didn't see him give any signal to anyone else, to lie in wait at the door, but my fear of the outside hadn't lessened one bit. First, I'd check the cut on my head; then I'd make the soup, but I'd put it out on the back porch and then wave him over, to tell him where it was.

And then he'd be gone, and I'd be safe for a little while longer, inside. . . .

The next thing I knew, I was lying on the living room sofa with a thick bandage on my head where I had rammed it into the table. I didn't remember a thing after standing at the front window.

I started to sit up, but a hand held me down. "Don't, you might faint again. All I know is Boy Scout first-aid, but I think you may have a mild concussion."

I sat up anyway, and stared at the guy from outside in dismay. "How the fuck did you get in here!"

He sighed. "I climbed up to the second floor and tried all the windows. Finally I busted the latch on the bathroom window, figured that would be the easiest to fix."

I started to say something else in protest and stand up, and then it felt like someone stabbed me over the left eye. He pushed me gently

back down so I was lying flat on the sofa once more, and then sat on the floor next to my head so he wouldn't be looming over me as we spoke.

"Why?"

"Well, I could see you in the window as I went across the way." I started to nod, and then stopped, because it hurt too much. "You turned, and then you just kept turning and went down in a heap. I ran over and saw the blood on your forehead, so I knew you needed help. What happened to you, anyway?"

"I hit my head on the table when you first yelled."

I turned to lie on my side so I could look him in the face. A pair of soft, apologetic, brown eyes met mine. "Oh. Uh, sorry."

"But still, why'd you do it? I wasn't willing to help you, remember."

He shrugged. "That's different. I was outside, and you were safe inside. Why should you go out of your way for me, after all?"

Then he smiled, and I realized just how very young he was—early twenties, at most. Just a boy, in the face of my weary thirty-eight. "Besides . . . I really wanted that soup."

And I wanted to laugh, because I could smell the chicken broth bubbling on the stove and I was so hungry my stomach growled. He smiled again, and got up to ladle it into bowls.

The lights went out.

The only light in the apartment was from the screen of my computer as the batteries cut in, enough for two or three hours at most. In its glow, I saw his scared face across the room; he knew, or could make a good guess, what the darkness meant.

I fought to keep my voice from shaking; if I panicked now, he would too. But as long as we were inside, we were safe. "Put the bowls on the table, in the light. Let's eat while we still have the chance to. Okay?"

His hands trembled as he filled the bowls, but he replied, "Okay," with as much cheerfulness as he could muster.

We ate in silence, as I tried to check off in my head whether I'd missed any little detail. I'd moved most of the food, but the house was sparse enough looking already that anyone who broke in could easily assume I didn't keep much in the cupboards in general.

Otherwise, there wasn't really all that much for anyone to take. The TV, the stereo—I could lose those a whole lot more easily than my own life.

Except the computer. I couldn't lose my work. I might as well lose my life as lose that.

My editor had always laughed at my predilection for laptop computers. "What do you need a laptop for?" Stella had joked. "You never go anywhere except inside your house."

Funny how true statements can be, sometimes.

And also, how much more true they can become.

He finished his soup and looked to me for direction. "Rinse and dry the bowls and the pan both. It should look like no one's been here since It started." He nodded and ran the last of the water into the sink, scrubbed the dishes swiftly with my blue and white checked washcloth, dried them with a paper towel, and threw both washcloth and towel into the wastebasket. Then he let the water run out.

I leaned over the computer to close down the files and turn it off. His voice came from over my shoulder. "I hope you don't mind . . . I read a little of what you were writing, while I was waiting for you to wake up. Was that the end of the story?"

Then I remembered that I hadn't gotten a chance yet to write the final few pages of it. Damn, damn, damn. "I hope not," I replied in exasperation. Shit. I hated leaving it unfinished. My fingers paused over the keys, longing to put down those last few moments of the tale. I felt the words beginning to enter my head, the perfect words, as I tuned into the story, and I almost swung the chair underneath me on one automatic motion, to sit down and finish—except that his hand clamped onto my arm.

"Hear that?" he murmured, and from the frantic look he gave me I didn't need a better light to tell that he was white.

I heard it. It was an ugly humming rumble, like thousands of flies ready to land on a fresh corpse. "Come on," I said, carrying the computer carefully in my arms to light the way in the dark.

"You first," I said when we got to the basement stairs.

He nodded. "In case you get dizzy and fall."

"Well, if I do, you let me fall, and catch the damn computer." I hissed. That brought a small smile to his face. "Hey, I'm not kidding, either! Now hurry!"

We got down the stairs. "What now?"

My head was starting to pound again. As we stood in the basement, the rumble was just as loud as it had been above, and that was a bad sign—it meant the crowd was close. I shut my eyes for a moment, trying to master the sudden rise of terror I felt.

I heard him start to move toward me with an involuntary, "Oh no!" I opened my eyes and waved him away. "I'm okay. Help me pull out the

middle bookcase on the back wall, the one with the paperbacks on it. I tried to make it as light as possible without it being too obvious."

I put down the computer, and between us we got one side pulled out far enough so that at least I could squeeze in behind it. He looked behind it, and his face brightened. "A false wall!"

Between my head and the fear, I was starting to feel woozy again. "Yeah, the lady who—owned the house before me—stored her fur coats there. I—can't move it any farther right now . . . give me—a moment," I panted, leaning down with my hands on my thighs.

He looked at me, concerned, and then grabbed me by the arms and shoved me through the opening. It wasn't big enough for him to squeeze through, and I looked out at him, backlit by the pale screen light.

"I'll push from here . . . just give me a moment."

He shook his head. "I'm starting to hear people out there. And I can't pull the bookcase any farther out by myself. Here." He picked up the computer reverently and handed it in after me. I turned it off, closed it and put it on top of some extra clothes I'd stored in one corner.

Now we were in total darkness, and so I couldn't see him start to push the bookcase closed, I only heard it as the fiberboard scraped against the cement floor.

"No! Wait!" I cried out, and instinctively pushed back against it, bracing my legs against the wall in the small open space to keep it from closing.

"Look, I'm trying to save one of us," he muttered. "And they're really close now. So quit pushing already, will you?"

I heard the smashing; it sounded like it was just up the block. "No, you got me this far, and I'm not leaving you out there now. You stop pushing and let me think for half a second."

He sighed—but at least he stopped pushing.

Thump, thump, went the blood in my head . . . or were those explosions in the street?

"I'll pull as hard as I can from behind on the edge of the other bookcase while you try to push the other one out and squeeze between. It's still going to be tight . . ."

He finished the sentence for me with quiet finality, "but consider the alternative, yeah. All right. On the count of three . . . One, two—"

"Three!"

Something tore, and he stifled a yelp, but he was inside. "Now what?" he asked.

My head was throbbing, and I choked out, "Handles—center—pull."

I moved aside as far as possible and leaned against the false wall for support, and heard his fingers slide along the back of the bookcase until they found the two drawer handles I'd glued onto the back of the bookcase two nights before. Now I had to hope Krazy Glue was all it was cracked up to be, or we were sunk, because it was the only way to close the opening from inside.

I heard the bookcase start to move, and whispered, "Don't pull too fast . . . if the books fall off, it will look suspicious."

He grumbled, "Any faster and I'd be going backwards in time. Not enough room to bend into it properly. And—"

Whatever he said next was destroyed by a loud bang-thump that exploded right next to my ear, and I jumped, wondering if the bookcase had toppled out somehow; but I put out my hand and could feel it inching backwards.

Another loud bang. Someone trying to kick in the back door, right above my head. Someone breaking in. The outside.

He fell silent then, but I could hear the bookcase still moving, moving . . . and then a slight tap as the rear of the bookcase met the plasterboard wall.

I reached out slowly and found his arm, pressing it to signal "stop". He let go of the handles and straightened up cautiously in the small space left between all the clothes, extra blankets, food and water bottles I'd piled up on one side, and my body on the other. I had thought I would be in there by myself, so I'd left only enough room for me to sit; his large frame in there as well was too much.

All we could do now was wait, and hope. His other hand found mine and squeezed as we heard a boot hit the door above, and the splintering noise as the door jamb gave way.

Even though it was pitch black in our little cave, I screwed my eyes shut as a child might during a nightmare. He squeezed my hand again, and we clung to each other for support, hardly daring to breathe.

Several pairs of footsteps, brutish and heavy, on the first floor. They were looking around, and sounded angry at the lack of thievables.

"Nothing in here . . ."

"Okay, you look upstairs."

"I'll check out the basement."

He squeezed my hand yet again, and cradled my head against his chest, with the bruised and bandaged side of my forehead on the out-

side and my face directed away from the thin wall to lessen the sound of my breathing. He buried his own face in my hair, and we tried to breathe as slowly and shallowly as possible as we heard one of the looters come down the stairs and look around.

The glint from the flashlight bounced around the basement as the outsider searched and muttered, and we could see the reflection as it lessened the darkness in the thin crevice behind the bookcase.

The shirt had ripped open where he had squeezed through the narrow opening, and my head rested against his bare skin as we stood motionless. So I could feel on my cheek the prickle of the hair on his chest rising as the searcher moved closer and closer to our hiding place.

From above: "Hey, you guys find anything?"

From below: "Nothing in here but a bunch of dumb books."

Moron, I thought. But I said nothing, just breathed in the scent of fear—mixed oddly with baby powder—from my companion's body. If the invader decided to look past the books, and pulled down a shelf. . . .

"Listen, we're supposed to get back to the main group now. The army's coming and we need to make plans."

"Aw, shit, man . . . no fair! We didn't get anywhere near our share yet."

"Save it for later. If the soldiers catch up with us, won't be anything left for anyone."

A reluctant shuffle started for the stairs, along with a grumble, "Man, we got nothing but crap here. . . ."

A lifetime of reading and researching thriller novels told me what the thug was going to do next, probably even before he knew it himself. As soon as I heard the ratchet of the gun I was moving, twisting to fall backwards onto the piled blankets and pulling the boy down with me as I went, trusting that the roar of the gun would cover any noise we might make in landing, and hoping that he hadn't yet learned to compensate for the tendency of gun barrels to migrate upwards while being fired.

I heard the bullets tear into the pulp of the books and the wood of the shelves, a brief but vicious burst of death, and then total silence. On top of me, the boy lay heavy and still; had I moved soon enough? I saw dots of light from the bulletholes on the wall above us but couldn't tell how far up they were.

"GodDAMN it, Traylor, would you fucking save it? There'll be plenty of people for you to shoot later on, I'm sure, so don't waste it. Now let's get moving!"

And the footsteps thumped up the stairs and outside, leaving the house dark and silent.

I held tight to the body above me, afraid to move, afraid he wouldn't. And finally he began to tremble with mixed fear and relief, and despite his weight I found I could breathe deeply again. At least he was alive; I'd done that much for him.

"I—I—" he stammered, and shook even harder as the shock passed and he realized how close it had been. Pushing aside my own fears, I pulled his face down against my shoulder and rocked him soothingly.

"It's okay. It's all right," I murmured and rocked him some more, his solid body melting into mine as he let go of some of the recent terror. His face was wet, but it was the salt of tears and not the iron of blood I tasted when I kissed his cheek.

"He would have killed us," he whispered.

"Shh. It's over now, and you're safe in my arms. Don't think about it. And we have to be quiet a little while longer; there are still people outside. Shh." The buzz had receded some, but we could still hear noise in the street above.

As a suspense writer, I had known quite well how to use mounting horror to evoke paradoxical arousal in a reader. Having escaped that horror for the moment, I realized how that reaction felt first-hand. I wanted him so desperately right then—for his youth, his innocence, his kindness, all the things that he was and I was not.

And most simply, for how alive he felt, in my arms.

He started to try to speak again, and I pressed my mouth up against his, to swallow his words, to stop all thoughts save those of the immediate present. Find your silent comfort in me, I said to him urgently with all of my body . . . for I am here with you, and no one else. We are alive together.

His reaction to my touch was wild and immediate, as if he'd been waiting only for a sign from me to loosen his own control. His mouth covered mine as his hands fumbled underneath my shirt, grasping my breasts with strong fingers and hanging onto them as if he were drowning and I was his only lifeline. His hips thrust against me blindly as he clung to me and tried to move closer.

We had little room to move, but I twisted underneath him a little so that he could find room to work buttons and zippers. He tore a button or two from my shirt before he got the hang of the cramped process, and he only managed to get my pants down to my knees before running into his own. As he lifted up slightly to pull them down farther, I

slipped my hand inside his jeans, and he uttered an almost voiceless, "Ohhh" as I cupped the head of his penis with my palm and began to rub it in a circular motion.

That stopped him for a moment and I tugged and pushed my own pants down around my ankles as he concentrated on my touch. Then one of his hands met one of mine undoing his fly, skin touching vein touching cloth touching hair. Down came his jeans, to the level of mine, and as he sank back down he sank directly into me, a bird settling into its nest.

I hugged him in silence as he lay very still for a moment, both of us taking in what it was like for him to be inside me. I could feel I was wet, but it had been so long since I'd been to bed with a man I was also very tight—and really, for all I remembered of those days, I might as well have been a virgin; from his previous fumblings and reactions, I expected he might be a virgin as well. So I did not want us to rush; we had all the time we could want for this.

In one sense, we had the rest of our lives.

We could not see each other in the dark, and we dared not make too much noise, so all we had left to us was touch. His mouth never left mine, and our hands went wherever they could, stroking, reassuring, exploring. Gradually we managed to shut away all sense of the time and place, and then there was nothing but his body sliding into mine . . .

For he began to thrust, slow, agonizing, quiet journeys in and out of me, his hips pressing mine open to widen his path into me. He had been so eager to take me beforehand that I half expected him to speed up and come quickly, but time after time he pushed into my hot opening with that same slow motion, and when he did come, with a sudden stiffening of his entire body that seemed to last an eternity, he continued right on past that without any noticeable loss of erection.

And something about that, I don't know what, unlocked some hidden door inside me, touched some unknown but vulnerable area of desire. I lifted my body up against him and came myself, biting my lip to keep from crying out, and now I found my eyes, too, were filled with tears at how it felt, for a moment, to be alive and to love.

At some point, exhausted but still locked together, we fell asleep. We awoke to silence.

"Do you think—?" he started.

I shook my head. "I don't know."

Then we heard the sound of heavy, ponderous vehicles, not far away. The armored cavalry had arrived.

"You were right," he said. "We're going to be okay."

We straightened our clothes as best we could. I grabbed my computer (which had had its own miracle of miracles in that we had managed to avoid falling on it) we pushed out the bookshelf, and soft morning light was coming through the windows as we walked up the stairs to freedom.

At least, he was. Buoyant with the knowledge that we were safe, he ran to the doorway to spot the oncoming soldiers. Then he continued out and beckoned for me to follow.

But I stood frozen, just inside the doorjamb, my laptop clutched in front of me like a shield.

"What's the matter?" he called back.

"I can't."

"What do you mean, you can't?"

"I mean, I can't!"

He stopped then, and really looked at me.

The distance between us couldn't have been more than fifty feet, but might as well have been five hundred or fifty thousand. I couldn't.

He walked back to the porch, and kissed me, the gentlest of kisses, a kiss to wrap up a story with, a kiss of goodbye. I felt my tears falling, as he backed away from me.

Just past arm's length, one step down, he halted and held his arms out to me.

I took one hesitant step, my foot brushed over the doorsill, and I froze again. I thought of all the outside there was, and how he was once again a part of it. He stayed right where he was, until I'd forced one unwilling foot through the doorway, and the other to the sill.

I was almost past the threshold, but it had taken everything I had to get there. I could go no further. I looked out at him, in utter panic.

He picked me up bodily then, one arm under my shoulders, the other under my legs, and carried me out into the open.

The first tank had just turned down my street, and as it pulled up beside us the commander riding in its turret gave a swift, worried glance to the bandage on my head and the young man carrying me.

"Are you injured, ma'am? We can spare someone to drive you back to our emergency hospital, if you think you need it."

I thought about it.

"No. I think I'm going to be okay."

And as I looked up, I marvelled at the sight of a patch of blue sky, now holding its own against the clouds of yellow smoke.

DINNER

ZOE BLOOM

We played a gig at the Roxy the night before my initiation. The place was a dive, the stage was cramped and the dressing rooms reeked of sweat and opened out onto the same corridor as the toilets. Everything had been painted black once, but was scuffed and worn and faded and even the graffiti was tired. The backstage beers were warm, the crowd was light, and it was June and hot and the place had no AC.

Even so, we were at the top of the hierarchy in our little world. We were a band, a band that reputably got paid, even if we were only the locals who filled in on Tuesdays, which were always dead. And the money we made barely covered the bar bill and the gas for the van.

But they didn't know that, the painted children of the night. They spent four hours before the shows painting their faces white and spraying their hair so that it stood in blazing mohawks or spikes like the Statue of Liberty. In June they wore velvet and risked death by heat stroke. They packed tight to the stage, standing on the concrete floor for hours on end, posing and studying each other, competition and prey.

They thought we were special, magical, and up on that stage we were. I certainly didn't spend any four hours doing my hair or my clothes. I only sweated and sang and for that I was royal, and after the

show they would all come for me and wait and hope that they would be chosen.

By me, who was some sort of demi-god.

The night before there had been at least seven crowded into the dressing room along with the band, the tech crew, and people whose names we actually knew. I knew we were nothing more than names to them, just as they were bodies to us. Collectors on each side, each running lists that reflected prestige. In the end, the hierarchy was more important than any other single thing.

I hate that. I hate being a name and a status that someone can take back and brag about any more than I care about bragging that I've had this or that one who is more beautiful than whomever some bandmate managed to find. I wouldn't dare say it, of course. In this world, it is not a thing one could admit.

Tonight there was a girl who had stood back near the door while her friends invaded our space after the show. She had huddled into herself, sliding down the wall to sit on her heels, her face concealed in a book. I noticed the title and I asked her how she had come to read it.

"Oh, you don't have to bother being nice to me," she replied. "I'm just waiting to see if Anne or Eddie or Shrike will need a ride home."

I shrugged. "I'm not being nice. It was years before I read Dion Fortune, and wanted to know what you thought. I already know what I think."

"Oh, like you've read it," she asked, her voice heavy with disbelief.

"All of them," I admitted. "Her real name was Violet Firth, and there is always some character whose name begins with a V. Vivian LeFay Morgan for one. I find her overly Christian and way too Anglocentric and her take on sexuality is psychotic. But if one can edit out those rather glaring inadequacies, her description of ritual is wonderful. And you know that she carried on a correspondence with Crowley until one of them died."

She blinked in disbelief. I've seen the expression before and it's one of my biggest faults—I can't help but enjoy it. Even do my best to lead them on. Everybody sees only what they want to see. They see Barnaby the front-man, Barnaby the slut-puppy, Barnaby the shallow hedonist who doesn't need to do anything but get up on a stage and sing.

I know what they call me. I've even enjoyed it in some strange way. It's a safe way to hide, so I've encouraged the image. Which isn't to say that I haven't enjoyed making it true.

Startled out of her book, I realize that the girl is really quite pretty.

She isn't wearing that thick white paste and her skin is fair and smooth. The requisite eyeliner emphasizes large dark eyes that are even wider with surprise. Her mouth is full, her expression is wary and intelligent, and something about the way she moves makes me think that she is not so very young. Perhaps she is my age, and perhaps even a little bit older. That wouldn't surprise me. Besides, I'd never heard of a high school kid who'd read something like *Training and Work of the Initiate* and be three quarters of the way through. The other thing I hadn't said about Dion Fortune is that her writing is really wretched, or horribly dated, or hideously British, and all three put together makes it nearly unreadable. So I added that to my catalog of her sins in my recitation.

The girl shook her head. "Compared to Waite, she's Hemingway."

I laughed so hard I nearly choked. "Point," I agreed when I could breathe again. "Would you like to go for some coffee? I think they want to close down."

Which was evident, since the Roxy staff were all standing in the hallway trying to look menacing. Which wasn't difficult, given that most of them were bouncers and the two who weren't were scarier.

"Just coffee?" she asked, eyebrow arched.

I shrugged. "Figure of speech. Actually, after ripping my throat raw for ninety minutes, I'm craving an Italian soda. Hazelnut, in fact. But Lido's has coffee and tea and pretty decent banana muffins if you're hungry."

The shocked expression lasted only a moment this time, and she agreed. Lido's is just two blocks away and open until 4 am, which means that it's crowded after a show. It's also got four walls painted in four different colors, none of which are reflected in any of the chairs or tables. There are boxed games piled on the window ledge, a pile of magazines next to the register, and half the tables are occupied by people who are either writing furiously in notebooks or sketching ostentatiously on oversized pads. Both are just performance art to bring them enough notice that they will be sought by someone more beautiful.

They never look at me except behind my back, but I can always feel their eyes on me. I've caught a few sketches, too, some of them not half bad. One of me in the nude and rather idealized—the artist was attractive and talented as well as flattering, so I offered to model. Fortunately, his apartment was only across the square.

Usually they come to me and take off their clothes and I touch and judge and decide. But when we got upstairs he undressed me and had

me stand in the middle of the light. There were charcoal streaks on my thighs and my chest from his fingers, lingering just long enough to let me know that he appreciated my body as well as my rep.

Still, standing there while he examined me so minutely, and him fully dressed, made me feel exposed and like an object. And beautiful. One of the few times I have ever felt admired in the way my admirers chose to be seen.

"Do you mind if I take pictures?" he asked politely. "That way I can do a number of reference studies."

"Sure," I said. "If you tell me your name."

He shook his head and smiled with some embarrassment. "I'm Mike. And you?"

I was shocked. Truly and deeply. I do not believe that I had ever, ever before been approached by someone who didn't know who I was. Who didn't want who I was, didn't want the rep and the notch in the headboard rather than the person. He wanted me for what he had seen in my flesh, not for my name. The knowledge made the blood rush to my face and to my cock. He only looked at me ever more intimately and smiled.

"Good," he said, and he began to shoot.

"Just move," he told me. "Any way you want to. Change position for me."

Change position? I arched my back and flung back my head, knowing that my hair would just brush my buttocks as I cupped my balls in one hand. I bent forward and let my hair drop over half my face and put two fingers into my mouth up to the knuckles. The camera clicked furiously as I draped myself on the sofa and stroked my cock and watched him, watched the bulge in his black jeans grow. I licked my lips and then rolled onto my knees and leaned over the back of the couch, my ass wide and willing. Begging, truth be told.

Because I'd always wanted to be used and taken, always wanted to be the object of lust. I'd wanted to be forced, made to do something hard. I'd thought about it so often, fantasized on the very few nights I was alone. . . .

But the front man of a popular band is never a bottom. Not my choice at all, but always theirs. The girls never thought of it, I suppose, and it seemed unfair to ask. And the boys were exactly the same, never showing a thought or even a suspicion that I might have my own ideas of what I desired.

But Mike didn't know who I was, didn't know what I could or

couldn't want. A moment later I felt his hands on my ass, cool lube as he muttered into my neck. I groaned. And whimpered when he backed away.

' "S okay," he whispered into my ear. "Just had to get a condom."

I shivered with anticipation, with fear. And then he fucked me as hard as I'd ever dreamed, pounded me until I couldn't hold back any longer, not even trying to recite the whole of the Emerald Tablet in my head.

Even though I went back to the coffee shop almost every night after that, I never saw him again. Two months after our encounter I'd seen a painting hanging up in the Lido that looked a lot like me. I'd asked after the artist and was told that no one had seen him around and that maybe he owed money somewhere, or maybe he'd gotten a job.

That had been last winter and now it was June. I couldn't help but look for him; by now I knew it was a ritual that was pointless but I couldn't help myself.

Tonight was better, though. This girl, who'd said her name was Elena, ordered an iced mocha and a brownie. I got my Italian soda. A miraculous place appeared for both of us on the corner sofa, the big purple one with the curvy arms that's everybody's favorite.

"I can't believe it," she said. Not in that breathy half-dreamy voice I usually hear this time of night, but in a hard matter-of-fact tone, as if she had just been confronted with absolute proof that we were being invaded by Mars. "Here I am with Barnaby Janeski, ultimate slut of the Eastern seaboard, and he hasn't put a hand on me. Moreover, we really are having non-alcoholic beverages in a public place. If I tell my friends they'll say that I'm lying. Or is it that you just don't find me attractive?"

When she said that I had a mouthful of soda, half of which went up my nose and the other half of which ended up on the floor. That only made her laugh.

"Let me put it this way," I said when I was able to breathe decently again. "I'm not supposed to even have a notion of attractive. What I've heard from the rumor mill is that my only preference is breathing. I'd add over eighteen, because I'm not interested in jail. Not that I don't think there would be some very exciting moments in jail, you understand, just that our agent doesn't think it would be a career-enhancing move at the moment.

"But for the record, yes I think you're very attractive. There are lots of attractive people out there. None of them walk into my dressing room and ignore me for text on ritual magick."

She looked at me for a moment, studying me as if I were a curious

specimen. "You're really a surprise, but you know that. Most people think you're a poseur when it comes to magick. And then there's the rest of the bad boy image."

"And a good part of that image is the truth," I added before she could rewrite my life. "I probably have done everyone who says that I have, and probably a fair few more."

She shrugged. "I believe you. But you're the one who brought up the subject of magick. Which does surprise me. I mean, I know that you supposedly read Tarot cards and have all kinds of ritual implements at home and all, but I thought it was all for show. More of the image thing, you know, the whole goth boy does magick kind of thing. All talk, no action."

I shook my head. "I've never been accused of not putting the rest of my body where my mouth is."

"The thing is, and what I don't get, is that you're not trying to get into my pants—or anybody else's. You're not drinking, which I thought was your hobby after sex. Though maybe you don't have all that much time for it. Didn't sound too much like a magician to me."

Yeah, I'd heard that before. That was the one, the only accusation that stung. I'd had to take a lot longer, show a lot more dedication, than anyone else initiated into the Lodge. Even though I'd been studying seriously since I was sixteen, although I'd actually taken Greek in high school and spent a year working on Hebrew, and my languages were better than everyone else in the Lodge combined.

There was nothing, nothing at all I wouldn't do for the magick. I realize that there was the core truth to that; the knowledge that this was what I had been born to do and that nothing at all could keep me away. And I knew the other truth, too. Nothing else would master me.

If I were going to do something hard, if I would have demands made on me, it would be by magick. Ritual has so many requirements and in the Lodge there is so much hierarchy, so much subjugation. I had submitted my application for Initiation in November. When I arrived to give it I had to wait for two hours outside the door, with nowhere to sit and the creeping cold making my feet numb. I had to wait and be still, not stamp up and down the steps of the building to wake up my toes, and stuff my hands under my arms.

When they finally let me inside and led me to the Council Chamber, I had fallen to my knees in front of the Lodge Council and bowed my head. I had never done this for anyone, anywhere, outside of my most secret fantasies.

They grilled me and then told me to return in two weeks. When I did I had to wait again, though only for half an hour, before I was admitted to their presence.

"Barnaby Janeski," Marlee Tydall had been the one to rise and speak. That had both reassured me and worried me more—Marlee was someone I'd known since my first days hanging around the occult bookshop. She was only a year older than me and had had sex with me maybe twice right before I graduated. She knew me better than the others—and she also knew my reputation.

"We are not able to determine if you should be admitted to the Lodge at this time. We know that you have studied for a long time and that you appear to be serious. In any other student this would be adequate. But from our more personal knowledge, it appears that you lack discipline. And discipline, especially self-discipline, is at the heart of ceremonial magick. Which you well know."

I knew better than to speak, but the words had burned in my head. Discipline? They thought I lacked it because—why? I had applied myself diligently to the studies. Being a musician may appear to be a job that took only two hours three nights a week, but that was only because they had no idea of what it really takes. Rehearsals, practice, and lessons (and I had been studying formally for years) were only the beginning. There were the nights when nothing works and you die on stage but you can't run. You just stand there and keep going because there is no other choice, even when the audience boos and jeers and walks out. There's the touring, driving seven hours at a clip to get to some dive in a backwater town where the club owner only pays half of what he promised and you sleep in the van and eat bagels for days on end because they're cheap and filling.

No discipline?

I had enough discipline not to laugh in their faces, to accept the verdict, to wait it out.

"It's because you're so promiscuous," Marlee told me two weeks later, when I gave her a lift to the ritual study group that was one of the required activities for members of the Lodge.

I'd shrugged. "I'm not any different from anyone in the Lodge. I just have more opportunities."

She snorted and rolled her eyes.

"Okay, so they're jealous," I said, smiling slightly. "But it's not like anyone believes that I'm doing anything wrong or harmful, or even particularly undisciplined." Which is true. People in the Lodge have

fewer partners than in the club world only because most of them have day jobs. I'd been enough a member of the group to know that, not that sex came up much as a topic when I was around.

"Actually, they think that you wouldn't make it through the restrictions for the twenty-four hours before the Initiation," she said. "And it's the same for any major ritual, and if you don't then you're draining the energy of the whole group. You know after Sarah everyone has a reason to worry."

"Ahhh," I said. All had been made clear. Most major rituals require a period of fasting beforehand. And celibacy. Guess which one they thought I wouldn't survive?

Of course I knew about Sarah. I had even seen her burned out and incoherent after she'd broken the strictures and took her role in ritual anyway. She called me once and talked on about voices and angels and how she thought some music she had heard on the radio in a store was a secret plan to give birth to the Antichrist and she wasn't babbling just because she'd seen too many bad movies.

That ritual hadn't been an initiation, either. Every member of that working group had been affected. I'd gone out for burritos with Warren and Grace weeks later and both of them were still having trouble sleeping and concentrating. They saw images, Grace said, horrific things that hovered on the edges of consciousness from other realms, seeping into their perceptions of the physical world. I walked the four blocks back to their house with them and we all did a banishing together. Warren said it helped when I saw him at the study group meeting the next week.

There is only one energy we use in ritual and I knew that as well as anyone, and it is sexual energy. Desire is what fuels the ritual, and when desire is sated there is only a hollow shell with no magickal power. But a working ritual team is a single entity, and a weakness in one is a weakness in the work of the whole.

Knowing that the consequences were real made me angrier. I might revel in my secular success, but I certainly wouldn't risk a working group because I was too embarrassed to admit that I hadn't said no. I was at least that responsible, though it appeared that no one in the Lodge had noticed.

"The thing is, for you it would be absolutely abnormal not to have one or two strangers for sex. It might even be noticed and people would ask questions. It's not normal for you to go home alone," she continued.

"It's not normal to fast, either," I pointed out. "But everyone in the Lodge manages when they have to." I managed to shut up before I told her that I had slept alone more than once since we were in high school, and certainly more often than I had gone without food, which was absolutely never.

"A few don't," she mumbled. "And several of the senior members just think that between the world you live in and your nature, well, it just wouldn't be fair. To anyone."

"Well, they won't know until it's time," I told her. There was plenty more I wanted to say, but I was trying to remain calm and logical. "I've done more to earn entrance to the working group than anyone else in the Lodge and you know it, and so does everyone else. I think spending one night alone will be a lot easier than learning Greek, to say nothing of Hebrew."

"Not just alone," she mumbled. "The point is no release."

"I know what the point is," I snapped. "And I know what celibacy means. I know what fasting means, too, though I believe that the ritual requirements do permit fluids."

We were in the parking lot by then, and I didn't say anything more when we got out of the car.

They had told me only three weeks ago that my application had finally been approved, and named the day. There had been things I had to do, had to get, had to make, in order to be ready. And now I was sitting with a very attractive woman in the Lido having finished the soda that was permitted on the fast that I'd maintained all day, though I was finding that her brownie looked far more tempting than it ought.

"It's late," Elena said softly.

"Would you like me to walk you to your car?" I asked, aware that the neighborhood wasn't great.

"I gave the keys to Eddie," she said. And she smiled, a warm, knowing, slightly conspiratorial smile. Her mouth was full and glossed dark red and her velvet tank top was cut low.

And I knew what she expected and I didn't want to disappoint her. How could I explain that I really had wanted to talk to someone who had read the same books, maybe was better at astrology than I was or had tried some of the old rituals that had been reconstructed in the last century? How could I explain that I did find her attractive and I would love to have sex with her, but I wasn't going to take her home? Not tonight.

She was going to be hurt and I felt like a jerk. I shouldn't have asked

her out to coffee. I should have realized that she'd just assume that I meant to take her home, and most nights I would have. Most nights I wouldn't have bothered with the Lido and would have maybe found one or two more to join us, too—though maybe not with Elena. Not too many people in the club world know quite how seriously I've taken the magick and I'd like to keep it that way.

"Come on," I said. We walked out to the street and I hailed a cab. I opened the door for Elena and she got in, moving over so that I could follow. Instead, I handed the driver a twenty and told him to take her home. She looked like I'd just told her that I voted Republican.

The cab drove away and I stood, like a dolt, in front of the door. And I saw him. He had an oversized sketch pad under one arm and his backpack was bulging. Charcoals and pencils, I thought, and maybe other things. My mouth went dry and I tried not to gasp. After all these months, finally, I had found him. After I'd given up for ever and for good.

I waited until he finished crossing over the street to catch up to him. "Mike?" I asked cautiously.

He stared at me for a moment and his eyes grew wider. If he'd forgotten me then it would have been worse than if I'd never seen him. Then he smiled, guarded. "Barnaby. Did you see the painting?"

I nodded. "It was really good. You want to grab some coffee?"

He hesitated for what seemed like eternity. "Yeah. I was planning to do a little sketching, but sure, a coffee would be nice."

I got my second Italian soda of the evening but even the hunger of the fast had disappeared. I couldn't stop looking at him—I hadn't remembered his arms being so defined, his hair brushing his eyes so that I had to look twice to be sure they really were green.

"I've been looking for you," I said finally, when he was content with the shaved chocolate in the frothed milk and had settled back into the overstuffed chair (the purple sofa now being full).

He shrugged. "I found out you were some kind of local celebrity when I brought in the painting. From what they told me, I didn't think you'd remember me."

The cut words like ice. "I remember," I said, my voice soft under the bright lights and conversation. "I wondered every day about where you were and why I couldn't track you down. I tried back at the apartment, and was told that you'd left. Even with the painting—someone else was holding the money and no one would give me a number, email, nothing. You disappeared into thin air and I'd started to wonder if you real-

ly did exist or if it was just my own fantasy life had taken over."

He shrugged those very developed shoulders delicately and combed his fingers through his hair. "I got a commission in Texas, a bank lobby, and then I went up to New Mexico. Lots of art in New Mexico."

Not just one of the artist wannabes, then, but the real thing. A commission for a bank lobby in Texas? He was more successful than I was, and I suddenly felt a little bit shy. I'd always been the one people had envied.

"But you came back."

He shrugged. "There were still things I wanted to do here. And some people I wanted to see again. But then I heard that you never saw anybody twice."

"Not true," I told him. "I've wanted to see you every day since November. I want to take you home right now and keep you in bed for a week."

I realized that it was true. And that, of all nights, this was the one night I couldn't do that. Or maybe it was worth it, I thought. Maybe this one was worth giving up the Initiation, giving up all the magick. For a moment I even believed that it was true.

Discipline, they had said. That I didn't have it. But was it discipline to walk away now, or would it merely be stupid? Which would I regret more in the end? I had waited so long for both of them, and now both of my greatest desires were so very close.

"That's a little over the top for a first date," he said, but this time he was smiling like he meant it.

There is a God. A God/Goddess/Divinity/Angelic Presence/Providence that creates and guides our lives. There is magick, because without magick and without God there would have been only a cruel choice. I was willing to choose Mike over the Lodge, but I knew that someday I would wonder if it had been worth the sacrifice.

But since there is a God, He and She gave me the words to say. I couldn't believe that it was that simple, though the notion had never occurred to me before. It had never been part of my world, no one had ever suggested it to me before and I certainly had never considered the notion before. After all, I was supposed to be there, available for whoever showed up, ready for whatever amusements the night presented.

"Okay." I said. "How about dinner tomorrow night?"

"Something for Everyone"

By Jennifer Stevenson

"Know what, Elise-honey?"

"No, what, Morrie-bunny?"

"Today's our anniversary!"

"Baby! You remembered! Does this mean we're going to—"

"You betcha, sugarplum."

"Awww, we don't have to."

"We do. For my dollface, anything."

"Oh, Morrie! I'm getting—"

"All choked up?"

"—horny."

"Flight crew, prepare for takeoff."

!ding!

"Good morning, passengers, and welcome to Sol's Local Shuttle to Saturn. Today on board our jumbo seven-seventy-seven we're flying four hundred forty passengers. Flight time is expected to take ninety minutes."

"And undocking, takeoff, landing, docking, and deplaning will take five hours. Hell, I used to fly to Jersey in less than five hours. Including all the bullshit at the gate and runway. And I didn't have to wear diapers."

"We're not flying to Jersey, Sam."

"No, we're flying to Saturn. I ask you. Why can't your niece get married in Palm Springs like everybody else? What the fuck is Saturn? Just another fucking amusement park."

"Don't be coarse, Sam."

"Oh, you know damned well what's going on here. Right here on this plane."

"Stop it, Sam."

"No, I'll prove it to you. Hey stewie, what powers these things? My wife wants to know."

"Sam, really."

"C'mon, tell her. Tell her."

"Uh, it's technical, sir."

"There, see the way she blushed?"

"Sam, I'm blushing. You're embarassing everybody."

"Well, what the fuck is Saturn."

!ding!

"Should the cabin lose pressure, the emergency seal will drop down over your seat. Please listen for this chime."

!dang!

"If you hear it, immediately remove your arms from your armrests and place them in your lap, and place your feet under your seat to prevent accidental amputation."

"Great. I'm already folded up like a pretzel."

"Does that mean I can't hold your hand, Sam?"

"Doris, this isn't like a jet takeoff."

"Just until we're up. You know I hate takeoff and landing."

"You won't feel a thing."

!ding!

"Our plane will be flying through 'O' space for approximately ninety minutes. Passengers who experience discomfort in 'O' space should notify their flight attendant immediately and request medication."

"Better call her now. I can take it, but can you?"

"Sam, honestly."

"Any first-timers back there?"

"Yeah, one oldster couple in row twelve."

"Trouble?"

"He looks like a pincher. She'll be all right."

"These geezers always get carried away."

"*I heard that.*"

"Ahem, Elise, your team getting settled?"

"*I'm running the check now, Captain.*"

"Take your time, ladies."

"*It takes as long as it takes, Captain. And tell those snot-noses in the cockpit that we could use another team in here.*"

"Sorry. Four's all you get today."

"*Don't come crying to me if this whole flight goes to hell instead of Saturn.*"

"Define the difference!"

"Flight crew, pipe down. Check your teams, Elise."

"*Nag.*"

"All right, girls, status?"

"Nadine checking in, Jared's up."

"Barbara checking in, Tristan's up."

"Lucille checking in, Brett's up."

"Selma checking in, David's up."

"And Morrie's up. Very good, girls. We're short-handed today. Let's make it as smooth as we can. Get those he-men working and don't let 'em quit."

"I hate it when she calls us 'he-men.' "

"David, you're not supposed to hear that. My headset is supposed to be sealed."

"Well, how can I help it? Elise has a voice like a dog whistle. Must cut clear through your ear and out the other side."

"Just ignore her. So. How you want it today?"

"Ooo. Like that. Definitely. Um. The thing is it's so hypocritical."

"What is?"

"You all are 'girls,' and yet she calls us 'he-men' and we're half her age. Half."

"If it comes to that, you're half my age, Mr. Smartypants."

"Well, I guess I am."

"Big guy, it takes a young man to keep up with this work."

"And apparently it takes an old—uh, more mature woman to—ow!"

"To keep your mind on business."

"You didn't have to do that!"

"You don't have to fly, if you can't be nice to your partner. Want to stay home today?"

"Grrr. No. Besides, we're short-handed."

"So we ground the flight, big deal. I don't fly if I don't have fun."

"That is *so selfish!*"

"This is selfish work, boyo. Now I want you to put everything out of your mind—everything—while I—"

"Oh. Oh, Selma."

"You going to be selfish for me today?"

"Ah! Guess I have to."

"Okay, kids, we gotta double up again. Nadine, you take Jared the first leg to Yesod. Selma, David does Yesod to Hod. Barbara, can Tristan handle Hod to Netzach yet?"

"Piece of cake."

"So you say. Last time he did it backwards and we had to do two legs over."

"Tristan's just a little dyslexic. We've been working on his visualization."

"Well, keep him on target this time. We damn near lost David, pushing him through the hot zone twice in ten minutes."

"Hey, David can do it. If you just *warn* me a little sooner, he can handle twice in ten minutes. He doesn't even have to regroup."

"Brag, brag brag. Good thing you kids got me and Morrie, is all I can say. Okay, the usual lineup after that—Lucille, Brett takes it from Netzach past Tiff to Chesed and across to Geburah, with me and Morrie running backup through the middle. We'll take over for the last leg, Geburah to Chesed to Binah. On the way home, reverse and repeat like usual."

"Brett's gonna pish. He's bored with that run."

"So's David."

"So's Tristan."

"We're short-handed, ladies. This means safety first. You come and go to the same place—"

"—By the same path."

"—same path."

"—path, yeah, okay, okay."

"And keep the chatter down, girls. Whisper. Don't want our he-men getting distracted."

"Not Jared. No way. He's gone already."

"Take your time from me. In. In. Don't get anxious and speed up just 'cause we're short-handed. In. In. Follow my stroke. In. In. Is everybody horny?"

"We're horny!"

"We're horny!"

"We're horny!"

"Present."

"Stupid way to travel."

"It's quiet, it's pollution free, and it's safe."

"Except for the occasional passenger who strokes out in 'O' space."

"That's a green sheet in your file, Matthews. Two more infringements and you're grounded."

"Well, jeez. Besides, it's technologically stupid. Whoever heard of stopping at every planet on the way from point A to point B? Our flight path looks like three-D connect-the-dots. We're all over the system before we make dock."

"That's how this works."

"It's stupid."

"Stupider than burning a ton of kerosene to punch a hole in the sky?"

"Plus it's religious. Personally, I'm an atheist."

"I heard that, and I resent it! This—this *travesty* has no relation whatever to orthodox practices! *My* religion is being *trampled on* here—"

"Shut up!"

"Stifle it, Smutty!"

"My name is Schmidt. You can call me Smitty if you have to, but I resent—"

"Your name is *Smith*, Smutty, and you eat BLTs and have an egg hunt for your kids every Easter. *Orthodox* you ain't!"

"*Children, children! My teams are prepped, Captain.*"

"Undocking complete. Commence translation in your own time."

"Doris, you're squeezing my hand off."

"I'm a little nervous, Sam."

"Take it easy."

"I mean, how does it *work?*"

"It's just some guys getting yanked off. Safe as houses."

"Excuse me, I couldn't help overhearing. It can be very dangerous. Rising on the planes is a very high-risk occupation."

"Look, don't scare my wife. She's squeezing my hand in half as it is."

"Oh, we'll be all right."

"Hello, I'm Doris. This is my husband, Sam."

"Nice to meet you Doris, I'm Sylvia. No, the worst that ever happens, somebody gets too excited and he gets left behind *without the plane.* Out in space, maybe two blocks away from the Sun or something. I read about it in *Fresh Heresies Review.*"

"My God! Sam!"

"Oh, not one of the passengers. We're like all wrapped up in the plane. It's a kind of energy field they generate. Oh, flight attendant! May I have one of those little pills? Thank you."

"What's that for?"

"I never take them, really. My late husband used to. I request one because he always did. It's a sentimental habit, but it makes me think of him. Do you want this, Doris?"

"Do you think I should? I don't fly well."

"Waidaminit, I don't get it. How can the guy get out of the plane? I thought they were in this love nest upstairs."

"Sam!"

"It's all about visualization. It takes years of practice. They start training at puberty, you know. Think of it! Those handsome young men up there, *concentrating* away, with their faithful shekhinahs *assisting*—"

"I thought you hadda be over forty and orthodox to mess with that shit."

"Well, it *is* a heresy. But apparently most of the older men can't always keep it up. It wouldn't be safe."

"Sam, you're blushing!"

"How's my favorite geezer?"

"Doing good, Elise. Can you lift up a hair?"

"Better?"

"Oh. Yeah. Mmmm. Beats me how you can do that."

"Thunder thighs, Morrie."

"I'll never laugh at your horseback riding again. You remember the pace?"

"Can't you tell?"

"I just get it up. It's your job to count."

"Men."

"You gonna slow down, or set it slow from the beginning?"

"Git-go."

"Feelin' good?"

"Mmm. Hush now."

"You're the best, Elise."

"I'm concentrating."

"I love you."

"Mmmm."

"Baby?"

"Mor, don't you have a planet to think about or something?"

"Do you love me, Elise?"

"*Yes.*"

"Nadine here. Jared's en route."

"Good. You having fun, Nadine?"

"Betcha!"

"Lucille?"

"Always."

"Barb?"

"Check."

"Selma?—Selma?"

"*Yes,* I guess I'm having fun."

"Am I having fun. What the hell is that all about? Who cares if I'm having fun?"

"You'll never convince me you hate the work, Selma."

"Lucille, you would fuck a doorknob."

"And love it. That's why *we* have this job. You and me, and Barbara, and Nadine, and good old Elise."

"*Good* old Elise. Fucking cheerleader. Hang on, I have to concentrate, my stud's losing altitude—easy—slow down—ah, atta boy. It never fails to amaze me that we have to manage this stupid process. All they have to do is get off!"

"It never fails to amaze me how much you complain about the crumpled rose petals on your mattress, Selma. If you'd pay more attention, you'd have more fun."

"How can I concentrate on fun? I've got to monitor stud-boy's wood every second, and I'm talking to you, and Elise drops in on the frequency snoopervising, and then the flight deck chimes in with the fucking *weather* report, like it *matters*—"

"They want it to matter. They feel inadequate."

"We shouldn't have to listen to that stuff."

"We have to, Selma. You should be tuned to the cockpit all the time."

"Doesn't it distract you?"

"My third and fourth were twins. Nothing distracts me. Except sour-pussies."

"Well, I feel frustrated."

"Mmm."

"Lucille?"

"Mmm."

"Does it seem to you we're moving slower than usual?"

"Yes. It does."

"I kind of like it."

"I do too, Selma. Now do you mind getting off the air? I want to enjoy this."

"There goes Mars. I can't believe this works. I can never believe it."

"Luckily, Matthews, what you believe is supremely unimportant. Field monitor, Smith?"

"Field's holding fine. Elise and Seymour are holding up great."

"They always do."

"What's with that, anyway? How come they're the only team that's married?"

"It's traditional, Matthews."

"Like we tell the passengers, 'it's technical.' C'mon, Captain, why them? Why the geezers?"

"Didn't you retain anything in flight school?"

"I did, yes. It was all boring stuff about combustion rates and air-speed-to-drag ratios and trigonometry. *Science.* Remember science?"

"Matthews. Their expertise is not ours. Frankly, I'm glad of that. I'm glad I've still got a job."

"Why the old people?"

"There is compelling evidence that the older practitioners have bet-ter control."

"The old men? Or the old women?"

"The old men."

"Then why are most of the lifters young guys?"

"They only have to get it up for one leg—one *path*, they call it. Their recovery time is quicker, the little snots. They can turn it around fast enough that if one blows his wad too soon, there's backup. It's why we put up with their prima donna bullshit."

"I get the message, Cap."

"I doubt it."

"So why do all the shekhinahs have to look like my mom? I mean, yuck!"

"You ever slept with one?"

"Gosh! Why, no, sir, now I come to think of it. I've never slept with my mother. Must be an oversight."

"Don't be sarcastic, Matthews."

"And you have?"

"A few times."

"So?"

"They're better."

"Awww. The old sweetie."

"Mmmm?"

"Never mind, Morrie, you're doing fine."

"You with me, Elise?"

"Right with you. Coming out of the straightaway past Tiphareth."

" 'S beautiful."

"Sure is, Mor."

"You're beautiful."

"Your eyes are shut."

"I see your soul, Elise honey."

"Awwww."

"Sam, I'm feeling funny."

"So hold my hand."

"Sylvia, doesn't this bother you?"

"Not at all. I like watching people's faces."

"Huh. Bet you get an eyeful."

"Oh, I expect we all look a little foolish. We're all in the same boat."

"Sam?"

"Just hold my hand, old girl."

"Sam, I'm going to shut my eyes."

"You always do."

"This is the part I hate."

"Matthews, just how long have you been flying?"

"A week—and what's that got to do with anything?"

"Ah."

"Aren't you going to post a hull pressure report?"

"They know about the pressure, Matthews."

"I don't see how."

"Because they're doing the work, asshole."

"Smith."

"You must have slept through qabalistic meditation."

"I was transferred into this service *straight* from flight school, butthead."

"Matthews."

"Oh *that* flight school. Flight of the dinosaurs. Flight of the petroleum pterodactyls."

"Smith."

"So you haven't got the faintest idea how hard it is to hold an erection for twenty minutes at a time, I mean *right* on the edge, and maintain visualization of a divine journey!"

"Is that what they're up to? Coulda fooled me."

"It's incredibly taxing. Physical *and* mental control. Not that you would know anything about that, asshole."

"That'll do, Smith."

"Butthead."

"You too, Matthews. Nervous?"

"Restless, sir. Ninety minutes is a long time in 'O' space. Plus these darned rubber pants."

"You ever been all the way to Saturn?"

"No. But I'm fully qualified."

"Don't be defensive, Matthews. There's a reason for everything."

"What's Saturn got to do with it?"

"Well—every now and then—"

"Every now and then what?"

"—Something's—different."

"Where?"

"—On the longer run."

"Why?"

"Matthews? Just look out the window for a while."

"Elise, I'm getting a funny feeling."

"Me too. David feels feverish."

"Just hold your rhythm, ladies."

"This doesn't feel like Binah to me."

"Hold your rhythm."

"It happens sometimes, Selma. Hang in there."

"Easy for you to say, Nadine."

"Hold your rhythm."

"Barb, what's today, the twenty-first?"

"Yeah. Elise and Morrie's anniversary."

"Ahhh."

"Hold it—hold it—"

"Holy Moses, what the hell is *that?*"

"That, Sam, is Shiva and Shakti."

"Wowser! They're doing the nasty! I've never seen anything like it!"

"Awe inspiring, aren't they?"

"They must be as tall as the Sears Tower! It's better than I-Max! What the fuck are they doing, Sylvia?"

"Creating the universe, Sam."

"Whoo-ee!"

"Like it?"

"I feel like a teenager!"

"Now I think you should shut your eyes, Sam."

"And miss the show? Why the hell?"

"Because this show comes with sensurround. And Doris would like it if you were—with her."

"What, if I shut—oh. Oh!"

"You see now?"

"—Yeah!"

"Elise? I'm getting really nervous! Elise?"

"She'll be back on in a minute. Take your time from me. In. In."

"Nadine, Elise is supposed to be marking the time."

"She's busy, Selma."

"But—but this isn't Binah! I *know* it isn't! It feels wrong!"

"Then you'll feel pretty foolish trying to get home without the plane, won't you? *Stay with the rhythm.*"

"Oh my God! Nadine, I'm scared!"

"Fear is one of the paths. Not my favorite. But it'll get you there. In. In."

"I'm hyperventilating!"

"Bad idea. In. In. Stay in sync with David and you'll be all right. In. In."

"Oh my God."

"In. In. Just shut your eyes, Selma."

"Oh. Oh!"

"Sam, that was simply amazing."

"Yeah."

"Where are we now?"

"Docking. Two and a half hours in a wet diaper."

"Don't grumble, Sam. I—I think it was worth it. All the trouble—Sam?"

"What."

"What are you thinking about?"

"Wondering if your niece is pregnant."

"Sam!"

"Because if it's a boy, we can come back for the bris."

"And now you know why the rubber pants, Matthews."

"I'm so embarrassed!"

"That's the first time you've ever shot your wad on a run?"

"Leave me alone, Smutty."

"Talk about your slow-on-the-uptake."

"Smith."

"I don't know why they sent me here. I hate 'O' space flight."

"You must have shown aptitude, Matthews, or they wouldn't have transferred you."

"Well, that's a crock. God! An hour and a half with a stone boner! I'll never make it home!"

"The whole ninety minutes? And you came just the once?"

"Please, sir, I don't want to talk about it."

"Lifters don't have to talk, son. You're going to have to work on the shyness, though. Those shekhinahs are raunchy."

"Wooo-hooo! <squeeeeek! squeeeeeeeeeek!>"

"Happy anniversary, Elise!"

"Happy anniversary, you two crazy kids!"

"Awwwww."

<squeeeek!>

"Thank you, ladies, thank you."

"And now you know why Brett and I love the Saturn run, Selma."

"My God! I thought I was going to stroke out!"

"Gonna take a pterodactyl home then?"

"Hell, no."

"Elise-honey?"

"Yes, Morrie-bunny?"

"Isn't your sister's grandson graduating from sixth grade next week?"

"Why yes. Yes he is. Imagine you remembering that!"

"Do you think we should do something to celebrate?"

"Oh, absolutely."

The author would like to thank the ever-ready Phil Foglio for the idea of the "lifters," an aeronautical innovation which he introduced in "Hoisters," episode 2 of his widely applauded stroke book XXXenophile, number 5, July 1991. His URL is: http://www.studio-foglio.com and/or http://www.xxxenophile.com.

DELFIDIAN
SASKIA WALKER

"Thus it was found that human beings, in their most impassioned sexual encounters, reverted to their animal origins, indulging in uninhibited acts of lust and degeneracy, often with members of the opposite gender. Whilst this may seem strange now, to our more advanced species, it also indicates the way in which one's ancient origins can reveal themselves, in this, the most basic function of any species."

<div align="right">

DR MIRANDA K AZEKIAL.
Research seminar 87
Central Space Station
Delfidian Timezone 3824.

</div>

Aurora snapped shut her viewcom. It was too soon to try to contact Zed again, she had tried an hour ago; only four days to go until he was back, thank The System. She was desperate to see him. The hormones they were building into her body didn't seem to co-ordinate very well with his month long absences from the station. At least, that was how she explained her longing to herself A great sigh escaped her. She shook

it off and began to prepare for the day ahead.

"You're just in need of sex, you stupid female," she muttered to herself. She did have an attachment to Zed though. It wasn't expected to develop strong feelings of attachment to males, but she had.

Aurora gave a wry smile as she thought over it. The ironic part of that argument was that selected females, herself included, were given hormones and assigned a male lover, in order to encourage them to bear children. It wasn't necessary very often, due to direct impregnation and longevity.

The Human genes were what they were most proud of, and Delfidian females were only selected to birth in the ancient Human way if they were fertile to begin with, thus selecting the best and most economic recipients. In her very public role as cultural knowledge supplier in the governing body, it was also appropriate for Aurora to be a birther, to set the good example to other females who rejected the task of coupling with males.

She glanced at the day spacer. It was almost time for her to go for her image session, before work. Aurora documented and circulated the Cultura history issue for consumption each month. She was a supplier of knowledge, in the arts, ensuring each and every member of their society had access to information on their origins in Human society. Such knowledge was essential. They were no longer purely Human, but it was the prime ingredient in their genetic make up. There were a team of suppliers, each focusing on different fields, between them they ensured education was a living thing that existed in the life and soul of every member of their society, from birthing to phase-out.

The image session was a chore she was not looking forward to, having her image co-formed with the other governors was bad enough, but the theme of the forthcoming milestone celebrations was historic; they were all to appear as some ancient race of Human warrior women—how ridiculous! It was the furthest thing from what they had become, and had she, the cultural historian, been consulted, she would have advised against such a ridiculous idea.

The image maker, on the other hand, was not such a chore to think about. Aurora was rather looking forward to seeing her at work in her techzone. She crossed to the mirror, stroked her pelt down where it always defied her will, at the nape of her neck, and plucked some color into her lips with her fingers. She smiled at her reflection; she looked perky, her green tiger eyes sparkling. Her flame colored fuzz suited her today; often she was unhappy with her Creslet genes, there wasn't a lot

you could do with a half body covering of vivid red fur, extending from hairline to tailbone. She tweaked a couple of strands into spikes on her head, then transferred her cultudata to workzone, to be open and ready for her arrival there later. She called the transport controller and alerted them to her readiness. In moments she was in the shuttle coursing the electronic rails to the other side of the station where Diva worked.

The journey gave her time to let her excess hormones flow in the direction of Diva, the image maker. She was a tall Human-looking creature, with an excessively long black mane and a jeweled visage; a sign of her role as a Delfidian creator of beauty and strength, embedded in the skin of her face. Tiny jewels and filaments of fine fibres, chosen by her teachers to reflect her personal qualities, outlined her exotic purple Roganza eyes and her full mouth in glistening decorative coils. She exuded the kind of beauty and serenity that Aurora had previously only read about in her work with historical documents. Everything about her personified a bygone age, and Aurora's love of ancient beauty meant she responded immediately to Diva. Whenever she saw her, a kind of transfixion overcame Aurora, and Diva never flinched under the gaze of those that admired her beauty.

Aurora had met her formally, in The System, of course, and she'd had her image manipulated for Government use before. But she hadn't yet had a personal session with her, to make an image from scratch. When she got to the image maker's zone the relaydoor burst open and Aurora looked at the female that walked towards her in amazement. She had always seen Diva dressed in smooth draped robes in the publiczone, with her hair trailing her back loosely. This moment, all her hair was tied up and it looked like some wild and ancient Human headdress, where it sprung from her head. She wore molded boots and legholds in black rubber, flexible and provocative, a tight purple vest stretched over her breasts. It gave her a dynamic, outrageous look. A mysterious bodygraph wavered with movement beneath the skin of her chest, a coiled shape that peeped out from beneath the purple vest and disappeared under it in a cascade of glittering scale-shapes. Aurora could barely drag her eyes from the outline of the other female's breast, wondering what the bodygraph depicted.

"Come in, come in," she said, and Aurora walked into the spacezone. She was immediately confronted by a projectory of the Knowledge suppliers, a moving imagegram of their last public duty. A massive image of herself, smiling happily at the comment of one of her

co-workers, forced Aurora to glance away.

"I was just looking over some of the footage, to get a feel for you," Diva said, smiling, one hand plucking at the strap of her vest on her shoulder. There was an intimacy in her words; Aurora wondered if she always sounded like that, or if she felt an attraction between them too.

"Make yourself at home." She turned and went over to her control desk and switched the image to fade. Aurora watched the wall turning to blank white and then glanced around. There was an air of comfort about the place, despite the fact it was a workzone. Comfortable seating interspersed the technical equipment.

"Very comfortable," she murmured.

"Yes, it has to be. I sometimes end up sleeping here. I have a bed upstairs." She gestured with her hand and Aurora looked over to where a small spiral staircase led up to a mezzanine. Her attention was soon drawn back, when Diva pushed a datareel eye into the centre of the space. It seemed huge, the probe that would select her image for manipulation, overwhelming the space.

"The aim is to draw on each supplier's individual characteristics, and colorings, but with a theme of strength. With you, I thought we'd go for a relaxed, but subtly strong mood," Diva said, as she arranged a fake stucco pillar among a few spreads of fabric in the center of the floor.

"You are the expert, whatever you decide is fine by me."

Diva smiled slowly and walked over to her. "I'm looking forward to working with your image. I have lots of really strong images of overtly powerful females. You have something else, Aurora, a real femininity with an underlying suggestion of control and power. It's very interesting. I hope we can catch it on datareel."

She walked off towards an anteroom. "I won't be a minute, I'll just get some spare reel."

Aurora wandered over to the wall of images that were on display; some were familiar, portraits of Government envoys. Some were more intimate, as if taken purely for personal pleasure. She noticed a naked Creslet, full-furred body turned away from the image eye, her face looking back toward the viewer, coyly. She smiled. Perhaps Diva had a taste for fur. Diva came back and returned the smile when she saw Aurora looking at the Creslet.

"A lover," she said quietly, then began shifting the lights around, focusing her equipment on the spread of material on the floor. Aurora stood quietly, watching her; her pulse was beating faster, arousal

heightening with every moment she spent in Diva's company. She exuded sexuality and Aurora silently cursed the hormones that pounded in her veins, causing the heat to intensify between her thighs. Diva switched on a large fan on a stand and directed it at her.

"It'll get pretty hot under the lights," she said. *Too right*, Aurora thought. The air moved the damp fur on her neck, making it flow out like tiny gills fluttering in the breeze. Diva paused and looked at the wavering strands of red. Her eyes on the fur prickled the movement beneath Aurora's skin. Her hand reached automatically to smooth the movement and Diva's eyes lifted. Her pupils were dark, the catlike Roganza spheres of purple shifting wide to accommodate her dilated pupils. Roganzans had no whites to their eyes, only color, like cats. With her exotic looks the effect was particularly stunning on Diva.

"Come on, let's get started," she said. "Colors first." She indicated for Aurora to move into position in front of the data eye.

Aurora sat cross-legged in the center of the spread while Diva clambered about on her knees, testing the different clutches of material for the effect she wanted. She sat back on her rubber boots and rocked, her mouth pursed as she squinted her eyes and sought the appropriate props.

"Here. You get undressed and put this on and I'll get us something to drink. Perhaps I'll be inspired when I get back." Aurora stood up and took the red and black gown from Diva's hand. *Undressed.* That was news. She began to shed her clothes. When Diva came back she paused in her passage as she looked over at Aurora; the two glasses trembled their contents.

"That's it!" She put the glasses down and came over. She pulled the longer parts of Aurora's fur out over the red pattern on the gown. "Reds, lots of reds. Obvious, but dramatic, looks good; a dash of something else maybe." She handed Aurora her glass and headed off toward the mezzanine. Aurora glanced up and saw that she was stripping red satin sheets off her bed and when she came down she had them bundled in her arms.

"Oh yes!" Diva said, as she arranged the satin over Aurora's bare shoulders. "We'll make a fiery warrior woman of you! An ancient fiery warrior, at rest in her Bedouin tent." She laughed when she saw Aurora's glance. "It is a bit of a joke isn't it? Still, we can make something of it."

Aurora was surprised at her intuitiveness, Diva seemed to sense what she was thinking about the centenary event. Was she psychic, perhaps?

A dangerous talent, psychic ability, one that had been obliterated centuries before, in the name of security. As Diva began to plump the red and purple cushions she chose for the background, Aurora moved the satin on her skin. It felt cool but was warming. It gave off the heavy aromatic perfume of Diva's scent; a hint of sex also emerged from its folds. Diva paused to stroke her pelt over the material before moving to the control panel. Aurora's blood roared. Diva glanced up at her with dark eyes. There was definitely something there, passing between them. They had both felt it that time.

"Sit down," Diva whispered. She moved away slowly and paused for a drink. She smiled down at Aurora as she took in her look.

"You have been assigned a male lover, haven't you?"

Aurora was surprised again. It wasn't the sort of thing she expected her to say, especially not at that moment.

"Don't worry, I read that in your dossier, I'm not psychic." Diva winked then and Aurora began to feel her tension melt away, she felt comfortable. This female was so easy to be with, as well as being incredibly attractive.

"Yes, his name is Zed. He is an agricultural programmer. But he's off-station, observing the Field Stations. Unfortunately, it's killing me." She laughed, embarrassed at her confession. Diva didn't bat an eyelid.

"Tell me about males," Diva said, as she slipped behind the datareel control panel.

"Why the curiosity? You can't be a birther, yourself, otherwise you'd have been assigned a male lover."

"Yes, that's true, but it doesn't mean I don't want to know what it would feel like. . . ." She paused. "Do you always think of procreation, when you have sex with Zed?" She threw her a direct, questioning gaze. Aurora didn't answer, she was so shocked at Diva's words, and Diva continued, as if she didn't need her to answer.

"I would like to feel a male come inside me, not for birthing, but simply because he wants to."

"That's a pretty outdated concept. Sex with males was recognised as purely functional aeons since. . . ." Aurora replied, feeling indignant.

"Simply because of the clitoris, as I recall. But that's not everything is it? It's the physical bond of bodies, the mental bond that comes from reciprocated desire that interests me. I suspect not all Delfidians have lost that need . . . admit it Aurora!"

Aurora floundered. She realized Diva must be seeing into her thoughts, and her attachment to Zed was why she felt safe talking about

this; she saw in Aurora someone who could maybe understand her curiosity. There was no point in pretending otherwise.

"Yes, I do feel some emotion, a reaction to him, not entirely familiar, but comfortable . . . it makes the sex function more attractive." Diva nodded. "In the Human societies, they lived in male and female couples, as well as same gender relationships," Aurora added, quickly, as if offering some sort of excuse for her attachment to the procreator she had been assigned. But Diva drew her back to what she wanted to hear.

"Tell me how he makes you feel when you are in sex."

"You mean his penis?"

Diva flicked her hand in a gesture of dismissal. "There are adequate replacements for that. I mean the male, his being, the whole being, wanting you, connecting with you in that way."

She really had thought about this a great deal, Aurora realized. She put her glass down and focused into space as she considered her words. The low ambient soundwaves Diva had switched on were accompanied then by the regular sound of the datamachine opening its electronic eye to the scene before it, and closing again, taking away a frozen moment in its memory. But Aurora didn't notice the dataeye any more, she was following the thoughts that Diva had asked her to describe.

"It's incredible, because I sense he really wants me, not just to fulfill his role as procreator, which surprised me at first. . . . His eyes seem to burn my skin when he looks at me with desire." She bent forward and stroked the back of her hand as if to cool the skin where he had touched it with his sight. She was thinking of the way he held her eyes with his, seeking her responses to him when he took her in sex.

"Is he a good lover?" Diva asked quietly.

"Oh, yes." Her lips parted as her mind went through its favourite images, and her hands trailed up against the short fur on the sides of her head. She was feeling his, his tousled mane of dark brown hair, very Human hair, like Diva's.

"At times he is like one of those ancient priests of love that I wrote about in last cycle's Cultura. He is strong, powerful, asking me to show myself to him, to offer myself." She paused, blushing, as she realized Diva would know where her inspiration for that article had come from. Not simply textbooks. "It's probably just the hormones. . . ." she whispered. She breathed deeply. His presence was near, she had reached out for him; she had conjured him there. "He is sometimes adoring, supplicating himself before me. The beauty of that is almost too much to bear. . . ." Her voice descended to a whisper.

"When his desire is fiercest, he is like a demon spirit that sweeps over me, leaving me hungry for more when he is gone." She turned as if to look for his shadow and, as she moved on the cushions, the satin slid across her skin. It felt as if it was his hand on her, enquiring her readiness for him with the lightest touch. Her eyes closed as it slid from its place on her shoulder and placed a satin kiss on her nipple, before it fell away. Her hands went to her pelt, pushing it up and back. Diva was riveted to her movements, her mind envisaging the male lover that was causing Aurora's extreme arousal in front of the datareel.

"Tell me more," Diva said, her voice low and husky. Aurora lay back on the cushions. As she felt their embrace against her body she arched up as if it was too unbearable. Her body was pounding with desire.

"I want him, now," she whispered, and her voice was pained. The datareel ceased to whir.

"Poor Aurora, you have got it bad." Aurora opened her eyes. Diva was climbing across the cushions, her eyes shining, her lips parted in a suggestive smile. She slid up and kissed Aurora on the mouth, crouching over her like a wildcat scenting its prey. Aurora pressed back into the cushions and the other female climbed in her path and ate the flavour of desire from her mouth. Her hands moved over Aurora's body and captured the movement of desire on her flesh, took it from her and absorbed it into her own body. Aurora responded to the luscious kiss and shared her desire, offering its delectable flavour, its succulent body. They shared it, they tasted its strange male stimulant together. Aurora found that the shared deviance of it fired her all the more.

Diva leaned back and pulled the satin sheet from around Aurora's waist. Its sweep revealed her arousal in a low cry from her mouth, a reach from the breast that yearned to be touched. Aurora gave herself up and Diva fell to her breasts as they rose and took the offering. She took the trembling flesh into her mouth hungrily, and Aurora moaned. Her eyes closed and her arms fell over her face. Diva's hands roamed her body, feeling for the soft firm flesh that she wanted to taste, before sinking down to it with her mouth. As her mouth moved down to the source, to reach for a taste of desire's elixir, Aurora felt the bite of her own teeth on the back of her wrist. Diva's mouth slid deeper against her and Aurora writhed as a great sweep of movement climbed through her pelvis. Her tongue flicked slowly inside, then crept along the sensitive folds of her sex, hunting for the darting responses that lurked there. The feeding mouth against her was too exquisite and Aurora cried out in an agony of rapture.

Diva spread her tongue wide and hard against the morsel of lusting flesh that ached and throbbed its response and then she slowly and firmly ringed it with the tip of her tongue. Her hands were caressing the soft skin of her inner thighs, gently teasing the surface of her skin with waves of movement. She was pushing and pulling the sensations with her hands and her mouth and Aurora felt herself slipping away, her awareness disintegrating. Diva lapped hungrily, her tongue a demanding dart, the heat of climax approached. Aurora rippled, her body reaching for escape.

"I am going to come Diva, oh dear Jupiter, I'm coming!" Diva sat back and watched the heat unfold with a gleam in her eye.

"Good. Come Aurora, I want you to." Aurora groaned. No other lover had said that to her, or had been that direct and caring with her. It sent her flying closer to the edge of her orgasm. Diva stroked Aurora's belly gently and moved her other hand between her open legs, dipped into her moist sex, and then placed a knowing finger in the right place. She applied the firm touch of knowledge and watched the results of her movement and pressure on her friend's body. As Diva's finger rocked, gently, a network of nerves sprang up across her body. As they meshed their thrill together Aurora struggled, but she was caught in the net, trapped in the bliss of her own orgasm.

As the tangle of nerves finally slid away from her body, and freed her again, the sound of the datareel opening its eye to take one last look at the scene echoed through her awareness, but didn't take form. Eventually Aurora opened her eyes and saw that Diva was squatting between her open legs, rocking back and forth on her boots. Her chin rested on her folded arms across her knees as she watched. She had an amused smile on her face and a glint in her eye. Aurora sat up and pulled the other female nearer her, to kiss her mouth. Diva took the offering then laughed.

"You are a creature, aren't you Aurora?"

"And you?" Aurora said in reply. She was still heavily aroused; she wanted more.

"I'm weird. I really get off on making other creatures come," she replied. Aurora looked at her. There was a dare in her expression, it was obvious her words were only meant to give her the chance to escape if she wanted to.

Aurora smiled and let her hands slide over the black tails of hair on Diva's shoulders and down to her breasts which strained near her own. She pulled at the purple vest and fought against the tight material to

reveal her breast and see the elusive bodygraph. As her nipple finally bounced free Aurora looked down and saw that it was some strange mythological creature, covered in scales and with a tail the length of its body. It was chasing itself around Diva's breast. Its long, fiery tongue licked at her nipple with a darting touch that reached for her own nipple through its image. Diva laughed quietly as Aurora stared at the thing. Aurora's finger was drawn to the creature's head and she stroked its body around the line of Diva's breast.

"Oh it's lovely," she exclaimed. Then she rolled Diva back onto the cushions and descended to the creature with her mouth, following its line with her tongue. As her lips closed on the nipple she hummed her pleasure when she felt it grow erect and her hands began to explore Diva's body. After a moment there was a distant chime as the relaydoor signaled the approach of another visitor. Aurora dropped the nipple from her mouth and gave a growl of disapproval. Diva looked at her and smiled calmly.

"That will be my next client." When she saw the disappointment on Aurora's face she added: "Don't worry Aurora, you'll be with your lover soon." As she got up she threw the robe to Aurora. She stood over her, smiling smugly, as if she had won a game, and dragged the material of her vest over her breast, watching Aurora. Before she opened the door she turned and spoke again. "I would like to know what it is like to make a male come, like you do with your lover."

"More footage, in action." Aurora ran her fingers along the edge of the viewcom. She was trying to look professional, because that's how Diva looked. She broke into laughter. "Aurora! Are you listening? I need some footage and I thought I could come down to the centenary rehearsals. You are there today, according to your dossier."

"Yes, that's right, at the Jupiterzone. Please come down. It would be good to see you. I've been thinking about you." Diva smiled at her new friend's cautious intimacy.

"I'll see you there at time space ten. I've been thinking about you too, Aurora." She leaned toward the viewcom, filling the screen with her face. "And your male lover!" She laughed and closed down the connection. Aurora almost jolted with surprise, Diva was the strangest female she had met, but so intriguing. And she, after all, had an attachment to Zed, so who was she to criticize?

Aurora had found herself thinking almost constantly about Diva, and the things she had discussed with Aurora, since they had been togeth-

er. She couldn't help wondering to herself why she didn't feel any shock at Diva's obvious perversity, in the face of Delfidian norms. Was it because she too was deviant, in a similar way? She tried to dismiss the idea; its strangeness disconcerted her, but the thrill of it was taking hold of Aurora.

As if she had called to him, Zed appeared on the viewcom suddenly, moments after Diva's image had left it. His deep brown eyes and strong features drew a smile from her.

"Aurora! Glad I caught you. Thought I'd better let you know, we're going to be a day late back to station . . . you look well." He was smiling cautiously, always with that reticence in his expression, that she had taken for awe at his status as procreator. For some reason, it occurred to her then that it might mean something else. She knew that he missed the male lover he had to leave behind when he had been assigned to her, but could it be that he felt an attachment to her too?

"Yes, I am well. Thank you Zed. And you?" His hair hung over his shoulder, unkempt, his eyes looked a little tired, but alert nonetheless. She wanted him, she wanted Diva. What was happening to her? Her hormones were all over the place! When Zed closed the connection she paced her restzone in frustration. She paused and laughed at herself. She thanked The System she was seeing Diva, at least, that day, and went to prepare for the meeting.

When Aurora got to the Jupiterzone, Diva was already there, waiting for her. She had a portable datareel in her hand. She was looking sultry, dressed in a flowing robe; black, her hair merging into its dark silkiness. Her gems glittered under the strong lights of the entrance to the auditorium. She gave Aurora a big smile as she came into the zone, and then walked over to give her a light kiss on the cheek.

"Lovely, Aurora," she murmured, as she looked over the dark green robe that hugged her body with cool but provocative simplicity. Aurora didn't say anything but took Diva's arm with a smile. Zed would be home soon. She was with Diva again. She was feeling good, life was wonderful.

They followed the sounds that emerged from the main auditorium, music that stopped and started and returned to the start again. Voices sprang up, instructions and responses. The seating area was in darkness. A few dim lights on the stage gently illuminated two male figures that moved across the space. As they grew accustomed to the limited light they saw a row of five figures sitting near the front and Irenie, the centenary Director, leaning on the stage, a sheaf of papers in her hand.

Diva giggled quietly and squeezed Aurora's arm. She began to walk, drawing Aurora along to one side of the place. They drew to a halt near the front and the dancers glanced over at them. Irenie turned when she saw them.

"Aurora." She put out her hands, taking both Aurora's hands in the gentle sign of greeting customary in workspace. "I'm afraid we aren't ready for you yet. I'm so sorry to have brought you down here. We're still working with the preliminary dance team."

"How intriguing," Diva said, her eyes on the males on stage.

Irenie didn't notice the glitter of sexual interest that flickered in Diva's eyes.

"It seemed necessary to have males in equal numbers, as they were such an important part of ancient Human society. You're quite welcome to stay and watch us at work." Irenie blushed a little, thinking that she was the focus of Diva's attention. Diva flashed her a smile.

"That would be wonderful, thank you. I am always interested in new imagery." Irenie turned back to the males on the stage and clapped her hands over her head.

As the dance routine began again, Aurora and Diva were close enough to see everything, including the intent expression on the face of the sleeker of the two males. He began to trace a pattern across the empty space of the stage. He was pacing, yet with a deliberate rhythm, a kind of exotic dance movement contained in his steps. He was barefoot, his blond hair sleeked back from his face into a tight knot at the back of his head, giving him a feline grace. He was stripped to the waist, loose black legholds hanging on his hips, exaggerating his slim frame. The other male on the stage was dressed the same way. He was even taller, well built, with muscles that glinted in the stage lights. His head was completely shaved, his face heavily boned. He looked powerful, like a warrior from the Viking age. That was obviously why he had been chosen for the centenary show.

"Wow," murmured Diva, when his body captured the light as it moved. She looked at Aurora. "Beautiful!" she whispered. Aurora nodded; she felt a little unsure, but they were indeed attractive creatures. Diva was infecting her with her deviance, but it felt so good, Aurora was acutely aware that her resistance was breaking down.

They edged forward again and Diva found them a hidden spot to watch from, nestled in the heavy drapes at the side of the stage. The sound was muted there, but they had a good, close view of the two male figures as they worked through the choreographed steps. The

datareel was set down and forgotten as the two females watched.

The dancers paced apart in perfect timing, then rose toward one another; each time their pattern ended with them standing closer together, until they were almost touching the naked skin of their chests together. Aurora's body began to pound in response, but her mind still flickered with doubts.

She turned to Diva and saw that she too was enthralled by the vision of male beauty before her. She was pressed up against a low barrier, her fingers locked over its metal edge. Her eyes glowed, her gems sparkling; her lips were parted, her breasts rising and falling with quick intakes of breath. She was heavily aroused too. Aurora remembered the dare she'd had in her expression the night before, and closed in behind her.

She looked over her shoulder at the stage. The dancers were rising, doing the scene from the top again. As they paced in and out towards each other Aurora let her mouth slide to the back of Diva's neck, drew her hair back and kissed her lightly, tracing a pattern up and down her neck. Diva's head sank back in response and she gasped quietly. Aurora moved on her response immediately and let her hands curve over Diva's breasts as she moved close against her back.

"They look so good, don't they?" Aurora breathed in Diva's ear.

"Mm," Diva murmured. She was leaning into Aurora's body, pushing back from the barrier. She was so hot, Aurora could feel it climbing out from inside them both.

"Would you like to have them?" Aurora asked against her ear. "Both of them . . . together?" Diva murmured another response in agreement. Aurora wondered where her own outrageous words were coming from, but reassured herself that there was no harm in toying with a little warped fantasy. She spoke again.

"Two of them, lovers at your command. Think of it, their beautiful male bodies serving yours, in perfect unison as they are now, but with you as their subject." Diva groaned at the image and Aurora began to lift Diva's robe and slid her hands beneath the material.

Diva was naked beneath the robe and the discovery drove Aurora's fingers on in their exploration. She followed the curve of Diva's thigh into the warm groove that melted in response to the questing fingers, sending warm juices out in invitation to come closer. Aurora was molded against her back, her eyes on the males before them. Her mouth breathed against Diva's neck, one hand caressing the full breasts through her dress, the other nestling deep between her thighs. As she

slid two fingers inside, her thumb settled against the pulse point that throbbed out from the silky lips of Diva's sex. Aurora's hand slowly stirred, searching out a rhythm for itself and its lover. It felt so good, she was dripping herself.

As the two males closed on one another again, she moved more quickly. Diva's breasts heaved against her hand in response. As the two figures reached up and their fingers meshed together Diva took a quick intake of breath. Her thighs crushed together over Aurora's hand as liquid heat spilled down her inner thighs. Aurora pressed close against her back and rocked her body gently. Diva crumpled silently against the barrier. Aurora rested her eyes on the dancers just as their bodies met once again, while her fingers caressed the rich female sex that had rewarded her quest.

After a minute Diva rose up and Aurora let her hand slide up across her downy pubic fur before leaving her body reluctantly. Diva turned, her shoulders lifting up as she sucked the power back into her body. She looked at Aurora.

"You took me unawares, you cheat," she said and gave a low laugh. Aurora replied by sucking her fingers gently, her eyes sparkling with amusement as she licked herself with all the grace and poise of a cat. Diva's mouth fell open, then she grabbed Aurora's hand, pushed deeper into the curtains and drew Aurora behind her. She found a path through to the backstage area and then along a gloomy corridor. They came to a doorway and she reached for the handle but found it locked. Aurora laughed and Diva turned to her.

"Oh no, you're not getting away with it that easily!" she said. Her eyes were filled with humor but also with lust. She was still hot for more. So was Aurora.

Aurora's body rippled, physically, straining on the tethered hand. Diva absorbed the ripple and then hurriedly pulled her on again. She found a door that opened and they walked in. It was a props room, lined with shelves of strange objects and mounds of scenery cloths piled up on the floor.

"Perfect," Diva said, and shut the door behind them. Then she walked over and pushed Aurora down onto the mound of material. Aurora gave a cry of laughter when she hit the deck and Diva was soon chasing after her, tearing her robe up as soon as she got to it. Her hands moved like lightning, homing in on the heat of Aurora's sex, to the wetness that she knew awaited her. Aurora wanted her own release badly and her legs opened wide, letting Diva creep in on her. Diva pulled at

the silk across Aurora's hips.

"Take your robe off, quickly!" she said, laughing. Aurora flew at the order, pulling the material over her head as Diva drew the silk down her legs. Their laughter filled the place. The shelves behind them rattled and something fell down, then came a ripping sound as the robe complained over the haste. They paused a moment and then caught each other's eye. They both laughed again and Aurora threw the robe off. Diva stroked her hand over the red fur that coiled around Aurora's ribcage from her back, then her eager fingers reached for Aurora's sex.

Diva moved straight for Aurora's heat, for her clitoris, taking it in her mouth, nursing its fullness and sucking deeply. She moved over her sex in smooth wide sweeps, always ending back on her clitoris with the tip of her tongue circling it closely, firmly. Aurora felt as if an exploding comet was about to go off inside her.

"Oh sweet Jupiter," she said and Diva lifted her head. Her fingers replaced her mouth and she plowed inside Aurora's sex, sweeping in and out and along the folds of her sex in deep, probing movements. Her free hand crept up to Aurora's breasts, stroking gently, then she lifted Aurora's hands and drew them over to her own breasts.

"You want it don't you?" she asked, as Aurora's hand moved over her nipple.

"Yes, yes, yes!" Aurora cried, laughter surging up again.

Diva smiled and stretched up, lifted the skirt of her own robe and slid her body down with her hot, wet sex lying over Aurora's bare thigh.

"Oh Jupiter!" Aurora murmured again, as she felt the beautiful wet slide of Diva's heat on her leg, and there was a note of desperation in her voice. A wave of ripples took her inside and Diva's movement slowed when the warm, moist, sex flesh embraced her hand. A look of total mutual appreciation was exchanged. Diva began to move faster again.

"You cheat," she said again and her eyes were aflame. She began to move her hips, pressing her sex along Aurora's thigh, rubbing frantically. "I'm going to come again you devious creature!"

"You and me both," Aurora replied darkly, as her hips reached again for the probing fingers.

They were both moving desperately, climbing over the threshold. Aurora let her hands close tightly on Diva's breasts as her head fell back and the fingers inside her collected the dewy drops and delicious spasms that crept up and came suddenly to fruition. As the orgasm

sprang up through her body she pressed her leg up into the hot wet valley of flesh that rode her. Diva's lips parted and her eyes closed. She ground her hips down and pressed home. With a blissful cry and a long sigh, she came.

Diva rolled next to Aurora and gave another great sigh of relief, followed by a chuckle. Then she rolled, panting, into Aurora's arms.

"Got you back!" she said, and Aurora nodded.

"Yes, you win, Diva darling," she replied, with mock disappointment. Diva nodded in approval and Aurora pulled her close and kissed her beautiful soft mouth. Her body felt so warm and voluptuous that Aurora held her close for a long while, watching as her gems sparked in turn, like the far stars showing themselves in a night sky.

"What's your bodygraph creature called?" she asked as her hand closed over its hidden shape.

"Narcissus," Diva replied. "Someone else named it for me though. My Creslet lover." She was smiling self-indulgently and Aurora traced the outline of her mouth with a gentle finger. "She said it was the name of an ancient creature who fell in love with itself." She chuckled. "But, she also told me that if you don't love yourself, you're not capable of loving anyone else." Diva reached again for a kiss, teasing her slim tongue against Aurora's. Their soft luscious kisses carried on, as their hands crept in exploration of each other's glowing bodies.

When they eventually emerged, Jupiterzone had gone quiet, the rehearsals long since over. They walked through the empty auditorium, until a voice halted them.

"You should have asked me for my company." It was the sleeker of the two male dancers. He was standing in the shadows, waiting for them to pass by. He knew they had been aroused by the sight of him; he must have seen them as they watched.

Aurora glanced at Diva. She was looking at the male creature with desire, her eyes sparkling. Aurora felt a protective urge. This was dangerous. Fantasizing about males was one thing, doing such a thing was another. It would be frowned upon, for Delfidians of their status. Aurora sensed Diva was too ready to by-step the system, to seek out the things she wanted to know about males. It was dangerous; she needed protection.

"It is not permitted, as you must know. Unless the birthing administration permits it." Aurora said quickly. She drew Diva's body closer to hers, protective of her new lover. She looked at the male. He was hiding in the corner, his sharp blue eyes darting from her, back to Diva. It

was so strange, males who weren't selected rarely made any attempts to approach a female; it was almost unheard of, although there were always rumors about the occasional rebel, a throwback from different times. A sound in the distance made Aurora take action.

"What's your name?" she hissed, already beginning to pull Diva away. The male looked surprised, then moved as if to follow them. She put her hand up to caution him. "Your name?"

"Cal. My name is Cal."

One jerk, two, the final vibrant leap. Aurora's arms slid tighter around Zed's head as he freed his seed inside her. His face was buried against her throat, his lips wet against her skin. She stroked his head. Her legs locked him against her; she had been concentrating on his experience of the sex act, but now, surprisingly, she felt her own warm heat start to build in response to him.

Her body replied to his with a long, luxurious orgasm that drew her on and on; each time she thought she had reached the peak, it drew her on to the next plateau, a series of hot ripples melting her flesh to his.

"Aurora, oh precious. . . ." he whispered against her cheek, when he felt her beauty. He had never said anything so intimate before, but then she had never held him so close, nor let herself go to the experience so fully with him. Her body was suffused with heat, the warm wetness seeping out across the inside of her thighs, her voice making shallow rasping sounds with the intake of breath on each pulse of her blood.

"Do you think we might have created, tonight?" Zed asked tentatively, as he lay close alongside her later.

Aurora smoothed his hair back from his face, looked at his enquiring eyes, so intent on her.

"I wasn't thinking about that," she found herself saying. Then she hid her face against him, embarrassed at her confession. It was Diva's influence. The desire to explore sexuality, that Diva was sharing with her, was leading Aurora to deeper and more intimate as well as wider and wilder experiences.

Zed did not respond, unsure what she meant. After a while she began to tell him about Diva, and her curiosity about males. Without planning to do so, she found the whole story came out, and Zed listened carefully. Aurora realized that she wanted Diva to experience this thing too, this intimacy between a male and a female.

"Is there a way?" she asked cautiously. "Could you help her meet this

male, the one called Cal?" Zed had a slight frown, and she blushed. "I'm sorry, I shouldn't ask you to get involved. . . ." Her voice drifted off, embarrassed.

"No," he said, hurriedly. "No, please, I. . . ." He was always cautious with his words. This time, he didn't know quite how to respond. He smiled. "I'm glad." She mirrored his smile, and he leaned over to kiss her, a tender affection traveled back and forth between them.

"I'll find a way," he said, then his breath caught on a sharp intake, as he felt her hand on the stem of his growing erection.

There was an awkwardness between them when Zed entered Aurora's spacezone with the dancer. He was dressed in dark colors, his hair loose around his face, hanging forward as if he wanted to hide in it.

Diva was already there, sensual, awaiting. She eyed Cal openly, and he returned her hunger with blatant eyes, pacing in front of her, twisting and turning his lithe body beneath her eager gaze. She gave an open-mouthed smile, a guttural sound akin to a purr, and then forced herself to turn away from him for a moment. It was Zed she sought out.

"Thank you for arranging this." He nodded, awkwardly, in response. This was so utterly strange to them all.

"I have a gift for you," she continued, and presented him a smooth sheet of glass imprinted upon which was a still from her datareel. Zed glanced down at it; it was an image of Aurora.

"She was thinking of you, when I grabbed the image. She was telling me what it was like, to be with a male." Diva smiled to herself, as if satisfied, when she observed Zed staring intently at the still she had placed in his hand.

The image was unbelievably striking. Aurora was in profile against the red cushions. Her fur was thrown back and merged into the textures and colours around her. It made her look as if she was growing out of the surroundings. Her arms were bent over her face and chest at different stages and the pointing elbows suggested a dynamism over her still body. One hand trailed in her pelt, the other against her arched neck. Her lips were parted, her eyes closed. She had a look that Zed knew, intimately; he knew it not only from sight, but from all the other senses in his body. The strangeness of the experience affected him deeply, he felt as if he had truly learnt something new about her. He looked over to her; she was watching the movements of the others, distracted. He closed on her back, joining her.

Cal was leaning over to Diva. Diva grabbed him suddenly, around

the neck, and pulled his mouth to hers, kissing him. Aurora watched as the black and red clothes, the black and blonde hair entwined across the cushions. She felt Zed's hand slide around her waist and looked around as he caught her mouth with his; a slow, lingering kiss arresting her movement. He turned her body to face him and crept closer; his tongue teasing into her mouth as it opened to him. It was an exquisite kiss, the charm of the new intimacy between them laced its very touch.

Aurora heard the movements of the other two, and laughter. She drew her mouth from Zed's and turned to look as their bodies untwined again. Diva had pinned Cal to the floor, straddling his hips and holding his shoulders down. He struggled up against her body, bucking his hips and lifting her. She laughed delightedly. Aurora glanced at Zed, who was smiling, his eyes sliding back and forth to watch the other couple and Aurora's reactions to them. They seemed unaware of the onlookers, or at least, they didn't seem to care. Diva was slowly pulling the black shirt he wore from Cal's belted waist, all the time chuckling. Each slow, revealing tug aroused Aurora more.

Cal leaned back then, cast his arms out to the sides and closed his eyes. He looked beautiful, like some Human saint, vanquished by a dark force. Aurora was riveted. Diva pulled the shirt slowly undone, revealing the smooth, luminescent white skin of his slim chest. His body had a sleek, adolescent sexuality; nubile. Diva descended to his chest and teased his nipples with her tongue. He arched exquisitely, his expression pained. As Diva finally drew the shirt off him Aurora let her eyes run over the slim, naked torso that had been revealed.

She felt Zed's hand moving slowly on her arm again, but Diva and Cal still held her attention. Diva was taking her hands over Cal's body in deliberate, knowing movements, her hips shifting on his as she explored him. Aurora wondered if she should feel as if she was intruding, but didn't. She felt part of the scene, part of the arousal.

"Aurora," Diva called in a low voice as she lifted her mouth from Cal's. She turned and looked at Aurora with sparkling eyes. "Help me with Cal. . . ." Then she leaned forward and pinned his arms by the wrists above his head. An almost visible thrill tugged at Aurora and began to draw her forward.

She moved away from Zed and dropped to her knees, facing Diva, and took Cal's wrists into her control. Aurora looked down at him. He was a streak of white on the dark floor, pinned at wrist and hip by the two females. His lashes flew up suddenly and he looked into Aurora's

eyes. His expression was pure, innocent. He was their victim. She felt her mouth curl as she looked at him and he gently lowered his lids, but she could see that a slight smile teased the corners of his mouth.

Diva fell over his chest, kissing and nipping his skin with her teeth, her hands roaming around his body. He moaned and his arms twisted beneath Aurora's grip. Diva was moving down his body, her hands undoing his legholds. Cal's arms flexed then stilled, as if the nerves were in suspense a moment. As the black hair moved down again, his body arched, then began to stir gently in response to Diva's mouth on him. She was teasing the stem of his erection with nipping kisses and he writhed suddenly, the pleasure he was getting obvious in his expression. Aurora held his wrists tighter. The feeling of his transported body working against her while she held him captive was deeply satisfying. She felt a movement at her back and realized that Zed was standing behind her. She glanced around at him. He smiled at her and knelt down, climbing his knees around the outside of hers, enclosing her body with his, his hands caressing her breasts, his face against her fur, as she leaned over the prone male on the floor. It was so very delicious. Her breasts leaned into the caress, her hips swaying back to nestle against his.

Diva had taken Cal's erect penis in her mouth and was drawing him off with long slow sweeps back and forth. Her black mane was splayed out across his white skin, like a wave of dark shadows creeping across a dazzling starlight. Cal's arms lifted and struggled beneath Aurora's hands, his head moving gently from side to side as his body went with the rhythm of Diva's mouth. Aurora felt power surge up in her. She was aware of Zed at her back, but was focused on Cal. She wanted to touch Cal too and held his wrists with one hand while the other went to his face. She stroked his cheek and slid her fingers into his mouth as his lips parted. Her fingers ran along the inside of his lower lip. He moaned and looked up at her pleadingly. His teeth grazed her finger lightly and as she glanced up she saw that Diva was moving frantically on him, her fingers clawing at his hips. He was about to come.

Aurora fell on his mouth, plunging her tongue into it and kissing him deep. Zed was stroking her hips and at each stroke she plunged her tongue deeper against Cal's. As his body flexed and he came into Diva, his mouth reached up to Aurora, meeting her kiss and holding her with it until she finally let his wrists go and slid back away from him.

Diva was climbing across his chest with a line of sticky kisses. Cal let his freed hands creep down toward her and hold her as she came up to

his mouth, then he rolled her over and she laughed in delight as she fell back to the floor. Aurora watched again as they kissed, and as Cal's hands began to explore Diva's body. At the same time she was aware of Zed, still behind her, caressing her body. She glanced back. He was waiting for her attention, a smile apparent on his face as he observed her with the others. She was aware that the arousal she felt was showing in her eyes and lowered them to his lips. His mouth was too inviting, she turned her body and leaned into his kiss.

"They must have so many Human genes," she whispered, feeling awkward once again. Zed brushed his hand against her cheek, observing her downcast tiger green eyes with affection.

"Let us be Human too, Aurora," he replied.

Aurora felt the bow of his erection straining against her. It had aroused him too, this strange inter-gender experiment, for the sake of pleasure, pure pleasure. She wanted him, she wanted Diva, and Cal too; the possibilities were endless. *Was this Human?* she wondered. But the question went unanswered and forgotten, as the hot hardness of Zed's erection pressed between her thighs. She lay down, pulling him with her, and gave herself up to the desires that had lain dormant inside her for so very long.

ANTHEM TO THE SUN

RAVEN KALDERA

The sacred king of ShadahKet went up to the top of Mount Kekauris, and it was not until sunset that he came down. He was going up on that mountain, one of the few on ShadahKet's flat river-slashed desert plain, to find out if he would be allowed to live.

Three hundred priests or more sat in vigil at the great temple carved into Kekauris's base, not moving even in the dead heat of the day save to take a little nourishment, brought to them by servant children who moved like brown gnomes through the crowd. Once in a while one would fan himself with a woven-reed sandal, and once I saw the high priestess herself, Isaurat, bend forward slowly until her head touched the matting thrown hastily onto the sand, but it was only for a moment, and she gracefully resumed her stiffly upright pose. All in all, it was a terribly boring and hot day for me, a day I'd consider a huge waste of time and tridee chip space. I was immeasurably grateful when the cliff shadows began to lengthen.

I wanted to take a walk, play solitaire, anything to break the heat and the monotony. Although a makeshift canopy had been thrown up for me, sweat was pouring down my pudgy out-of-shape body, I was almost out of drinking water, and I was damning Jesus to hell. Jesus Haldemann, that is—the desk chief who had given me this unholy

123

assignment. Just cover this sacrificing-the-king thing on ShadahKet for two weeks, that's all, just the human-interest bit, then maybe we can get you a combat assignment on the front lines. Right, Jesus. Sure. Three days and I hadn't been able even to get to the king for a little interview, or for that matter his grand vizier or the high priest of whoever-the-heck it was they were worshiping this week. I couldn't tell one deity from the other, thanks to Haldemann who shipped me out here with only two days to prepare and no available braintapes of Ket culture. And I could tell by now that most of today was going to have to be edited out.

Tish Lu, the Federation consul, had pulled few strings with Isaurat and gotten me a few square feet of sand and this canopy to watch the going-up-the-mountain thing. Isaurat wouldn't interview, either; looked at me like I was distasteful and wouldn't speak Standard in my presence, which I knew from Tish she was perfectly capable of. She obviously hadn't dealt with implant reporters before; the way she treated me was going to be the way the world saw her. Or maybe she just didn't care. No one on this backworld seemed to care very much about anything offplanet anyhow.

The sun was creating a red halo when the king and his small train of followers came in view down the winding road. I strained to see him, careful to hold my head at the right angle. Golden skin that gleamed in the sun, hair darkest blue. He was holding his head up, ramrod erect, not looking at the great white-clad swath of priests waiting for him like a huge flock of predatory herons. Did that mean he'd been given a good sign, or was it just bravado? I held my breath so as not to let the noise of my bodily functions interfere with the long-range sound, and waited.

The king took the hand of his little queen and swept away into the waiting palanquin without a word.

"What do you mean, three days!" I raged at Namir, my interpreter. "It's already been three days! What's the point? I don't understand."

He sighed and rolled long-suffering eyes at the ceiling. Namir was a junior priest, assigned to me by Isauret, and I sometimes got the feeling that chaperoning me was considered a punishment, or at least a hardship duty. "It's the custom," he said in flawless braintape Standard. "The King is not required to speak the message of the gods for three days. He will address the people at sunrise on Hri. We will pray for him in the meantime."

Pray for him. "Why?" I demanded, and then tried to lower my tone to something reasonable, like an anthropology professor. "What's the basis of this custom?"

"King Ausir has heard the gods' mandate. Now he must make peace with it."

I leaned forward, sniffing a human interest point. "Do you mean he can throw it out the window if he doesn't like it?"

Namir looked shocked. "The King is the leader of the Faith, the child of the Gods he serves. He would no more disobey them than cut off his own hand."

We'll see, I thought cynically. And as I left Namir to return to the hotel, I muttered, "Theocracies!" in Pru and spat. On PrusKim, where I was born and raised, that's an obscenity.

The hotel was poorly cooled and smelled bad, but I didn't care about anything at the moment except getting a decent drink. The spaceport bar was decorated in twentieth century fake jungle movie, and was nearly deserted. Good. I nursed a Chiban khru-and-tonic for about a half hour, staring at my reflection in the mirror behind the bar. Unlike the population of this godforsaken planet, which tended to be small, slender, and delicate, with hair like long black horsetails and exotic, chiseled faces, I was large, bulky, and hairy. PrusKim had been settled by emigrants partly of German and partly of Korean extraction, and my hair and beard remained dishwater blond while my almond eyes had a slight epicanthic fold. Yep, that's me, one of the Korean Krauts, from the planet of hard-working cynics who'd shoot you as soon as look at you when you came to their door selling religion, trapped on a planet where they rewrite the calendar every time a priest has a nightmare and calls it a "vision."

I'd had my skin dyed darker to protect it from the sun; it was about the same caramel shade as the natives now, but there was no way I'd ever have their oiled grace, their angular beauty, their dramatic cheekbones. Their seeming complete lack of cellulite. I had been eyeing them for some time under their transparent caftans. The women were as slim as boys and the boys made your crotch twitch every time they bent over.

And, worse luck, there was apparently nothing even remotely like a red-light district in this place. I'd asked Tish Lu in a roundabout way, and she'd given me a pained smile and said that the Ket natives don't believe in messing with offplaneters. Oh well. I supposed it'd be worse

on the front, where the Oxa'ang were making chop suey out of our
boys, or so they were saying. But there'd be action there, not just sitting
around in hundred-degree heat.

There was one other thing, of course, that made me stand out. That
was the lenses set into my forehead, like a line of blued steel jewels just
above eyebrow level. The sides of my head were shaved where the
soundspots glinted, and a fashionable-on-Gorion faceted plate covered
the comlink access plug on the left side. Everything I saw was down-
loaded into the small chip under it, inside my skull.

Finishing my drink gave me the courage to face my flea-ridden hotel
room. To my surprise, it wasn't empty. A diminutive figure sat stiffly on
the bed, ramrod posture like all those priestesses. She—I could guess it
was a she from the tiny delicate hands—was swathed in draperies from
head to foot. Black ones, which was unusual. I'd never seen a Ket in
black.

"Milady?" I asked, taken aback. "I—er—perhaps you have the
wrong room, Miss—"

"Mr. Andreas Kiang of Tri-World News?" she asked, her voice high
and clear.

"That's me." I closed the door behind me. "What can I do for you,
milady?"

She unveiled her head then, and I both caught my breath and sent a
mental message to turn up the lightmeter in my headlenses. It was the
queen, sitting on my verminous hotel bed. How long had she waited
there, I wondered. She was tiny, almost childlike in the way she drew
up her knees, but her voice was not young at all. "I have a favor to ask
of you, Mr. Kiang, and in return I will arrange the interview with my
husband that you so desire."

Hot cookies. "I'm at your service, Your Brilliance." No kidding, that's
the polite title for Ket royalty. "Whatever I can do. . . ."

"It is very simple. I would appreciate it if, after you complete the
interview tomorrow, you would speak to him of offworld things.
Politics. Arts. People. Interesting places. You are a reporter, you can do
this, yes?"

I blinked. Tomorrow? "Why, certainly, milady. If you think your hus-
band will be in the least interested." I realized too late that my tone had
conveyed the entirety of my opinion of ShadahKet insularity.

"He will be interested, Mr. Kiang. My husband . . . has been offworld
before."

"Yes, I'm aware. The modifications on Maitel." Every monarch of

ShadahKet is sent, briefly, to the very expensive cosmetic center for body modifications. They are made over to more closely resemble the gods they worship. As I've said, ShadahKet has a strange attitude toward offworld technology.

"It is more than that . . . but I cannot say more. Please, Mr. Kiang. I wish to give him . . . to show him . . . that there is more in the universe to see, to know. More than he dreams."

I was beginning to understand. "Where I come from, that would be called 'influencing the course of media events,' milady." If only subtly. I was realizing, also, that this entire conversation might have to be edited out. Still, an interview was worth it.

She seemed distraught. "Do not ask him what today's message was! It would be unfair . . . pressure. He will announce it when it is time, as decreed by custom. Please, Mr. Kiang, just . . . talk to him . . ." She trailed off, pawing distractedly at the air with one slim brown hand. I could tell that the steadiness of her voice was failing her, and that she despised her own weakness.

"It's all right, Your Brilliance," I said as gently as I could. "I'll do it. I'll do it."

Day Two. The King was tense, nervous. I felt almost as if I were confronting a deer, shy and apt to bolt. He was young, too; if he was twenty-one in Standard years I'd be surprised. It made me remember his possibly impending fate with more force. "Why is it necessary, Your Brilliance?" I asked, as neutrally as possible. Don't let the natives know what you really think.

He turned away so that his profile was backlit by the morning sun. "Once every forty-nine years, it has to happen. If a king is to be more than just a petty tyrant, he must always be aware that he may well have to give his life for greater things." He turned his dark eyes toward me. "It is an act of magic, you might say. The greatest act of magic that anyone can do to achieve a goal."

"And your goal, Your Brilliance?"

He sighed. "Please, Mr. Kiang. I know you are unused to our titles, and they sound like such a trial to your tongue. Every time I hear you say, 'Your Brilliance,' I feel as if you are eating a sourfruit first thing upon awakening." There was a twinkle in his eyes as he said it, and I had to smile.

"What would you prefer I call you, Your . . . ah." I trailed off.

The King turned his eyes away from me, frowning a little. "I don't

suppose there is anything appropriate, is there?" He paused, and I watched him closely. His skin was gleaming gold, not yellow, but metallic, with a glitter like a statue, as gold as the elaborate earrings that hung against his neck. Hair of an iridescent dark blue was sheared off at his shoulders and hung in a fringe across his forehead, and his fingernails were also dark gleaming blue. None of it was paint; it was the body modifications. I wondered what it must be like to have looked like a living statue since childhood. He turned his gaze back to me, penetrating under high winging blue eyebrows and lashes. "When I was a boy, before I ascended the throne, I was called Seshi. Perhaps you could simply call me by that name, Mr. Kiang."

All right, I was touched. "Andreas, please. Do you miss those days, before you were king?"

His long, graceful hands fiddled with his perfectly pleated white kilt. There was a large signet ring on one forefinger. "Before I was king?" he asked, rhetorically. "I was nothing then. Nothing. I barely remember . . . You must understand, I took the throne quite young." His dark eyes were on me again, and I felt an odd thrill. King Ausir—Seshi—was an archaicism come to life. If you blurred your eyes a little, you could imagine he was a living god. The viewers would love him.

We talked a little more, about his hopes for ShadahKet, his four children, his three wives. Then, conscious of the queen's bargain, I slowly shifted the talk into comparisons of his world geography with others, then customs of other worlds, then the politics in the local Nebula. The queen had been right about one thing; he lit up like a Blink machine. The living statue melted into an animated young man as he questioned, marveled, frowned. Most of the frowns came when I spoke of the war with the Shi'ir. He seemed mostly worried that they would defeat the Federation troops on the front and then invade other planets. I tried to assure him that Oxa'ang troops were no match for our ships, and I got the chance to talk up quite a few space battles in the process, never quite mentioning that I hadn't actually managed to see any of them yet.

His intense gaze hardly left my face the entire time, and in retrospect I know that even as I drew him in, I was drawn in myself by the golden boy-king in his otherwordly palace. When the sun had passed overhead and servants brought the noon meal, I realized that we had been sitting alone for some time, talking as if the idea of an interview had never occurred to us. Then Seshi threw me a curve. "Would you like to take lunch in the bath, Andreas? I often do, this time of the day."

A dozen thoughts ran through my head, not the least of which was

the nagging worry that my copious Prussian sweating was offensive to him. Still, when in Rome . . . I agreed, and found myself naked and chest deep in an inlaid pool, trays of food and drink floating between us. He dismissed the servants with a gesture and proceeded to have me try each bit of food. The viewers were going to love this, too, I thought. "Try this," he said, holding up a slice of apricot-colored fruit. "It's actually native to this world, not imported with the coming of my people." He held it out to me and I instinctively opened my mouth. Seshi fed it to me, and his fingers lingered on my lips before they pulled away.

Whoa, Andreas. I pulled in the reins on all my mental horses at once. Don't misinterpret customs. These people walk around in practically nothing and it's not sexual, and this is their king, for Murphy's sake. But those golden fingers were trailing down my chest and over my belly, and then they found my cock, which had already given its own interpretation of the events by becoming embarrassingly hard.

I opened my mouth and closed it, like a fish out of water. "Your Brilliance—Seshi—" I gasped. This was not the way most of my interviews ended.

He looked up at me through wet bangs. "I have been wondering," he said, and then ducked under the water in a cloud of midnight blue. The food trays bobbed lazily toward the other side of the pool and I made a whole range of inarticulate noises as his mouth slid down over my cock. He blew a whole mouthful of bubbles out around it—a sensation that if you have never felt before I sincerely recommend—and then emerged from the water in a splash. Like a painted god rising from the sea.

"But—" I tried once more "—the servants—your wife—won't somebody mind?"

Seshi tossed his wet hair out of his face and lifted his blue eyebrows in a quizzical expression. "I am the king," he said as if it was self-evident. Then he pulled himself up to sit on the edge of the tub and his genitals were on a level with my face. Yes, his cock was gold, and hard, like some finely carved fertility wand. Almost unreal, like a delicate toy. There was no hint of pubic hair. I couldn't resist. I put my mouth on it, half expecting it to feel smooth and cold, but it was warm flesh. I sucked it in to the hilt, tonguing it, licking like a cat. Seshi didn't touch me, only sat completely still with his harsh, ragged breathing being the only sound in the room.

I came up off him and looked up. His head was flung back in serene rapture, long golden earrings brushing his shoulders; when his eyes

opened to look down at me and smile I had that strange thrill again. I was touching a living god.

Living god! I was sucking the cock of a rich pampered kid who was probably going to be dead in two days if I didn't do something about it. And suddenly I wanted, very much, with all my heart and soul, to stop him. It was more than just the sentimentality of sex. If Seshi left the universe, we would be poorer for it.

I pulled myself up onto the tiled floor beside him and his hand went to my groin. The wet flesh skidded in his fingers, so he reached for a jar of pale translucent stone and dipped out a handful of perfumed salve, lubricating me. Those delicate, sexy fingers stroked me until I was closer to losing control than I felt I wanted to be. There was something else I wanted.

I took his wrist and removed his hand from my cock; he looked up at me quizzically, high winging eyebrows arched, but before he could ask I had pushed him backwards onto the wet tile floor and reached for the unguent jar. I greased him as he had me, but instead of touching him purposefully I teased him, hard and then soft strokes. Then my fingers slipped down over and beneath his naked golden balls, finding the puckered hole beneath them. He gasped and his eyes flew open, wide and dark; I put a finger to his lips and he silenced. Then I slathered unguent between the cheeks of his tight firm ass and wriggled a finger in.

Seshi's hands clenched and unclenched on the wet tile, but he didn't stop me. I slowly worked in two fingers, then three, then I spread his legs as wide as they would go, and put the greased head of my cock against my hand. In a smooth motion I had learned from years of boy-whores on primitive planets, I removed my hand and slid my cock in to replace it. He gave a whimpering inarticulate cry as my cockhead passed his sphincter and flailed the air as if it would give him purchase to hold on to. I caught his wrist, as gently as possible, and let his arms go around me as I started to pound into his warm wetness.

Don't think it was worship, this act of sex, or service to a king's whims. Whatever it was for Seshi, for me it was on some level a meeting of civilized technology with primitive superstition. I, the atheist, the unbeliever, the voyeur who witnesses and is not touched, had taken the living god-king, worshiped by an entire planet, had turned him upside down and fucked him up the ass on the floor of his pretty little palace. And I was filming every moment for posterity.

It was the hottest thing I'd ever done in my life.

Later, when we lay curled together on the flat uncomfortable matted box that these people called a couch, Seshi lightly touched my now-limp genitalia and nuzzled my chest hair. "Geib," he said. "You are my Geib."

"Who?" I asked.

"Geib, the earth god. Do you know why we build all those great tall obelisks?"

"No. Why?"

He nuzzled me some more. "They are dicks for the earth god, so he can fuck the gods of the sky." As he finished speaking, my eyes suddenly refocused and I nearly sat straight up, dislodging him. The last sentence had been spoken, not in Ket or Standard, but in the underworld street cant of Ganymede and Canobia.

"What the—" I couldn't have heard wrong, I know that speech. Anyone who has trailed over half the seedy spots in the galaxy has to know a little of it, and his accent was natural.

"Andreas! Don't be upset." Seshi reached up and pulled me down. "It's a secret. No one else knows about it but myself, the queen, the grand vizier, and the priestess Isaurat. And now you. I was born on a small station, a refugee, a squatter. My mother was one of the homeless who travels from station to station, hides and steals. She died of drugs when I was seven, and I would have died too except the slavers found me and sold me to the grand vizier."

"And they made you king?" I was incredulous.

He shrugged, his expression on of wistful humor. "I would be king in the forty-ninth year. Why waste a native Ket?"

I felt anger boil up inside me. "You don't have to do it," I said harshly. "You can say no. It's your choice. Don't you understand? I don't care what you think you heard on top of that mountain, Seshi—"

"I heard nothing," he said simply. "I waited all day, and I heard nothing. Perhaps it is because my blood is not of this world. Or perhaps the gods are truly allowing me to make a choice."

I grabbed him by the shoulder, wanting desperately to get through to him. "You heard nothing because there is nothing," I said. "It's all crap. Crap! Used to keep people in line with fear." I paused, realizing I was probably out of line, and went on in a lower tone, "Please. Don't die for nothing."

He was staring at the horizon through the arched window; the sun was starting to set and the palm-strewn courtyard was already in shadow. Then, quickly, he turned his eyes to me with a glance that was

almost flirtatious and said lightly, "My Geib, I have no intention of ever dying for nothing."

I was so relieved that I didn't hear the emphasis on the last word. Or perhaps I didn't choose to.

Day Three. I came to the palace first thing in the morning and Seshi was waiting for me with his glowing starry smile, robed in a diaphanous white mantle that he tossed aside the moment we were alone. He had limned his eyes with green and tucked a lotus blossom into the cloth band that held back his hair. I had an odd embarrassed feeling; it had been a long time since a woman had dressed up to please me, and I wasn't sure how to take it from a man. He was on the couch with his legs spread and cheeks greased so fast you would never have known his ass was virgin only yesterday. We fucked for three hours. I drove into him while he wrapped his legs around me in an almost rib-bruising grip; I put him on his knees and took him from behind ("like my hounds," he laughed); he straddled me and sat on my cock like a victorious kid that has just won king-of-the-mountain. For that afternoon, it didn't matter that I was unhandsome at best and at least twice his age. After I had spent all my rounds, I took his gold cock into my mouth again and this time sucked him until he came, calling me again by a god's name as he spewed hot come into my mouth.

We walked in the gardens that evening, the oil torches reflecting off the pools lined with fig trees. Seshi's hounds tumbled and panted around his feet as he went, as sleek and quick as he was himself. He laughed and patted them, gave them little treats from supper's leftovers. "If there were time, I would take you up to the mountains myself," he said, gesturing at the horizon. "You can see nearly to Abdiz from here. It is so beautiful, the rivers like bands of green in the red deserts, with the thin blue line in the middle." His hand brushed my shoulder affectionately. "I would have you love my land a little before you go," he said, almost shyly.

I looked down, feeling like a callous jerk. "You're here," I said. "That's enough."

"But it is not just the people of ShadahKet. I was born offplanet. You are all my people, in a way. I have a responsibility to all humanity," he mused, frowning.

Like the jerk I was, I laughed. "I doubt there's much you could do for the rest of humanity, Seshi. You worry about yourself first. Everyone

else can wait their turn."

He was looking at the horizon again, wrapping his arms around himself as if he were cold in spite of the heat. "But there is so little time," he said quietly, to himself. Then he turned to me and seized my hands in his. "Stay with me tonight, Andreas!" he whispered fiercely. "Just this one night. If there is no more time for us—if you must leave—at least there will have been tonight."

I wanted to ask about the queen, his reputation, but my words were swallowed by his lips as he kissed me for the first time. I had fucked a lot of boys and a few men, from high school on, but we were stoic, undemonstrative Korean Krauts and none of them had ever kissed me before.

But there's a first time for everything, I guess.

I was awakened early the next morning by my com going off, sending a buzzing through my skull like a swarm of angry hornets. I cursed and sat up. The last two days with Seshi had practically made me forget that I was technically here on an assignment, that I had bosses to report to. I moved out of range so that no one could see Seshi's sleeping form next to me and keyed on my projector. It shot a screen-sized hologram out about five feet in front of me, and conveyed my image to the sender simultaneously; in a moment I was staring at the stubbled jowls and close-set eyes of Jesus Haldemann. "Don't you know it's barely dawn here?" I snapped. "You've got a galaxy-wide time zone program. Use it."

His eyes were bloodshot and carrying dark bags. "No time. We got trouble. I need you out of there by tonight."

It was like a pitcher of cold water poured over me. "What—"

"It's Marquess and Ashida." He cut me off. "The battle's turned. Front line's been pushed back. The Oxa'ang cut into our territory yesterday, took a lot of casualties. Ashida and Marquess were covering the story; they got blown up when the enemy took out a civilian shuttle."

"Shit." I let my breath out in a long hiss, chilled.

Haldemann wiped the sweat off his jowls. "I need you out there, if you can get off the planet by tonight. Pick up the freight out of Junket in twenty-eight hours and you can be there by thirty-four."

"Answer me honestly, Jesus. How bad is it? Not what we're telling the viewers, the real dish."

He paused for a second. "It's bad." Another pause. "Thirty-four hours. Be there." The transmission went to static and I killed the holo-

gram, cold to the roots of my hair. Be careful what you wish for, boy.

Seshi was awake and standing by the bed as I turned, clutching his robe around him. His eyes were big and I remembered that he understood Standard, that he was no primitive fool. "It's all right," I said. "It's the other side of the galaxy. They won't get near ShadahKet for decades."

"But they are killing people over there," he said.

"Yes, but—"

"And you are going there," he said, coming toward me. "You are going there . . . to watch." One slender gold finger touched the lenses on my forehead.

"It's my job," I said. "Don't worry, I'll be all right, I've been out under battle conditions before," I lied.

Behind Seshi, a few figures appeared in the doorway. Servants, bearing his wide jeweled collar and headdress, oil for his hair, a freshly pleated kilt. Two figures, behind them, one tall and draped in white, one diminutive and veiled in black, backlit by the sunrise. Isaurat and the queen. "Your Brilliance," Isaurat said quietly, "it's time."

He nodded, his fingers slipping to my cheek. "And now I know what I have to do," he said. "You have shown me. It is true, I considered the coward's way out. I did not want to die for . . . for nothing." He swallowed. "But now I know that only I can save—"

"Seshi!" I croaked, my mouth dry. I grabbed him by the shoulders. "Seshi, no!"

"Andreas, my friend," he said. "More than dear to me. We all do what we must. And you, my friend, must be the sacred witness." Seshi took my face in his hands and kissed me one last time, and then King Ausir allowed himself to be led away by his servants.

Only the queen stood in the doorway, draperies blowing gently around her obscured face. I clenched my fists. "I've been set up, haven't I?" I snarled.

She was silent for so long I thought she was never going to speak, and then she lifted a hand to her face under the veil. "It is our custom," she said. "There is always one chosen to make the king question his choices, a devil's advocate, you would say. It is a holy duty," she added, as if it mattered.

"And has one ever succeeded?" I asked bitterly.

A light shake of the veil. "No. Never." She sighed. "The gods always win out in the end."

Did I watch while Seshi made his speech to the people? I did. I stood on the balcony with Isaurat and the courtiers, I recorded it all. Was it callousness, the ruthless voyeurism of the reporter, the professional witness, the intellectual observing the barbarous rites of primitives? Was it simply that old habits died hard? No. In the end, I was there because Seshi wanted me to be.

I still own a few copies of that tape. I play it back every now and then, watch Seshi—King Ausir—in his regal finery, skin almost blinding in the light of the sun, hair like liquid lapis lazuli. I watch him turn and meet my eyes at the end of his speech—he knows enough to look at my lenses, too, so I'll see him later, I'll remember—and speak to me. And then I watch him leap onto the high railing of the palace balcony and, like a gull, leap into the air, robe fluttering out like white wings. Face blazing like a comet, like a shooting star. I watch him leap, and I watch him fall, silhouetted against the rose-gold light of dawn.

I'm glad the balcony did not allow me the right angle to see where his body hit the ground below.

Jesus Haldemann contacted me again while I stood waiting for my flight that evening, a grey, shocked zombie on the landing pad. In a heartbeat, it seemed, the situation on the front had changed, and through a fluke. The sun around which the homeworld of the Oxa'ang orbited had suddenly gone nova, exploded, eaten their world and all its attendant stations. The backbone of their armada had scattered like bewildered bees when the queen is destroyed. It was over. The scientists were all gearing up to get permission granted to check out the rapidly shrinking sun, find out how it possibly could have pulled that trick. Jesus was sending someone along and wanted to know if I wanted the assignment.

After I play back Seshi's death, I always run the tape backwards to hear his words as he turns to me. The cynic thinks that he wanted posterity to know, to understand. The rest of me knows that my lover gave me a private message that only I would hear. "Sing an anthem to the sun for me, Geib," he says. "Any sun, it doesn't matter which one."

I still don't go to church, and I still don't touch religion, but there's something—someone—I have to admit I believe in now. There are a lot of worlds in the galaxy, and I've seen quite a few of the stars they fly around. And when I find myself under a particularly bright day, I find

a place where I can lay on my back, grease up my hand, and imagine I see the graceful, soaring figure of a hawk gleaming among the bright rays, and my cock sings a bright, hot anthem to the sun.

Soul of Light

Catherine Asaro

The two Jagernauts were watching Coop.

He didn't understand why he had caught their interest. He had a permit to display his light sculptures in the plaza. Although he had applied for the permit six months ago, he had no connections to speed its acceptance, so he had waited, striving for patience. Today he finally had a licensed place under the airy colonnade in this plaza known as Plaza, in the even more inventively named city of City. And now two Jagernauts were watching him as if he didn't belong here.

Coop tried to ignore them. Maybe they were only enjoying the gorgeous day. It was perfect. But then, so was every day on the Orbiter space habitat.

Graceful buildings surrounded the plaza, luminous blue or violet, with elegant horseshoe arches. A rosy bridge drifted to the ground from the upper level of a radiant white tower. Gold, blue, and green mosaics tiled the courtyard, and a colonnade of blue columns bordered it. The sky arched above him in a dome, far above, four kilometers to be exact. The Sunlamp hung low in the west. A group of people were hiking across the sky hemisphere, which everyone called Sky. Their bodies were hardly more than specks from this distance.

Coop looked around his exhibit, all holo-sculptures of exotic

worlds. These pieces showcased his best work, much better than the military holo-banners he designed to support himself. He loved making the sculptures. Unfortunately, they didn't pay his rent. He smiled to himself. Maybe if he renamed all his pieces Art, the Orbiter citizens would buy more of them.

The Jagernauts, however, were still watching him. His smile faded. What did they want?

The male Jagernaut was standing across the plaza, shadowed in the colonnade's overhang. Coop couldn't tell much about him, except that he was huge and wore a uniform. He drew Coop's attention like a magnet. It took a conscious effort to pull away his gaze.

The woman was in the other direction, leaning against a blue column, close enough that he could see her well when he snuck glances her way. Although her clothes resembled black leather, he had heard that the synthetic cloth and implanted web systems of a Jagernaut's uniform protected a person far better than real leather. Her snug pants tucked into black knee-boots, and the sleeveless vest fit her like a second skin. She had gold bands on her upper arms, indicating she was a Primary, the highest Jagernaut rank, similar to a naval admiral. Her black hair fell to her shoulders, framing a face with strong beauty. Like all Jagernauts, she was in excellent shape, her well-curved body taut with muscle.

Pedestrians flowed through the plaza, coming and going, or browsing exhibits. Coop turned to a woman admiring his sculptures. He didn't make a sale, but when he glanced at the Jagernaut again, she had focused her interest elsewhere. His tension eased. It must have been only coincidence that she had been watching him.

Just as Coop convinced himself that he was safe, the Primary turned back to him. He struggled to quell his surge of panic. Jagernauts were officers in Imperial Space Command. They served as intelligence operatives, Jag fighter pilots, and military advisors. Her rank indicated she stood high in the hierarchy on the Orbiter, this idyllic space habitat called home by the Imperialate's elite. Coop was here only on the sufferance of the politicians, VIPs, and nobles who dwelled inside the habitat. Had he offended someone? He couldn't imagine what he might have done, but his low status left him vulnerable to the caprices of the Orbiter's citizens.

Stop it, he told himself. Why would they send the equivalent of an admiral to apprehend a nobody like himself? It was absurd, really. Surely she had no interest in him.

Suddenly the woman pushed away from her column and headed his way. Coop froze. He couldn't run; he would rather face a marauding Jagernaut than abandon his treasured sculptures. So he stayed put, surrounded by the waist-high crystal columns he had set up to display his work. *Stay calm*, he thought. *You've done nothing wrong.*

The Primary stopped a few meters away and studied one of his works, a starscape he called *The Eternal Shore*. It rotated above its column, a spiral galaxy aglitter with gem colors, superimposed on a seascape with waves tinged red by an impossible trio of setting suns.

Doing his best to look innocuous, he walked over to her. "My greetings."

The woman glanced up. She stood half a head taller than Coop and moved with a grace that suggested martial arts training. Next to her muscled beauty, he felt self-conscious about his lithe build, which made him a good dancer but would never confer much strength. The exercises he did every morning gave him flexibility rather than bulk.

"This sculpture is incredible." Her voice was low and throaty. "Are you the artist?" She indicated his light signature in the starscape. "Coop?"

"Yes. That's me." He almost winced at his stilted tone. "Is there a problem?"

"Problem? No, I don't think so."

His shoulders relaxed. Maybe she just wanted to look at his art, perhaps even buy a piece.

"Do you have permission to sell your work here?" she asked.

Something *was* wrong. "Yes. Of course." Coop's pulse jumped. He had heard the horror stories about Jagernauts taking away hapless citizens who trespassed on unwritten codes of Orbiter life. Why lay in store for him now?

Then again, those stories might not be true. At times he suspected it entertained his new friends to tell him tales of dire shenanigans committed by purportedly depraved Jagernauts. This one hadn't actually done anything more nefarious than ask if he had a permit.

Coop unhooked the cube on his belt. As the Jagernaut took it from him, her fingers brushed his hand. He wasn't sure if her touch had been intentional or an accident.

When she clicked the cube into the gauntlet on her wrist, lights glimmered on the gauntlet, and a holo appeared above the cube, showing his head and shoulders. Coop flushed. Images of himself always embarrassed him. Rather than a grown man of twenty-four, he looked

like a boy, with yellow curls spilling down his neck, large blue eyes, and a face too angelic for people to take him seriously. The diamond ring in his ear sparkled. He supposed if he wanted to look more his age, he could cut his hair or wear clothes more severe than the blue trousers and billowy white shirt he had on today. He felt comfortable this way, though, so he had kept his style.

The woman studied his holo. Her gauntlet would be reading the cube and sending data to the biomech web within her body, which interacted with her brain. It gave him an eerie feeling, knowing she was part machine.

Finally she gave him back the cube. "It looks like everything is in order."

He began to feel more comfortable. "Yes, ma'am. I followed all the procedures."

"Did you now?" Her gaze traveled down his body, then came back to his face. "I think you break rules just by standing there."

He almost dropped the cube. "What?"

Her smile flashed with mischief. "I had more pleasant arts in mind."

Ah, no. So that was it. He had so far avoided Orbiter citizens with amorous intent, but one this powerful had never approached him before. Although he could admire her beauty in a theoretical sort of way, he doubted he could give her what she wanted.

"Trouble here, Primary?" The deep voice came from behind them.

Coop jumped, spinning around. The other Jagernaut stood only a few steps away. The impact of his presence hit Coop like a tidal wave, almost physical in its intensity. The man towered, over two meters tall, with a massive physique. He had classical features, stunningly hand-some, chiseled from gold. His metallic gold hair curled close to his head, glinting in the light from the Sunlamp. Metallic highlights gleamed in his skin. His eyes were large and violet, and fringed by gold lashes. Coop's startled surge of admiration had nothing theoretical in it this time. A thrill of excitement raced through him.

"No trouble, sir." The woman saluted, making two fists with her wrists crossed, then raising her arms to the Jagernaut.

The man grinned. "Relax, Vaz." He spoke with a cultured accent Coop couldn't quite place. "We're both off duty."

The woman, Vaz apparently, lowered her arms. Although she smiled at the man, Coop had the impression she was sending the fellow a less friendly message: *Get lost. I saw him first.*

Coop considered trying to slip away while they argued over him. He

could vanish as if he had folded up into one of his holo screens like a flick of laser-light. He discarded the idea, though. It wasn't only that he couldn't leave his work. He also doubted he could hide from two Jagernauts.

Besides, he wasn't sure he wanted to hide.

He didn't know what to think about these two. Vaz had one of the highest possible ISC ranks. If she saluted this man as her superior officer, what did that make him? He had a Jagernaut insignia on his chest, but his uniform was gold instead of black. His tunic went over trousers with a darker gold stripe up each long leg, and his heavy boots came to his knees. The uniform had almost no markings, only two gold bars on each shoulder. Maybe he was a Jagernaut Secondary. But no, Secondary ranked lower than Primary, which meant he would have saluted Vaz, not the reverse.

The man looked around at Coop's work. "Did you do these?"

"Yes, sir," Coop said. The shorter he kept his answers, the less likely he was to say something awkward. He couldn't stop staring at the Jagernaut.

"They're well done," the man said. "I'm surprised I've never seen your pieces in a gallery."

It flattered Coop that the Jagernaut liked his sculptures. "I don't have any contacts." He wanted to shut up, but he was so nervous he kept talking. "I've only been on the Orbiter a few months. I support myself designing holo-banners for Imperial Space Command."

"ISC propaganda banners?" The man shook his head. "An appalling waste of your talent."

Coop almost said, It really is boring, but he held back, doubting it was a tactful response under the circumstances.

Vaz was watching them. "It's almost time for you to close up," she told Coop. "Your permit says you have to be gone by the evening shift."

Coop realized then what they had been waiting for—the time he had to leave. He blushed, feeling his face heat. The male Jagernaut regarded Vaz with a speculative gaze. Again Coop had the sense that a message passed between them, this time an agreement in their dispute over him.

The man gave Coop with a slight smile. "Have you had dinner yet?"

This was going too fast. Coop could barely push out his words. "I wasn't planning to eat."

"You have to eat," Vaz said. When Coop turned all the way toward her, she looked him over with unabashed appreciation. "Keep that

beautiful body of yours healthy."

Startled, he stepped away from her—and backed right into the other Jagernaut. The man caught Coop's upper arms, holding them in his huge, muscular grip with unexpected gentleness.

"Vaz, slow down," the man said with a hint of exasperation. "You're scaring him."

"Don't be afraid, beautiful boy," Vaz murmured.

"Just come to dinner with Vaz and me." The man's voice rumbled behind Coop, deep and husky. "That's all. Just this one night. We won't hurt you."

Coop stood still, acutely aware of the man's massive height at his back, like a wall of muscle. Coop didn't even come up to his chin. Contained energy. A fantasy flashed in his mind, those powerful arms embracing him. He didn't know whether to be aroused or alarmed.

The Jagernaut rubbed his hands along Coop's arms, his touch alive with a controlled, seductive strength that made Coop's breath catch. He stared at Vaz, wondering what messages she and the man were sending each other now. Jagernauts had infrared units implanted in their bodies, which meant their biomech webs could communicate with wireless signals. They blurred the borders of humanity; were they augmented humans or human-shaped machines?

You're so far out of your league, you're drowning, Coop thought. He had never before met anyone even approaching the status of a Primary, let alone whatever rank this man claimed. The two Jagernauts also seemed to know each other as friends, which suggested they moved in circles he couldn't imagine. He would be crazy to become tangled up with them. But if he told them no, he might spend the rest of his life wondering what he had lost.

Vaz was watching him with a curious gaze. "You're so quiet. What are you thinking?"

"I'm not sure." What would happen if he turned them down?

"It's your choice," the man said. "No repercussions if you say no."

Coop tensed. *Did they know his thoughts?*

The woman's voice softened. "Just your moods." She smiled, her eyes glossy with desire. "Except when you shout your thoughts at us. Like you just did. We can't usually pick up even that much, unless the sender has the same neural augmentation as we do."

The man bent his head, his breath stirring Coop's hair. "Come with us. I'll take you to the Regency."

The Jagernaut's exhalation against his neck made Coop's skin tingle.

So did the thought of the Regency. Its clientele were so far above him, he couldn't imagine being in the same building with them. Interstellar leaders and royalty dined there. Maybe the offer was a lie, so Coop would go with them. For all he knew, these two would sell him as a pleasure slave or do some other harm.

But why would they lie? They could have their choice of companions. They needed no deception. Nor did his fear about their selling him have a logical basis. Imperial Space Command existed to protect Skolian citizens against the Trader Empire, with its thriving slave trade. It would make no sense for these officers to sell him to their enemies. Besides, didn't ISC expect Jagernauts to live by a code of honor? Certainly his health would be safe with them; ISC officers had to pass strict medical exams to keep their jobs.

The man brushed back a wayward lock of Coop's hair. "Take your time to decide."

Coop couldn't think straight now, with the male Jagernaut touching his arms and face, and Vaz gazing at him as if he were a delicious meal. He had no referent to judge their tantalizing invitation. On his home planet, Phosphor, he had lived a sheltered life, going to school and working on his sculptures. For a time, his parents had pushed him to marry, but they had finally accepted he would probably never take a wife.

The Phosphor settlement was a small frontier colony, inconsequential in the greater scheme of Imperial politics. But a traveling diplomat had noticed Coop's work and given him a letter of introduction to the Orbiter Arts Council. To Coop's surprise, the OAC granted him a visa to live on the Orbiter for a year, as an artist in residence. When he had arrived six months ago, he had viewed the Orbiter with naive wonder, envisioning it as a place where he could swim the heady waters of culture in a great center of Imperialate civilization.

It hadn't turned out that way. He struggled to support himself, far out of his depth in every facet of Orbiter life. In some ways, he had less status than the maintenance droids. But now that he no longer sought miracles, he enjoyed his life here and knew he would return home filled with inspiration. Certainly he had never expected anything like this. If he said no to this invitation, would he be losing a night of fantasy or saving himself from grief?

Vaz walked over to him, watching his face as if he were a bewitching puzzle. "Your moods are like clouds scudding across the sky. Are you afraid? Or excited?"

Coop spoke in a low voice. "Both."

She cupped her hand around his cheek. "Don't be afraid. We'll treat you well."

"I don't know what to say."

The man slid his arms around Coop's waist, pulling Coop against his body. "Say yes."

The embrace sent a swirl of heat through Coop. He took a deep breath. Then he said, "Yes."

The flyer's cabin defined the words "subtle elegance." The craft had come to the Plaza in response to a summons from the male Jagernaut. Gold carpet covered the deck, as soft as bliss. The walls glowed white. The three of them sat on white divans that molded to their bodies. The air had the barest trace of a scent, perhaps an exotic flower with a name Coop couldn't pronounce.

He still didn't know the man's name either. The Jagernaut sat sprawled on a couch across from him, drinking wine from a ruby goblet, his legs stretched out long across the deck. In the subdued light, his handsome face brought to mind an ancient god carved from gold. His broad shoulders sunk into the divan, and it adjusted to accommodate his bulk.

Vaz reclined on a couch at right angles to them, drinking from another ruby goblet. Coop sipped his own drink, painfully self-conscious. He had never tasted such fine wine. It made him feel guilty to consume it. He kept his holo-case on his knees, clutching the tube until his hand ached. The holographs for his art were rolled up inside. He wished he could go to his apartment and leave his work there, but he was too nervous to ask.

The man took a swallow of his wine. "Have you been making sculptures for long?"

"Most of my life," Coop said.

"You have talent."

Vaz smiled. "Your sculptures are like poetry, but in light instead of words."

"Thank you." Coop wished he didn't sound so stiff.

"Your style reminds me of Tojaie's approach," she said. "I like your choices of color more, though."

Her knowledge caught Coop by surprise. He appreciated that she compared him to Tojaie; Coop considered him one of the great names in the field. "His work had a big influence on how I use light."

The man raised his eyebrows at Vaz. "I never knew you studied art."

"I haven't." She sipped her wine. "I just like light sculpture."

Suddenly it hit Coop why he recognized the man's accent. It was Iotic. Almost no one spoke Iotic any more, only the ancient noble houses. Although they held less power now than in earlier eras of the Imperialate, they still lived in a rarified culture. Was this man of noble blood? That might explain why a Primary deferred to him. But no, she had given him a military salute.

So ask him. Coop started to open his mouth, then lost his nerve and closed it again.

The man smiled. "What is it?"

"Sir?" Coop asked.

"You're so tense." He laid his hand on the divan next to him. "Come sit with me."

Coop swallowed, trying to steady himself. Then he stood up and crossed the cabin. As he reached the other divan, the flyer swayed and he lost his balance. With a cry, he toppled to the deck.

The Jagernaut moved so fast, his body blurred. He caught Coop around the waist before he even finished falling. Lifting Coop easily, the man set him on his feet. Then he let go and settled back on the divan on if nothing had happened. It all took only seconds. The man hadn't even spilled his wine.

Gods. Coop stared at him. He had known Jagernauts had enhanced strength and reflexes, but it hadn't seemed real until now.

The man tilted his head, a hint of amusement in his gaze. "Are you going to sit?"

"Oh. Yes. Of course." Knowing his face was as red as a sunset, Coop sat by the Jagernaut, on the edge of the divan.

The man trailed his hand through Coop's curls. "You have beautiful hair."

Coop averted his gaze. "Thank you."

"Do you ever use yourself for a model?" Vaz asked. "For your sculptures, I mean." Relaxed on her divan, she watched him as if he were a wild and beautiful animal they had coaxed into their lair, but who might bolt if they weren't careful.

"I don't do self-portraits," Coop said. "I don't like the way I look."

"Good gods, why not?" she asked. "You're gorgeous."

A chime came from the flyer's computer. Then a mellow voice said, "We're coming into the Regency."

"Ah. Good." The man sat forward. He put his arm around Coop's

shoulders and pressed his lips against Coop's temple in an unexpected kiss. "She's right, you know. You're as much a work of art as your light sculptures."

Coop blushed, embarrassed, but also flattered. As they stood up, a portal shimmered open in the hull. He expected to see a landing area outside, but instead he looked down a corridor with luminous sea-green walls. A line of people stretched along the hall, and a man in an elegant black jumpsuit waited outside the flyer, the Regency logo gleaming on his shoulder. Coop marveled at it all, wondering if his friends would even believe his story, that a Jagernaut had invited him here, to a private entrance no less, with humans waiting on them instead of robots. Dire shenanigans indeed.

The male Jagernaut disembarked first. Coop followed and Vaz came last. The gravity had decreased; he felt about half his normal weight. The rotation axis of the spherical Orbiter pierced the hull at both poles and gravity always pointed perpendicular to that axis, so as they moved closer to a pole, the ground sloped more and gravity decreased.

The man in the jumpsuit bowed to the male Jagernaut. "It is good to see you, sir. You honor my establishment."

Coop blinked. He must have misunderstood. Surely the Regency's proprietor himself wouldn't come to meet them. But no, the man had said "my establishment." Coop wondered at the sir he used for his guest. If the Jagernaut came from a noble House, wasn't the proper title Lord? Or the proprietor could use a military title. Coop had heard that some nobles preferred "sir" because they considered their titles an anachronism. He had little idea how these matters worked; they went too far beyond his experience.

The proprietor accompanied them down the corridor. He and the male Jagernaut went first, and Coop walked behind with Vaz. The people in the hall bowed as they passed. Coop felt suitably intimidated. Vaz fell silent too, but the male Jagernaut was unfazed. He nodded to the Regency employees as he passed, seeming to take their behavior for granted.

At the end of the corridor, the Jagernaut tapped the wall on his right. It rippled into a view screen, which showed a dining room. White carpet sheathed the room's floor in glimmering opulence, sparkling with pearly highlights. The far wall consisted of a window with a spectacular view of both Sky and Ground. It spoke volumes about the wealth of the Orbiter's population, that they could waste an entire hemisphere of their habitat on an essentially useless sky. In the distance, City gleamed

in ethereal splendor, its towers radiant in the evening.

"It's beautiful," Coop said.

"It is indeed." The Jagernaut was studying the guests in the dining room. "So. Barcala is here."

That caught Coop's attention. Following the Jagernaut's gaze, he saw Barcala Tikal seated with several dignitaries by the window. Tikal was the Imperialate's civilian leader. He governed the Assembly. The military leadership went to a different person, Imperator Skolia. He commanded Imperial Space Command.

Tikal had won his position through election, whereas the Imperator had inherited his title as a member of the Ruby Dynasty. Technically, the Ruby Dynasty no longer ruled. In theory, the Imperator answered to Tikal. But in practice? Coop had often heard the words *military dictator* used for Imperator Skolia. It had relieved Coop to learn that the Imperator based his operations on a planet rather than here on the Orbiter. A person might see Barcala Tikal in the Regency, but not the Imperialate's alarming dictator.

"I wonder what they're discussing," the Jagernaut mused.

The Regency's proprietor spoke in a low voice. "Perhaps how to vote on import tariffs in tomorrow's Assembly session."

Coop froze. That sounded like restricted information, the kind that you went to prison for revealing. Or hearing. Glancing at Vaz, he saw she had carefully composed her face into a neutral expression.

"An interesting topic," the Jagernaut said. "I wonder what they will decide."

"Who can say?" the proprietor murmured. "Perhaps an affirmative vote."

The Jagernaut continued to watch the diners. "Indeed." He turned to the proprietor. "Well, Jaron, do you have a private dining room for us tonight?"

"Of course, sir." Jaron waved his hand, and the end of the corridor shimmered into a horseshoe arch. They walked into a sumptuous chamber. Blue silks with subtle designs paneled the walls, and a lush white rug carpeted the floor. A low table made from diamond occupied the room's center, with velvet cushions strewn all around it. Diamond goblets glistened at three place settings. The plates were mirror-china, white with blue edging. Someone had already laid out a steaming dinner, the platters piled high with delicacies.

"Is this acceptable?" Jaron asked the Jagernaut.

Acceptable? Coop wanted to laugh, more from nerves than humor.

That was like asking if the galaxy had a few stars.

"It will do," the Jagernaut said. "We won't need anyone coming in."

"Of course, sir." Jaron glanced at Coop and his eyebrow quirked. Coop's face burned. Was it that obvious why the Jagernauts had brought him here? He felt as if he were adrift in a sea of social clues he only vaguely understood.

The male Jagernaut spoke to Jaron. "I heard that your daughter graduated from the design school. Congratulations."

"Thank you," Jaron said. "It is kind of you to mention."

"Has she taken a job yet?"

"She applied to the College of the Arts on Metropoli," Jaron said. "They expressed interest, but unfortunately her letters of introduction lacked sufficient . . . stature."

"Metropoli." The Jagernaut nodded. "I know the school."

Jaron bowed. "Thank you, sir." Then he discreetly withdrew. The archway shimmered and vanished, leaving a luminous blue wall.

Coop wasn't sure what had just happened, but he suspected the Jagernaut had offered to make sure Jaron's daughter received her acceptance, probably in return for Jaron's information on the Assembly vote. Envy surged in Coop; he would give anything to study at Metropoli's College of the Arts. Of course, he had neither the connections nor the funds for such a dream. A wild thought came to him: ask this Jagernaut to send him too, in return for a night of pleasure. As soon as the idea formed, Coop pushed it away, angry with himself. He hadn't come here to use anyone. That would be like expecting payment for a gift. It would tarnish the gleam of this spellbound night.

Vaz was walking around the room, studying the silks. "These are incredible." She turned to the other Jagernaut. "You have good taste, Althor."

Althor? Coop barely held back a startled exclamation.

Then he took a calming breath. Many people called their sons Althor. This man could be anyone. The name had become popular in honor of Althor Valdoria, the Imperial Heir, successor to Imperator. That Althor was a prince of the Ruby Dynasty. Someday he would be Imperator.

The name could be coincidence—except everything made too much sense: Althor's Iotic accent, Vaz's attitude toward him, their private entry into the Regency, Althor's casual acceptance of everyone's deference. The two bars on his uniform didn't mean Secondary—they meant second in command of ISC.

Coop sat on the floor at the table, surrounded by pillows, his mind reeling.

Althor sat next to him. "Are you all right?"

"You're the Imperial Heir." *Tell me I'm wrong.*

Althor smiled, crinkling the age lines around his eyes. "Well, yes, but I don't bite."

Vaz laughed softly. "That's disappointing."

Stunned, Coop looked up. Vaz was standing across the room in front of a silk panel, her sensuous leather-clad figure a striking contrast to the airy hanging.

"Come on, Vaz," Althor said. "Sit down."

She obliged, settling at the table near them. Then she flopped down on her back, making pillows jump around her. "Gods, I'm tired." With a heave, she pulled off one boot, then the other. "Ah, yes. Much better."

Althor laughed, and Coop smiled despite his shock. The idea of an intimate dinner with the heir to an interstellar empire left him dazed. It made Vaz seem less intimidating in comparison. Now that he knew she wasn't going to konk him over the head and carry him off to a cave, at least not literally, he was beginning to enjoy her unabashed joy in life.

Althor took a platter off the table. Coop recognized neither the food nor the gold tines set to the side. He figured out the tines when Althor used one to spear a square of some undefined substance, then offered it to him.

Flustered, Coop ate the square. It was delicious, melting in flavors of meat and nuts. He couldn't believe the Imperial Heir had just fed him.

"Like it?" Althor asked. When Coop nodded, Althor fed him another.

Vaz sat up and zestfully heaped herself a plate full of food. Watching her devour it, Coop marveled that she could eat so much and stay so spectacularly fit. Althor ate even more, demolishing a giant steak. Yet their comments suggested they were having a lighter meal than usual. Coop wondered if their huge appetites came from the biomech within their bodies. From what he understood, an internal microfusion reactor supplied most of the energy a Jagernaut needed to run his or her systems. But that probably couldn't account for every last calorie.

Coop didn't eat much. He couldn't calm down. He drank a lot, though, draining his goblet each time Althor filled it with wine. The others also drank, especially Althor, but with his large size he hardly seemed affected.

Finally Althor leaned back in a pile of cushions. He reached out and slid his hand through Coop's hair, his fingers brushing Coop's neck. Then he pulled Coop down, laying him on his back. Half buried by pillows, with Althor leaning over him, Coop felt as if he were in a nest.

Althor gazed at his face. He traced his finger along Coop's cheek, his expression gentling. Then he lowered his head. Even knowing it was coming, Coop wasn't ready when Althor kissed him. He slid his arms around Althor, overwhelmed, but pleased too, unable to believe he was in the embrace of the Imperial Heir.

When Coop felt Vaz settling against his other side, at first he didn't understand. It wasn't until she started to unfasten his shirt that he realized they both intended to play with him at the same time. He wasn't sure how to respond; this was already well beyond his slight experience with intimacy. At first it excited him to have two such compelling people take him so far outside his unsophisticated fantasies. When they pressed in closer, though, he began to feel suffocated.

"No." Coop broke away from the kiss, aware that Althor could easily hold him down if he wanted.

"It's all right," Althor said.

Vaz tickled the sensitive ridges of Coop's ear with her tongue. "Do you know, beautiful artist, your hair could put the Sunlamp to shame with its golden light."

Althor smiled. "Poetry, Vaz? I didn't know you had it in you."

"Ah, well." She put her arms around Coop's waist. "I'm inspired tonight.

Coop began to unwind. He liked Vaz's sweet-talking. Althor must not be in Vaz's chain of command, if he could spend time with her this way. But wasn't Althor in everyone's chain of command? Whatever the rules on fraternization, they didn't seem to apply here. He gave up trying to sort it out. Tipsy enough to loosen his inhibitions, he couldn't keep straight which of them was doing what to him. He swam in a sea of sensations: Althor's lips against his skin, Vaz biting his neck, an arm around his shoulders, someone stroking his chest. Now they were taking off his shirt. Althor's uniform scratched his skin and Vaz's leather felt smooth.

Then Vaz slid on top of him, gripping his leg with her muscular thighs. Both Althor and Vaz were larger than him, and stronger. It was too much, too fast. Coop turned his head, straining to breathe. His cheek brushed Althor's chest and he inhaled the crisp scent of Althor's uniform.

Taking hold of Coop's chin, Vaz turned his face back to her. She kissed him, tenderly at first, then with more passion. He began to struggle, trying to pull away.

Vaz raised her head. "I won't hurt you," she said softly. "It's only a kiss."

"Only." Althor brushed his lips across Coop's forehead. "Except you've never kissed a woman before, have you?"

"No." Coop's voice was barely audible.

Vaz blinked. "Really?"

Coop averted his gaze. "Yes. Really."

"Then I'm your first." She smiled when he looked up at her. "I like that."

"Vaz, give him more time," Althor said. Then he put his big hand behind her head and pulled the Primary into a kiss himself, deep and full, capturing her attention.

After Althor distracted Vaz, Coop no longer felt so trapped. He wanted to embrace Althor, but Vaz was the one on top, so he put his arms around her. It felt strange, but sexy in its own way. He smelled a tantalizing hint of spices.

While Vaz and Althor kissed, Coop explored Vaz's body. When he ran his hands over her breasts, she sighed. They seemed too large to him, a contrast to the muscled planes of Althor's chest. Curious about how they felt without material covering them, he fumbled with the catches on her vest.

Vaz drew away from Althor, regarding him with a heavy-lidded gaze. Then both she and Althor turned their attention to Coop. With their hands moving on him, their bodies pressed against his, and both of them kissing him, he became so distracted that he didn't realize they were undressing him until they had his clothes off. He shivered, but it wasn't from cold.

Althor was moving against his hip, a steady rhythm, pressing his pelvis forward, then tilting it back again. At first it stimulated Coop, but when he felt the full size of Althor through his uniform, he almost panicked.

"I'll be careful with you," Althor said in a low voice.

Coop tried to relax. Vaz was rubbing on his thigh, her hip brushing his erection. He cupped his hands over her behind, enjoying the way her muscles flexed. Althor slid his hand between her legs, and she groaned as he played with her.

Then Althor pushed his hand further and stroked Coop the same

way. With both of them touching him so much, Coop knew he could-
n't last much longer. Closing his eyes, he let himself build to a peak.

Before Coop could climax, though, Althor took his hand away.
Stymied by the sudden loss, Coop opened his eyes—just in time to see
Althor put his arm around Vaz and haul the Primary off Coop, bring-
ing her against his massive chest with a thump.

"Hey!" Vaz made a throaty protest. "Let me go!"

Althor spoke near her ear. "Keep that up, and he'll shoot off like a
firecracker."

Coop turned on his side, dazed with alcohol and craving release. He
pressed against Vaz and tried to reach around her to Althor.

Althor nudged Coop onto his back again. "Not yet."

Suddenly Vaz moved *fast*, far quicker than an unaugmented human
being could ever achieve. She lunged across Coop, flipping over his
body in what he thought must be a combat roll, though it happened
with such speed he couldn't be sure.

Althor reacted even faster. He reached out and grabbed Vaz even as
she started to roll away. Then he heaved her back over Coop, her breasts
rubbing Coop's chest. Althor pinned Vaz against his body, her back to
his front, his one arm trapping both of hers.

Coop barely had time to blink. His body tingled where they had
touched him. If he hadn't been lying under the fighting Jagernauts, he
probably wouldn't have even known what they were doing, it all hap-
pened with such fleet grace. They made beautiful, deadly blurs.

"Let me go," Vaz growled.

Althor laughed, then scooted aside enough to let her roll onto her
back between him and Coop. He grinned at her. "I've never seen you
like this, Primary." He slid his hand between her legs, stroking her back
and forth. "You're usually so cool and collected at your command."

"Pah." Vaz glared at him, then laughed and put her arms around his
neck. She drew his head down until his lips met hers.

Coop lay with his head propped up on his hand, fascinated, watch-
ing while Althor divested Vaz of her vest and the metal and leather hal-
ter that held her breasts. She helped him take off her gauntlets, using
care to disconnect them from the sockets in her wrists that linked to
her internal biomech web. He left her Jagernaut bands. They glinted
gold on her upper arms.

Vaz gave Althor the full force of her sultry gaze. "What are you
doing?" She tilted her head toward Coop. "I thought you wanted him."

Althor's face gentled. "I'm slowing you down, Vaz, so you don't ter-

rify this beautiful boy."

Coop smiled. Terrify indeed. Captivate was a better word. Worse fates existed in the universe than having the Imperial Heir and a Jagernaut Primary desire him.

As Althor caressed Vaz, Coop laid his palm on Althor's hand, feeling the roughness of his knuckles, the weathered skin, the blocky muscles. He imagined what that hand could do to him and his body grew warm.

Then Althor folded Coop's palm around Vaz's breast. After a hesitation, Coop gave her a caress. She sighed, so he kept playing with her breasts, curious. Although she didn't stir his response like Althor, her vibrant sensuality intrigued him. The more he stroked her and tweaked her nipples, the more she groaned. He hadn't realized that seeing someone respond so much to his touch would turn him on as well.

As Althor kissed Vaz, he tugged off her pants and the scrap of black leather she wore for panties. Coop wondered if those were ISC regulation underwear. Somehow he doubted it.

Coop wasn't sure what to think of Vaz's sculpted curves. He had friends he knew would give anything to be here now, holding her spectacular body, enjoying all that gorgeous sexuality. Watching Althor handle her excited Coop more, though. He couldn't have Althor yet, so he put his arms around Vaz and rubbed against her thigh.

Althor slid his hand into Coop's curls and pushed his mouth to Vaz's breast. When Coop tried to pull away, Althor held him there.

Coop spoke softly. "I don't . . ."

"I know," Althor said. "That's why I like to watch you do it."

Coop blinked, trying to fathom why it aroused him to know that it turned on Althor to see him with Vaz. It was too complicated to figure out. So instead, he drew Vaz's breast into his mouth and suckled, pulling on her nipple.

"Oh, yes," Vaz murmured.

Coop moved his palm down to where Althor was stroking her. He slipped his hand under Althor's and they both pressed against the folds between her legs. It startled him how wet she had become; his fingers slid inside her before even he realized what happened. She sighed, rocking against his palm. Every time Coop bit her nipple, she moaned deep in her throat.

Then she stiffened under the pressure of their hands and cried out. Althor suddenly pushed Coop away and lifted his body on top of Vaz, settling between her thighs. He had his hand under his own hips now, unfastening his trousers. With a great thrust, he entered Vaz, pushing

her into the cushions. She held him close, pressing her body along his.

Lying next to them, Coop watched with aroused fascination as Althor moved inside her. The powerful drive of Althor's hips made his muscles flex like a erotician's holodream. Coop laid his hand on Althor's thigh, shy even now, but unable to stay away.

As Althor surged in Vaz, he put his arm around Coop, holding him tight against them. Vaz strained up to meet Althor on each of his thrusts. Suddenly she cried out and went stiff, arched against him, her head back, her glossy black hair spread out on the white pillows. Coop felt the climax shudder through her body.

Althor groaned, his voice low and deep, like the rumble of a starship engine. With a huge thrust, he shoved Vaz deeper into the cushions and held her there, pumping his life's fluid into her.

Gradually Althor and Vaz stopped moving. Then they lay still, breathing deeply, Althor's arm still around Coop.

After a while Vaz said, "You're a dream, Althor. But you're squashing me."

He gave a low laugh and slid off her, lifting himself over Coop as well. He grabbed a cloth napkin off the table and cleaned himself, then stretched out on his side behind Coop, his chest against Coop's back. Languid now, Vaz turned her head toward them, her eyes closed. A bead of sweat rolled down her temple and into her tousled hair.

Achingly aware of Althor lying against him, Coop felt like a string on a finely-tuned instrument, pulled too tight, ready to snap. He didn't realize he was still rubbing against Vaz's thigh until Althor caught his hip, covering it with his big hand, stopping Coop's motion.

Vaz opened her eyes, sprawled on her back, looking sated and warm. "Let the boy enjoy himself," she murmured.

Althor bit at Coop's earlobe. "We have all night."

Vaz yawned. "I'm on duty in the War Room early tomorrow morning." Her fingers drifted to Coop's erection. Folding her palm around him, she slid her hand up and down.

Coop moved in her grip, relieved. But then Althor nudged her hand away. Frustrated, Coop caught Althor's hand and put it on his shaft.

"Is this how you would like your first time?" Althor handled him with expertise. "Like this?"

Coop felt his face turn crimson. Was his lack of experience that obvious?

Vaz opened her eyes. "His first time?"

Althor kissed Coop's temple. "It is, isn't it?"

His cheeks burning, Coop nodded.

"No wonder you want him to yourself, Althor." Vaz sighed and closed her eyes again. "The beautiful boy is a virgin."

Coop had no answer for that. On Phosphor, he had never had much opportunity for partners; colonists married young and had children right away, to keep the settlements robust. Although he had long known his preferences lay in other directions, it hurt to be different than everyone else. But he couldn't force himself into a mold he didn't fit. Orbiter society was far more open to alternate lifestyles, but he felt out of his depth here, afraid to respond to anyone. If Vaz and Althor hadn't made such an effort, he probably wouldn't have gone with them either.

It was worth waiting for, though, to lose his virginity to the Imperial Heir. And now that he understood Vaz better, he was glad she had joined them. With the women on Phosphor, he had to put up a front, straining to fit roles of masculinity defined by a frontier culture that valued aggression and ridiculed artistic sensitivity. With Vaz, he could be himself.

Coop's lips quirked in a smile. The women on Phosphor would love Althor. He was the ultimate Phosphor male. Coop could almost hear the girls chiding him back home: *Why can't you be more like him, Coop?* But guess what? *He* was the one Althor wanted.

As Vaz dozed, Althor explored Coop, his motions slow and drowsy. Coop closed his eyes, submerged in the joy of being held, wanted, and pleasured. But gradually Althor's hand stilled. Coop felt the Heir falling asleep, though he couldn't have said how he knew. As Althor's breathing deepened, Coop held back a sigh. He wasn't the least bit sleepy.

After a while, though, Althor murmured, *You make me feel almost human.*

Coop rolled onto his back so he could look at him. "You are human. You're incredible."

Althor's opened his eyes. "I didn't say that out loud."

Coop wasn't sure what he meant. He also wondered if he was fooling himself, thinking Althor's voice had held affection. "You're so full of strength and beauty."

"Beauty?" Althor gave him a wry smile. "I don't think so."

Coop touched his cheek. "And sad."

"Sad?" His voice was a low rumble. "Why do you say that?"

Coop tried to put into words the pain he sensed behind Althor's shields. "You know you're strong. But that's not enough. Not for you. Strength isn't serenity."

Althor spoke quietly. "I'm a machine. Don't romanticize that."

"Your mind and body may be augmented, but you're still human."

"Am I?" His voice had a shadowed sound. "Link me into the Orbiter War Room and I become a primary node on the web of Imperial Space Command. A machine dedicated to destruction. It has nothing human in it."

"No," Coop said. "You're magnificently human."

Althor's face gentled. "And you, my golden beauty, are deluded." But he spoke with tenderness.

Vaz curled against Coop. "It doesn't feel human."

"But why?" Coop asked. If anyone could be called human, surely it was the vibrant Primary.

She spoke softly. "When we fight, our minds and bodies become part of the ISC machinery. Jagernauts are empaths. We have to be, to link to our weapons, our ships, and one another. Our biomech webs augment our ability to make those links, but we have to start with something to enhance. *Empaths.* Designed to kill. Do you have any idea what that does to a person?" Vaz shuddered. "Althor is right. Don't romanticize that life. It's hell."

Coop pulled her close, offering the only comfort he had to give, the warmth of his body. He felt protective. It was an odd response, given that she was the Primary, larger and stronger than him. What he felt, though, concerned emotions rather than physical defenses.

Althor spoke near his ear. "You're a harbor of light." The touch of his breath stirred reactions all over Coop's body. The Heir began to move his hand again. He brought Coop to the edge of orgasm, then backed off before Coop found his release, keeping him in a sensual torment of pleasure.

Vaz slid away from them and sat up, her hair swinging around her shoulders, black and lustrous in the muted light. She could have been a holovid sex-dream, leaning on one hand with her legs stretched to the side, and her glorious body nude except for the gold bands on her upper arms. Although she looked about thirty, she had to be older if she had the rank of Primary. With all her enhancements, and probably nanomeds in her body to delay aging, she might live for decades with this robust, strapping health.

"She's fifty-five," Althor said against his ear. "I'm fifty-seven."

"But you seem so *young,*" Coop said.

With amusement, Althor said, "So do you." He bit at Coop's earlobe, manipulating the diamond earring with his tongue. Vaz watched them, drowsy and curious. The lights had dimmed, leaving only a faint glow

that softened the lines of their bodies.

Coop tugged on Althor's tunic. "I'd like to see you." He hesitated. "All of you."

At first he thought Althor would refuse. Then the Heir sat up, shifting his long legs. The shadows enhanced the classical lines of his face and made his violet eyes look almost black. As he unfastened the high collar of his tunic, he glanced at Vaz. "There's a sapphire vial with a gold top."

She nodded, seeming to understand, and turned to sort through the remains of their dinner. Althor slid his hand down the front of his tunic, opening it up. The metal mesh shirt he wore underneath gleamed gold-black in the dim light. Metallic gold hair covered his chest, glinting, curling around the mesh. As he pulled off the tunic and shirt, his chest muscles flexed. Coop couldn't stop watching him.

Althor set aside the clothes. Then he indicated his knee-boots. "Take them off."

Self-conscious, Coop sat up and grasped one boot. After straining for a few moments, he managed to pull it off Althor's leg. He ran his hand along Althor's calf, savoring the ridged muscles under his trousers. Althor was leaning back on his hands, watching, his lashes lowered halfway over his eyes. Too shy to speak, Coop struggled with the other boot until it came off. Then he set the boots far away in the pillows, so Vaz could lie with him and Althor and not get a heel in her back.

Althor pulled his legs under him, getting up on his knees. His belt was already undone. He pulled it off slowly, then held it in both hands and snapped the leather, idly, as if he had done it so often he no longer noticed.

Coop's pulse lurched, not with anticipation but in fear. He backed away, sliding in the cushions.

Althor caught him around the waist and pulled him back. "What's wrong?"

He took a deep breath. Yes, he wanted Althor. But not that way. Maybe some people liked that belt; he had too little experience to know. But he had no wish to feel it. Was that what Althor wanted?

Althor brushed his fingers across Coop's cheek. "For some, it's a form of consensual play. I would never touch you that way without your consent."

"Do you always know what I'm thinking?" It made Coop feel even more vulnerable than before.

"I get more from you than with most people." He set down the belt.

"It's part of why I noticed you in the Plaza. Your innocence. It's so fresh. Did you know you're an empath?"

That caught Coop off guard. Empath? "People say I'm too sensitive." Was that why he always felt defenseless?

"You can learn to guard your mind. Some of us build such strong shields, we become fortresses."

He had no doubt Althor maintained prodigious defenses. Yet Coop was picking up some of his emotions. He wanted to believe Althor had eased his mental guards because he hoped to draw Coop closer to his emotions. But Coop knew that was unrealistic. More likely, Althor simply didn't feel the need for as many defenses right now. Coop wished he had even a fraction of Althor's mental strength, so he could protect his own mind. Maybe then he wouldn't always feel as if he were living without his skin, his emotions raw to the world.

Althor was watching his face. "An unguarded empath can seek the help of someone more powerful. A protector. Your guardian would build a shield in your mind with his strength. It would leave you unguarded to him, but your mind would otherwise be barricaded."

Coop couldn't meet his gaze. "I wasn't guarded at all when you saw me in the plaza."

"And in that," Althor answered softly, "you gave me a gift. If you had been guarded, I would have never sensed your radiance in the darkness."

Would you give me your protection? Coop thought. But he said nothing. He feared the almost certain rejection far too much to ask such a question of the Imperial Heir.

As Althor finished undressing, Coop watched, mesmerized. "You're beautiful," he whispered. And it was true. His body was perfectly sculpted and proportioned, but larger than life, a study in power. Coop didn't say what he feared, that Althor would end up hurting him no matter how much he intended otherwise.

Althor set his clothes aside, then drew Coop into his arms, holding him against his chest with his legs on either side. He spoke in a low voice. "Trust me."

"Hey," Vaz said. "I think I found it." She closed a drawer in the table and turned, showing them a blue vial. "Is this the one?"

Looking over Coop's head, Althor nodded. "Yes. There should be a sapphire dish with it."

"What are you going to do?" Coop asked.

"Here." Althor laid him down in the pillows, stretching him out on

his stomach.

Coop clenched his fists in the cushions. Lying this way, he felt help-less. He looked over his shoulder to see Vaz holding a gold cloth and a blue dish. Althor took the cloth and soaked it in the bowl, which held a fragrant oil. The musky scent tickled Coop's nose.

Vaz slid over to sit at Coop's other side. She seemed content to watch now, but he could feel her growing hunger. She was going to want him again, and this time he didn't think Althor would distract her. He hoped he hadn't gotten himself into more than he could handle.

Althor stroked his knuckles against Coop's cheek. "You'll be fine."

Coop made an effort to relax, putting his head down and closing his eyes. As Althor stroked his buttocks with the cloth, a pleasant shudder rippled through Coop. But when Althor started to rub the cloth down inside him, Coop tensed, fighting a swell of panic.

"The oil will just cause some numbness," Althor said. "To make it easier on you."

Easier? It had never occurred to him that Althor would try to miti-gate the pain. Nor was this a last minute concern; Althor must have considered it ahead of time, or he wouldn't have had the dish of oil prepared. Coop heard Vaz open the vial, then felt her massaging a gel into his shoulders. The release of tension in his muscles came like bliss.

"What is that?" he asked. "It feels wonderful."

"It's a nanogel." Althor kneaded some of the gel into Coop's back. "The nanomeds diffuse into your body. They affect neurons in your brain and nerves in your skin."

"Wait!" Coop pushed up on his elbows. "What are you doing to me?"

"Shhh." Vaz nudged him back down. "It won't harm you. It's an aphrodisiac and a muscle relaxant. It just feels good."

Althor took Coop's hand and folded it around the vial. "Here. Use it on me."

Coop rolled onto his side to face him. He blushed when he realized what Althor wanted. But he poured a dollop of the gel into his palm, then used his hand to pleasure Althor—and discovered that touching his lover aroused him just as much.

Althor drew in a sharp breath. He pulled Coop into a muscular hug that could have crushed him if Althor hadn't restrained his strength. Chills spread through Coop, maybe from the embrace, maybe from the nanogel, he didn't know, only that he didn't want it to stop.

This time Althor laid Coop on his back and stretched out on top,

supporting his weight on his elbows. Vaz stopped playing with Coop's hair and started to draw back, giving them room. When disappointment swirled through Coop, she paused, then came back and ran her fingers through his curls again. A smile touched his lips. Making love with empaths had advantages.

Althor slid his arms under Coop's thighs and lifted his legs, bringing Coop's knees almost to his chest. Coop managed easily, limber from his dancer's exercises. But he felt suddenly afraid, knowing it was too late to stop.

"It's all right," Vaz soothed. She kept stroking his hair, her touch softer now.

Althor joined with him as gently as possible, but Coop still clenched his hands in the pillows, trying not to cry out. Then the pain receded, surprising him. Sensations rolled over his body: muscles flexing, hands stroking his skin and hair. He pressed against Althor as if he could lose himself within his lover. He had thought he would come right away, but he stayed on the tantalizing edge, unable to sail over the top. With their bodies buried in the pillows, Althor took him, his immense power almost devastating, but contained and controlled so he gave ecstasy instead of pain.

Later, after Althor finished, he let his full weight rest on Coop. As they readjusted position, Coop brought his legs down. It could have been suffocating with someone so large covering his body. His head barely came to Althor's shoulder. He had to turn it to the side to breathe. But rather than confined, he felt protected.

Still restless, Coop slid his hand up Althor's back. His palm brushed across a small indentation in the Jagernaut's spine at the waist. He discovered another at the base of Althor's neck. It took him a moment to realize what he had touched. Sockets. Ports for hardwire jacks.

Althor stiffened, but then he exhaled, as if resigned to Coop touching his implants. Coop picked up complicated impressions from his mind. Part of the reason Althor hadn't undressed earlier came from his unconscious tendency to exert the control that defined his life as the Imperial Heir. But Coop sensed another reason now, Althor's wish to cover those aspects of himself that he thought made him less human. Cyborg. He hadn't wanted Coop to see or feel the sockets. Yet Althor still seemed human to him, maybe even more so, because his greater differences made his need for human contact that much greater.

Althor stirred and caressed Coop's arm. Then he subsided back into his doze. Coop wondered if the Jagernaut was always this careful with his lovers. The thought of Althor holding someone else bothered him far more than he wanted to admit. He had no claims on the Imperial Heir. Althor had already told him, in the plaza, that he could expect no more than this one night. Coop wished it could be different.

Vaz tweaked Althor's ear. "Don't go to sleep."

"Hmmm?" Blinking, he lifted his head. "Why not?"

"If you plan to sleep," she said, "then move please, so I can have him."

Drowsy, Althor said, "You can't have him." He rolled onto his side and pulled Coop into his arms, spooning him into his body, his front to Coop's back.

Vaz folded her hand around Coop's erection and gave Althor a wicked grin. "He isn't done, your royal somnolence."

Althor kissed Coop's cheek with unexpected affection. Closing his eyes, Coop lay still, content to let them argue over him as long as one of them eased his needs. Vaz took him into her mouth and used her tongue with an unexpected shyness, as if this wasn't usual for her. With a groan, Coop moved in her. He didn't think he had ever been this stimulated before.

Vaz lifted her head. She nudged him onto his back, then came up and straddled his hips. She had already slid down onto him before he realized he was inside of her. Startled, he opened his eyes. "Wait."

"Coop, you'll be fine," she murmured, stretching out on top of him.

Althor had fallen into a doze, but now he stirred. "Coop?" he asked drowsily. "Is that your name?"

Coop was so startled, he forgot to be disconcerted by Vaz. It was true: he *hadn't* told Althor his name. The Heir had never asked.

"Yes," he said. "It's my name."

"I like it," Althor said. Then he went back to sleep.

Coop bit his lip. Every time he started to relax tonight, another emotional jolt hit him. He knew he had no right to hope Althor would consider him special, but it hurt to have that made so blunt.

"What's wrong?" Vaz rocked her hips on him.

He shook his head. What could he say? *I want him to care for me as more than a beautiful body in his bed for one night?*

"Is it really so bad this way?" she asked.

At first he didn't understand. Then he realized she thought he was upset because he didn't want to make love to her. "Vaz, no. You're

incredible." He rolled her over in the cushions, covering her body with his.

Coop moved languorously with her. Even now, he couldn't come. Vaz closed her eyes, matching her rhythm to his. He knew she was lovely, her body lush, her passion strong and sweet. And he even appreciated it, the way he would enjoy a beautiful painting. He liked her. If he ever had the chance to know her better, he might like her a lot. But she wasn't the one he wanted to love him.

After a while she moaned the same way she had when Althor made love to her. No, not love. She and Coop were fucking. It was good, very good, sweet and wild, but it wasn't love.

She murmured his name, and her muscles inside contracted around him until he thought he would go crazy. He felt so close, poised on the edge, but he couldn't go the rest of the way.

With a cry, almost of protest, Vaz pressed against him. Her whole body shuddered, then stiffened for a long moment. Finally she gave a sigh of relief and went limp.

Coop wanted to keep going. She didn't ask him to stop, so he continued. But after awhile he eased into stillness. Lifting his head, he looked down at her face. In repose, her ardent sexuality had softened into an unexpected sweetness.

"Did you like that?" he asked.

She gave him a contented smile. "You're wonderful."

He tried not to think about the sleeping warrior at their side. "You too."

"Don't be angry with him, Coop." When he just averted his gaze, she spoke gently. "He lives with pressures no one should have to endure. He wages war against the Traders every day, as second in command to his brother. The Traders are stronger than us, much stronger. We only survive because of Althor's family. They're protecting almost nine hundred worlds and habitats. Someday Althor will have to shoulder all that responsibility. If he seems distant or cold, it's because he has too much to hold inside."

"I understand." He didn't fully; he couldn't imagine the nightmares Althor lived with. But he appreciated Vaz's words. He lay his head next to hers and she held him close. She didn't ask him to move, as she had with Althor, probably because he weighed so much less.

He didn't realize he had dozed off until a pressure around his waist woke him. He was still lying on Vaz, still inside of her, still aroused. Althor had put his arm around them both and was pulling them back

to himself. As the Heir nestled them against his body, he opened his
eyes as if to assure himself he had them both. Then he submerged back
into sleep.

Held within the circle of Althor's arm, Coop began moving in Vaz
again. She stirred, mumbling a protest. "Can't you?"

"No. I don't know why." He kept going, caught in an agony of pleas-
ure, rising closer to his peak, only to find it out of reach. He groaned
in exquisite frustration.

"Althor," Vaz muttered. "Wake up."

"Can't," he mumbled.

"Come on." She shook his shoulder. "Did you give Coop a suppres-
sant?"

Althor opened his eyes, his long lashes glinting in the dim light.
"The wine had a mild one. It should be wearing off now."

"A suppressant?" Coop asked. "What is that?"

Vaz sighed. "You are such an innocent."

"Why do you say that?"

"A suppressant acts on the neural centers in your brain that process
an orgasm," she told him. "It suppresses them."

Coop blinked at Althor. "Why would you do that to me?"

"It makes it that much more intense when you finally go." He gave
Coop a sleepy smile. "It feels good."

Vaz frowned at Althor. "It's also illegal."

"Why?" Coop asked. It did feel good. Besides, if Althor hadn't done
anything, Coop knew he would have shot off within moments after
they had begun making love. And he couldn't help but think of it as
love, no matter what it meant to Althor and Vaz.

Althor rubbed his eyes. "The Traders use suppressants on their slaves.
They get them worked up with aphrodisiacs, then don't allow them sat-
isfaction for days, maybe longer."

"It's cruel." Vaz glared at Althor. "You shouldn't be doing that to this
sweet boy."

"I'm not a sweet boy," Coop grumbled. "I'm a grown man."

"And charming," Vaz said. "But Coop, I need to sleep."

"I don't understand why it didn't affect you and Althor."

"I can have the biomech web in my body nullify the effects," Althor
said.

Vaz nodded. "Mine probably kicked in automatically."

Althor slid his hand between Coop's thighs, brushing his shaft
where it entered Vaz. "Pull out."

Coop didn't want to stop. But he wasn't about to refuse the Imperial Heir. As he pulled out, Vaz sighed, a sound half of relief and half of regret.

"It's your turn," Althor told him. "Both Vaz and I had you. Now you choose how you want to finish. And with who."

"Don't tease him," Vaz said. "You know you won't do what he wants."

Althor didn't answer. Instead he watched Coop, waiting.

Coop hesitated. "I'd like for you to—to use your mouth. On me."

"He won't." Vaz closed her eyes. "He never does. Only has his lovers do him. . . ."

Althor laid his hand on the pillows near his head. "Slide up here."

Coop slid past Vaz. Then he sat back on his haunches.

"Vaz," Althor said. "Wake up."

"Aw, no," she protested. "I'm tired."

"I want you to sit behind Coop."

"Whatever for?"

"So I don't knock him over."

Grumbling, Vaz pulled herself up and knelt behind Coop. She put her arms around his waist, her front against his back, her knees on either side of his body. Then she nuzzled the top of his head, taller than him even now. "You smell good," she said. "I love your hair."

Coop smiled, still watching Althor. The Heir rolled onto his stomach and levered up on his elbows so his head was over Coop's lap. Then he went down on Coop.

"Ahhh . . ." Coop groaned. He hadn't actually expected Althor to honor his request; he had no doubt that what Vaz had said was true for Althor's other lovers.

He submerged into a sensual daze. Althor used his expertise just right, sensing what Coop liked from his mind. Finally Coop began to build to a climax. It took forever, slow and maddening, more intense than he could have imagined. Nothing had ever felt like this. It was agony, it was heaven, and he never wanted it to end.

Just when he couldn't take any more, when he thought he would surely pass out from the intensity, he began to climax. Waves of pleasure spread from his groin throughout his body. It caught him in a tidal wave. He arched against Vaz, his body straining. When the full force of the orgasm broke over him, he screamed. He was dimly aware of Vaz murmuring to him, of Althor holding him, but only through a lush fog of uncontrolled sensation.

Eons later the waves subsided, until finally he sagged forward. If Vaz hadn't been holding him, he would have collapsed.

"Better?" Althor asked.

"Gods," Coop whispered. "That was incredible."

The Heir grinned. "Good." He put his arm around both Coop and Vaz. "Now you two come back down here and sleep."

So they lay with him, Coop sandwiched between the two Jagernauts, facing Althor. Vaz fell asleep right away, her front against Coop's back, her arm draped over his waist. Althor slid his arm around both of them, as if to assure himself he wasn't alone.

Coop's final waking thought was that he didn't want to waste his last moments with them sleeping.

The flyer landed on a balcony of Vaz's estate in the hills. The robot staff at the Regency had laundered their clothes while they ate breakfast, but Vaz still decided to go home before she went to work.

Coop stood with her in the hatchway, their bodies bathed in the streaming morning sunshine.

"Good-bye," he said, not wanting to let her go. They hugged each other, holding onto their last moments.

Then Althor shifted behind them, in the flyer. With a sigh, Vaz released Coop. She cupped her hand around his cheek. "Be well, beautiful artist." Softly she added, "Your work is better than Tojaie's sculptures. You remember that."

"Thank you." He kissed her. "You be well."

Then they separated and Vaz walked onto her balcony. As the shimmer began to form in the flyer's hatchway, she turned and waved to him.

"Good-bye," he murmured. He set his hand against the shimmer and felt the membrane of a molecular airlock. Then it solidified into the flyer's hull.

Coop turned to see Althor relaxed on a divan, drinking a mug of steaming khava. The Heir nodded to him. "I can let you off at your apartment. Or at the Plaza, if you're showing your work today."

Coop swallowed. This was it. The end. "I guess my apartment. My permit only lets me set up on the afternoon shift."

Althor spoke to the air, giving the flyer Coop's address. The craft lifted so smoothly, Coop didn't even lose his balance.

"Sit with me," Althor said.

Coop settled next to him on the divan. "How did you know my address?"

Althor tapped his temple. "I checked my memory files for the city."

Just like that. *I checked my memory files.* Coop wondered what it would be like to have a computer enhance his mind.

Althor indicated the holo case Coop had left on the deck. "Would you mind showing me your work again? I enjoyed it yesterday, but we didn't have much time to browse."

Coop almost made a joke about how Althor had used his browsing time to seduce the artist. But he held back, too aware of Althor's rank and title to dare teasing him. He picked up the narrow case. Holoscreens lay rolled up inside, each in a protected slot. He withdrew his favorite and unrolled the screen on the deck. Then he activated the holo. The image of an ocean ship appeared, all light and color, deep blue, vibrant. It was sailing through a sapphire sea frothed with white caps, stirred by a storm. Lowering sapphire clouds swirled in the sky. The dragon-head at the ship's prow suddenly roared, fire curling from its nostrils and mouth.

"It's gorgeous," Althor said.

"Thanks."

"People with artistic genius have always astonished me," Althor said. "I'm like my brother Kurj. Literal. Your gift seems to me an inexplicable magic."

Like my brother Kurj. Coop wondered if Althor had any idea how unsettling it was to hear him make such casual reference to the military dictator of an empire.

"He named the places in the Orbiter, you know," Althor said. "City. Plaza. Sky. Ground."

"Ah." Coop didn't know what to say. He doubted *Your brother lacks imagination* would be appropriate.

Althor smiled. "Tell me something. If you didn't have to make holobanners, what would you most like to do?"

"Work on my light sculptures."

"Suppose you had a patron?"

Coop swallowed, suddenly nervous. "A benefactor?"

"I know of an apartment available in the Skyway Building. It has a ballroom you could adapt into a studio."

Coop was sure he had heard wrong. The Skyway was to City apartments what the Regency was to restaurants. He didn't even have the status to set foot in its lobby. "I can't afford it."

Althor laughed. "Coop, when you have a patron, he takes care of that."

"I couldn't let you spend so much on me."

"Why not? It's nothing to me."

Coop stiffened. *Nothing to me.* Once again, he had begun to hope he meant more, only to have it thrown back at him. Then he became angry at himself. Here Althor was offering him an incredible apartment, and he was unhappy because Althor didn't also offer himself. *Ungrateful clod,* he thought. "I don't deserve your generosity."

"Yes, you do." Althor tangled his fingers in Coop's hair. "What amazes me is that it never occurred to you to ask, and you were actually ashamed when you thought of asking for my help with the school on Metropoli." He rubbed his knuckles along Coop's cheek. "I'll arrange a stipend for you, so you don't have to design holo-banners any more. And I'll have your visa changed to permanent residency."

Althor would let him stay on the Orbiter? "I don't know what to say. It's so much."

"Credit and housing are nothing." Althor regarded him. "What goes beyond that, though, does matter."

Coop hesitated. "What do you mean?"

Althor started to speak, then stopped. For the first time a hint of uncertainty showed on his handsome features. "I'm not an easy person to care for, Coop. And my schedule is a killer. Yesterday was one of the longest breaks I've had in years."

Although Coop heard all his words, his mind stopped working after *care for.* Afraid to hope for the impossible, he only managed, "I don't understand what you're saying."

"The apartment and stipend are yours no matter what you decide. I don't want you to think they're conditional on your pleasing me in bed." Althor's voice gentled. "When I saw you in the plaza yesterday, an angel surrounded by those ethereal light sculptures, I couldn't believe that someone so beautiful could be that way inside, too. But I felt your mind, untouched by the ugliness I live with every day." He paused. "I would like for us to take some time together, if you agree, to see if we suit each other for something more permanent."

Coop wanted to shout it from the towers: *Yes!* He managed more decorum, though. "I would like that."

"How would you feel if I asked Vaz as well?"

Uncertainty rippled over Coop. "You like her?"

"As a friend." He smiled slightly at Coop. "I can tell how much she wants you. And her happiness is important to me. We've known each other for decades, since the academy, though neither of us would

choose the other for a partner." He traced his fingers along Coop's chin. "You're the one we each want. Can you handle that, two people expecting your affections at the same time?"

The idea both excited and disconcerted Coop. It also told him a great deal about how Althor felt toward Vaz, that he would trust his lover with her. But Coop didn't know if he could handle it. Although he liked Vaz, it wasn't in the way she wanted him. Last night had gone well, yes, but she had been new and different, he had been stoked up by the nanogel, and most of all, Althor had been there.

"I'm not going anywhere," Althor murmured.

"I don't think I'm enough for her."

The Heir gave a low laugh. "I think she likes it, knowing she has to work for you. It's a challenge." His voice turned pensive. "Why do you think she and I don't suit, despite our friendship? She doesn't want a warrior, Coop. She wants the beautiful, gentle artist with the radiant soul." Softly he added, "And so do I."

Coop spoke shyly. "It would be wonderful, then."

Although Althor's face didn't reveal his relief, Coop felt it from his mind. It astounded him to think that Althor had feared rejection, even knowing how Coop felt about him, as he must have known, given that he was an empath. Strange how life worked, that such a powerful man, one considered more machine than human, had such a poignantly human response.

Machines don't doubt themselves, Coop thought. They didn't love or need to love, nor question how they expressed that love. What he, Althor, and Vaz gave one other, both the questions and the answers, was achingly human.

He and Althor sat together, content, while the flyer hummed through the clear morning air.

Althor and Coop also appear in the Skolian Saga novel The Radiant Seas. *Family trees for the Ruby Dynasty and a timeline for the saga appear in* The Last Hawk, The Radiant Seas, Ascendant Sun, *and* The Quantum Rose.

STONE, STILL

A. R. MORLAN

"They can't force me to do this."

Pierretta let the letter from the government fall from her stiffened fingers. The single sheet of watermarked paper see-sawed in the air as it descended, then landed on the floor at her feet with the free ends of the tri-fold upright, much like a curled, drying autumn leaf whose stem-end and tip come close to touching.

Pierretta's caregiver (exactly which one she was, Doreen or Geri or that slow, overweight one whose name Pierretta never did bother to recall, was something Pierretta refused to think about any more—mentally, she allowed the women to merge into one, intrusive being, flitting just beyond her limited range of vision like sooty dust-motes to be endured, nothing more) shook her head, and said, "But this should do you good . . . it's for everyone's good. I read you those studies, from the papers—the government's established that being in a nurturing, sexual relationship is of benefit to all people—"

"You've just said the magic word . . . 'People'. Not—" she looked down at her shiny-skinned, stiff arms, bending her neck with difficulty, before saying with as much emphasis as her pulled-back lips would allow "—stiffs."

The caregiver (Doreen? Pierretta dimly recalled this woman saying

169

that name at some time to her) shook her head again, before soothing, "Now, now, that's like a bl—African American calling themselves by the 'n' word. Don't degrade yourself like that. Why don't you re-read the letter? It plainly states that they've found you an ideal emotional and sexual partner—"

Pierretta wished that she could cross her arms in front of her chest, but the best she could manage was a cagelike balling of her hands into near-fists. "Yeah, and during his day job, he pickles real stiffs in a—"

"The letter didn't say anything about his occupation, did it?"

God, spare me from the literal-minded, Pierretta mentally sighed.

Doreen (?) bent over at the waist, making her fleshy midriff inner tube under that tight smock she wore, and picked up the letter from the government. Tilting her head back to better see through her bifocals, she began to read aloud:

—an ideal potential sexual lifemate has been located for you in this city. Mr. Howard Noach is 34 years old, a nonsmoker, and currently single/unattached. He has been found to be compatible with your sexual preferences/predilections, and should prove to be a lasting, stable partner. Your first meeting is scheduled for—

"Enough . . . I remember what the letter said."

Doreen kept reading silently, her lips making the occasional moue. "It doesn't say anything about what he *does*—"

"It doesn't matter, does it?"

Pierretta mentally willed her rigid legs to move, scissorslike, as she walked away from the caregiver. The sun was hitting its highest point in the sky, and its rays became dust-mote-swirled warm fingers, caressing her taut skin through the skylight above. She closed her eyes, and ever-so-briefly imagined that that fervid pressure was human fingers gently stroking her flesh . . . until she imagined the expression of revulsion on the face of her phantom lover—

Bad enough that she'd been born in a body whose very DNA was tainted with this disease, this thing the doctors called scleroderma (and which those less inclined to be politically correct dubbed "stiff's disease"), but to lose not only her mobility, but her very sexuality in the process . . . Pierretta supposed the latter loss was a fair trade, given that one of the few medications which helped her in even a small degree was Thalomid, which had once been known as thalidomide. For her, procreative sex was impossible, prohibited by morals and law . . . which is

why she'd initially been bemused by the long questionnaires every adult over the age of eighteen had been required to fill out last year. While the forms were a mere technicality for those already married, engaged, or otherwise promised to another (simply a way to disentangle potentially non-sexually-compatible couples before their relationships disintegrated on their own), for those who remained unattached, unloved, unfulfilled in the most intimate sense, the forms were meant to be salvation for those otherwise doomed to depression, short lives and physical problems . . . all traceable to a lack of sexual expression.

That things had come to this state of governmental influence in matters heretofore personal and intimate seemed absurd at first—until people remembered how the government had managed to turn a nation of smokers and casual drinkers into an abstaining, ostensibly healthy body-and-psyche-conscious community. Then, despite all the efforts of the government-sponsored do-gooders, when it was discovered that people remained depressed, unhappy, and even defiantly unhealthy, still more grant-funded do-gooders took yet another look at the nation's mental and physical state of being . . . and decided that the panacea for almost every remaining ill in society rested squarely below everyone's waistline.

Virtually all doctors concurred; those who stayed single/celibate were cheating themselves of health, happiness, and longevity. (Religious celibates not included.) Pierretta had found those initial articles about this new-found sexual requirement amusing, in a bitter fashion; no matter how many men she might service, not a one of them would make her skin supple again, or release the pervasive stone-like stiffness in her internal organs and tissues. She remembered joking with one of the caregivers that the naysayers had had it wrong all these years—masturbation didn't make people go blind, it actually cured blindness.

The caregiver didn't understand the joke.

Slowly turning her head, Pierretta said to Doreen, "I don't recall something . . . does the letter say whose apartment Mr. Noach will live in? I do have certain requirements—no stairs, no—"

Pierretta's hope for finding a legal way out of the enforced meeting was extinguished when Doreen replied, "Uhm . . . it's here, at the bottom of the letter. 'Due to your pre-existing medical condition, you will be allowed to remain in your current dwelling. Mr. Noach will move in the day after your first meeting—' Are you all right, can I get you something to—"

Pierretta creakily shook her head, her thin-lipped mouth moving into a downward arcing crescent. *Damn them and their "concern" for my well-being.* "I'm fine . . . tell me, again, what time is this first scheduled 'meeting' of ours?"

"Tomorrow, at nine A.M. . . . uhm, since you brought it up, I got my own letter from the government . . . as of the day Mr. Noach moves in, he'll be taking over your caregiving duties. It's designed to encourage bonding—"

Does this man have a job? Do they realize what he's taking on? Trying to keep her voice even, Pierretta said, "I'm sorry—you were offered another job, I trust? You are set financially, yes?"

"Oh, not to worry . . . me and the mister, we're doing fine. I have other clients, so not to worry, Miz P. I just hope everything works out with Mr. Noach. . . . If he was picked to be with you, he has to be right for you. I wouldn't worry none, Like they say, it's for everyone's good—"

The woman continued to speak, but Pierratta closed in on herself, cocooned in her carapace of tight, taut flesh, allowing herself to only experience the warmth of the sunlight above her, devoid of any accompanying flesh-fantasy. . . .

The envelope from the government had contained more than the letter concerning the impending arrival of her selected sexual "mate"—a thin pamphlet was also enclosed, filled with suggestions for making the first meeting between sanctioned sex-partners successful and "fulfilling." So early that morning, Pieretta grudgingly submitted to Doreen's physical ministrations—a bath in scented oils, followed by a thorough massage, after which she was helped into what the pamphlet dubbed "enticing" garments—lacy panties, a push-up bra, filmy stockings, a strappy garter belt, and, over those scratchy yet clinging undies, a simple wrap-front robe, belted loosely at the waist. Looking down at herself, as she sat before her dressing table, while Doreen brushed her chin-length bob of dark honey-gold hair, Pieretta thought that a store-window dummy would look more erotic, more sensual . . . against her unsupple flesh, the clothes seemed to wear her, imparting no hint of sensuality, no erotic aura whatsoever. Even the uplifted rounded globes of her breasts looked surreal, more like rounds of stone sitting in slings of frothy white lace.

Once Doreen was done with her hair, she took up a tube of mascara, and began applying the brown-coated wand to Pieretta's eyelashes.

With each stroke, Doreeen's breath puffed out warm and soft on Pieretta's cheeks. Staring past her caregiver, Pieretta daydreamed of the last time she'd actually had real sex with anyone, in the days before her body began its slow, grating transformation from playfully supple to stilted and stiff.

His name had been Aubin. The surname was lost to her, lost in the haze of those endless, golden days spent in Provaince, during her last summer abroad, but she supposed that surnames no longer mattered, in memory. He'd been blond, curly-haired, with a thin small thatch of downy hairs between his small-nippled breasts, which matched the tight small patch of down over his manhood. His hair had tickled her, against her breasts, along her thighs, under her chin as she'd gone down on him and he'd run his own fingers through her much-longer hair, weaving his fingers through her curls, tugging playfully when she'd used her tongue and teeth . . . then, when she was done, and they were lying side by side on that ridiculously lumpy mattress in her motel room, he'd taken the ends of her flowing hair, and brushed it against her nipples, until they puckered like sweet pink raisins over her swelling breasts, and then he was kissing her, moving from her lips to her aching nipples, down along her convex belly, until his tongue part- ed her other lips, and she could feel his own curls tickling her lower belly, until she'd let out a low, throaty laugh, and reached down to mas- sage his soft, sunburned shoulders, pressing him closer to her parted softness. . . .

She'd been so soft, so flexible, then; she and Aubin had slithered snakelike together, on that uneven mattress, their bodies shifting and reconfiguring, forming positions of the most complex sexual geome- try . . . in memory, they flowed, sweat-slicked flesh slapping and suck- ing gently with each movement, each shift against the yielding sheets, and as Doreen now smoothed foundation on Pieretta's slack cheeks, the stone-still woman closed her eyes, and imagined Aubin's broad palms cradling her cheeks, as he held her face between his hands, and kissed her deeply, his tongue twisting and teasing against her own. . . .

"There we are, all done. Here, take a look—" Pieretta felt a swivel- ing motion, as Doreen moved her around to look at her reflection in the vanity mirror.

As long as she concentrated on her hair, which hadn't changed all that much during the long years of her illness, Pieretta could stomach what she saw before her. And her eyes; they were still murky sapphire blue, still what might be called beautiful. Best to concentrate on those

two unaltered features, and let her vision glaze over when it came to her angular-planed face, the taut lips, the oddly shining skin

"I think you look stunning . . . I'm sure Mr. Noach will be most pleased—"

" 'Pleased' doesn't have anything to do with it, does it? He has to come here, whether he wants to or not," she found herself saying, but when she saw the reflected hurt in the caregiver's eyes as she continued to stare just past her own image, Pieretta quickly added, "I'm just nervous, please don't mind me. . . . Yes, I'm sure he'll be happy with what you've done for me."

Doreen gave Pieretta's hard shoulders a squeeze, before reminding her, "Be sure to take your Thalomid before he gets here . . . I suspect you two will be quite busy afterward."

Telling herself that the woman really did mean well, Pieretta coaxed her lips into a smile under the coat of pale pink lipstick (specifically suggested in the pamphlet as being more sexually inviting than the traditional red shades) Doreen had stroked onto her mouth, and said, "Oh, I'm sure we will be," hoping that her voice didn't betray her feelings to the contrary

The apartment was too quiet, too echoing, as Pieretta waited for Mr. Noach's arrival, but she was loathe to turn on her radio, or put some CD's into the changer. She was damned if she'd make things easier for him; true, she'd done what she was tacitly required to do—make her body as clean and tempting as possible—but other than that, Mr. Noach was on his own.

He'd have to be; sex *per se* had long ago become too difficult, too taxing for her, as she'd so plainly stated on those forms she'd filled out months ago. Eating was difficult enough, let alone giving head, and her body had lost all physical rhythm years before, to the point where anyone who might be able to put it in her wouldn't get any more response than a blow up doll or a mechanical vagina might offer. Less, probably.

"I hope your wrists are strong. They'll be getting plenty of exercise," she mumbled to herself, seconds before the doorbell chimed. Already standing—the effort of getting in and out of a chair was too exhausting—she forced herself to say loudly, "I'll be there in a minute," then deliberately took a full minute to reach the door, and jerk the knob open.

A rush of cool air from the hallway beyond hit her, reflexively making her nipples pucker under her filmy robe, as she got her first look

at the man whom the government had chosen as her ideal sexual mate.

He was an old-looking thirty-four. Fine creases hammocked his light brown eyes, and his jawline was already jowly and slack, with the first hint of a double chin. His hair was lightly salted with silver, but still mostly dull brown, cut severely at the nape of the neck and above his ears, but somewhat more generously over his wrinkle-banded forehead. His nose was . . . a nose; not too wide, not too big. Slightly large pores, but his face was clean-shaven, and obviously well-scrubbed.

His envelope had contained a pamphlet, too.

Howard Noach was taller than she was, at least five-ten or five-eleven, and while not buff, he wasn't overtly flabby. Average, in virtually all respects . . . save for his hands, which were far more used-looking than his somewhat bland face and unremarkable body. The raised, healed whitish scars and thick calluses, coupled with his roughened, webbed flesh, spoke of hard, perhaps dangerous work in his past. His hands worked, *hard*. The nails were worn down to the quick, with absolutely no white showing. A small nail-bed, so each finger was tipped with a tiny hard end, and no more.

Despite her previous trepidation, she wondered what those hands and those blunt fingertips might feel like on her skin, and thrust deep within her unyielding inner folds—

Her . . . mate wore the male version of the government pamphlet's suggested sensual wear: loose-fitting cotton pants, a softly clinging shirt over bare skin, and slip-off shoes, while his flesh had likewise been bath-oiled and cologne-anointed. He'd shaved just that morning; a tiny nick was fresh-healed on one cheek.

Turning her attention back to his face, Pieretta noticed that he was smiling, but wasn't sure if it was from nervousness, or pleasure.

"Please, come in . . . I didn't mean to keep you standing out here—"

"Thank you . . . may I . . . call you Pieretta? It's such a beautiful name . . . French, no?"

Nodding as much as she was able, she said, "My mother's French. . . . I used to summer there, when I was in college . . . please, sit down—"

Mr. Noach hadn't stepped beyond the door, but remained quite still, with his hands hanging loosely by his hips, as he smiled and said, "No, I'd rather stand, for a while . . . I'm used to it, from my job—"

"Which is—?" Pieretta was momentarily grateful for her condition; back when she was younger, she'd had a habit of rocking from side to side when nervous. . . .

Her new mate rubbed the sides of his legs with his hands, making a gentle sussurrus of fabric and flesh which Pieretta found deeply erotic; between her rigid legs, she felt a deep, fleshy twinge—

"I'm a sculptor . . . marble, some stone . . . when I was in college, I moonlighted as a monument carver, y'know, dates, names on the stones. But my main love is sculpting . . . figures, especially. I guess that's why I was chosen for you. I love figures . . . looking at them, forming them with my chisel . . . touching them, afterward. They're so . . . still, so . . . there. I like the smoothness, that doesn't yield like flesh does. Rubbing my hands over the surfaces . . . polishing the marble with my palms, after the dust's worn away. It gets warm, the marble, the stone . . . heat from my hand transfers to the statue . . . it's beautiful. Those small, warm spots . . . rubbed smooth and slick . . . better than the women who model for me. Some of them, they're so fleshy-soft, they're like dough. And of course, no respectable artist fondles his models . . . it's unprofessional. God, don't mind my blathering—" Noach's voice was a soft, slightly baritone drone; as he'd spoken, his eyes never left Pieretta's body.

"No, it's okay . . . I'm interested. Please, go on," she said, as she slowly moved her stiff fingers into the deliberately loose knot Doreen had tied in her robe-belt. Working one forefinger into the center of the soft knot, she jerked the belt loose, and let it drop to her stockinged feet. Noach's eyes followed the fabric rope's fall, then moved back up to the narrow swath of parted fabric over her legs and torso. As she used her rake-fingered hands to pull open the robe, Pieretta said, "I'm not very good at undoing my bra . . . if you wouldn't mind, I'd be happy if you—"

Covering the distance between them in three quick strides, her new mate was standing before her, his own chest rising quickly under the silky-fine fabric of his shirt, his hard, blunt hands moving slowly, reverently, to first shuck the robe off her shoulders, then gently slide under her arms, to reach the hook-and-eyes in back of her bra. The tips of his fingers were pleasantly hard and smooth against her taut back muscles; when they unhooked the bra, and slid up her shoulderblades, to tenderly lift the straps off her shoulders, before pulling the bra off her rigid torso in a downward, breasts-revealing motion. Pieretta found herself sighing, as her eyelids slid closed.

While her breasts had long ago become permanently jutting and what the caregiver's had affectionately dubbed "perky," her nipples could still react, slowly, but significantly, and as they puckered into

ever-tighter nubs in the middle of her areolae, she could feel the wet heat of Howard Noach's lips and tongue caressing them, gently sucking and kneading them with his teeth, while his hands slid down her hard, smooth flesh, down to her hips, where he slid off her garter belt and panties in one firm, shucking motion. The rush of air which tickled her legs as the lacy fabric slipped down her body was intoxicating in its subtlety. Moving his hands in a circling, rubbing motion, Howard polished her firm, unyielding skin as if it were the finest marble, leaving circular patches of hot, sated flesh in his wake.

After he took his mouth from her breasts, exposing the wet flesh to the dry warmth of the air, Howard kissed each of her taut cheeks in turn, whispering, "So still . . . so stone-still . . . all my life, I wanted someone like you, someone so alive, so still. Before, when I'd try to tell a woman what I wanted, she'd think I was a kink, but it's just . . . something I like, so much . . . what I'd carve could be touched, but it never cared whether it was touched or not . . . I never thought of it as being a freak, I just love touching, and looking . . . kneading and manipulating just isn't my thing. I like what's there, already . . . can you understand that? I'm not some weirdo . . . I just love looking, touching . . . but not changing a woman. Just looking at the planes of her skin, seeing the light hit it . . . feeling that smoothness and firmness under my hands . . . you can't believe how that turns me on. But the statues, they didn't . . . radiate warmth back. And the smell was always the same, that clean-water-sterile scent . . . slightly dusty at first, then . . . just clean. But your skin . . . there's heat, and a tang to the flesh. . . ." He moved his lips close to her ear, under the well-brushed hair, and continued, his words a soft, wind-soothing rush, "Something I couldn't get from the women who posed for me, something that wasn't there in the statues . . . but something I still wanted. When I filled out the forms, for the government, I never dreamed . . . I thought they'd toss me aside, consider me unworthy of any match. I never dreamed anyone like you could exist"

Somewhere deep within Pieretta, the memory of Aubin and his tickling pale curls grew faint, faint as a whisper, while the dry heat of her mate's circular caresses whisked away the last faint echoes of that whisper, in a raspy sussurrus of hard flesh meeting harder flesh

CONTRIBUTORS

A challenger of rules since childhood, Catherine Asaro regards those which constrict literary genres with a why-not gleam in her eyes and a talented hand. That's why the sexy stories from this Harvard Ph.D. in chemical physics and owner of Molecudyne Research draw praise from reviewers and readers of science fiction, romance, action adventure, and suspense, and from men as well as women. Among the many honors earned by the Columbia, Maryland, author are the National Readers' Choice Award for Best Futuristic Fiction for The Veiled Web and Romantic Times magazine's Reviewers' Choice Award for Best Science Fiction Novel.

Zoe Bloom is a glass artist and writer living in Somerville, MA.

Renée M. Charles's fiction has appeared in Dark Angels, Blood Kiss, Women Who Run with the Werewolves, Best American Erotica 1995, Forum (UK), Eros Ex Machina, Erotica Vampirica, Selling Venus, Sexcrime, Genderflex, Fetish Fantastic, and other erotica anthologies, while her nonfiction has been published in Virgin Territory 2, and Bad Attitude. She's single, and lives in a big pink painted lady Queen Anne house in the upper midwest.

Suzy McKee Charnas was born and educated in New York City, attending Barnard College (1961) and, after a two-year stint in Nigeria with

179

the Peace Corps, New York University (MAT, 1965). She taught at the New Lincoln School in New York until Flower Fifth Avenue Hospital hired her away as a curriculum consultant for their high school drug-abuse treatment program. In 1969 she married and moved to New Mexico, where she began writing fiction full-time. Her first novel, *Walk to the End of the World* (1974) was a John W. Campbell Award finalist. Her SF and fantasy books and stories published since then have won her the Hugo Award, the Nebula Award, and the Mythopoeic Society's Award for young-adult fantasy.

M. Christian is the author of over 100 published short stories in such books and magazines as *Friction, Best Gay Erotica, Best of Best Gay Erotica, Best American Erotica, Noirotica III, Wired Hard II, More Technosex, Selling Venus, Sex Crimes, Blue Food, Black Sheets,* and many other books and magazines. He's the editor of over seven anthologies, including *The Burning Pen, Best S/M Erotica and Rough Stuff* (with Simon Sheppard). A collection of his short stories, *Dirty Words,* is available from Alyson Books. He thinks WAY too much about sex.

A born and bred San Franciscan (who left when he realized he was free to go), Eric Del Carlo now makes his home in the world's most elegant ghetto: New Orleans's French Quarter. His sf, fantasy, horror, and porn have appeared in *Aberrations, Talebones, The Leading Edge, Options, Figment, Pandora, After Hours,* and the Circlet Press anthologies *Wired Hard 2* and *Dreams of Dominance.*

Reina Delacroix is the pen name of a shy, quiet information architect, living in Northern Virginia with a Pet, a Wolf, and four Cats. "Blue Sky" is a tribute to Jim Mayo, Linda Nielsen, and two very, very different Bulls.

Raven Kaldera is an intersexual transgendered FTM activist, organic farmer, parent, pagan minister, and pornographer whose writings are scattered hither and yon. Raven's work has appeared in over a dozen Circlet anthologies, including *Sexcrime, Fetish Fantastic, A Taste of Midnight,* and *Best Bisexual Erotica.* 'Tis an ill wind that blows no minds.

Since 1985, A. R. Morlan's fiction has appeared in over 90 different webzines, magazines, and anthologies, including Sci-Fi.com, *F&SF, Weird Tales,* and other genre publications; her erotica has appeared in *Love*

in *Vein*, *Deadly After Dark: The Hot Blood Series*, *Cherished Blood*, and other publications. She currently lives in the midwest, with a house full of cats.

Jennifer Stevenson gets her ideas from porno comics, dreams, junk mail, and the Reader's Digest joke column. In this case, she would like to thank the ever-ready Phil Foglio for the idea of the lifters, an aeronautical innovation he introduced in "Hoisters" in his widely applauded stroke book *XXXenophile*, no. 5, July 1991, from Palliard Press.

Since she founded Circlet Press in 1992, Cecilia Tan has edited several dozen anthologies of science fiction with erotic themes. Her own fiction has also appeared in *Isaac Asimov's Science Fiction Magazine*, *Absolute Magnitude*, *Ms. Magazine*, *Best American Erotica*, and many other places. She welcomes visitors at http://www.ceciliatan.com

Saskia Walker is English and lives on the edge of the Yorkshire Moors where she enjoys extremes, suits herself and lives the life of a benevolent shrew. Saskia writes fantasy, erotica, and music reviews. HTTP://www.zoetic.demon.co.uk. Delfidian is dedicated to Mr. Walker.

If you enjoyed Sextopia, you may enjoy these other erotica titles from Circlet Press....

Sexcrime: An Anthology of Subversive Erotica
edited by Cecilia Tan, $14.95

Taking its title from 1984, George Orwell's dystopian novel, *Sexcrime* explores the erotic heat and intensity that can come from love under repressive conditions. In twelve stories, erotica authors and science fiction writers (including Jean Marie Stine, Simon Sheppard, M. Christian, Raven Kaldera, and more...) celebrate the ways underground love can flourish through the intimacy of secrets.

Mind & Body
edited by Cecilia Tan, $15.95

This anthology explores the erotic connections that go beyond the merely physical. Using Circlet's trademark combination of the erotic with the fantastic, Mind & Body brings together stories of telepaths, psychic connections, and extra-sensory perceptions.

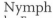

Nymph
by Francesca Lia Block, $16.95hardcover

Francesca Lia Block (Weetzie Bat, Dangerous Angels) writes edge tales of the Los Angeles dreamscape that is "Shangri-L.A.", thrilling millions of readers and critics alike. The award-winning author now brings her sensual dream-like fantasies full circle with this erotic work for adult readers.

Fetish Fantastic: Tales of Power & Lust
edited by Cecilia Tan, $14.95

Top writers in today's sexual underground present tales of futuristic fiction. These lush stories transform the modern fetishes of S/M, bondage, and eroticized power exchange into the templates for new worlds. From the near future of cyberspace to a police state where the real power lies in manipulating authority, these tales are the cutting edge of both sexual fiction and science fiction.

Order Online At www.circlet.com
or send check, money order, or credit card information (Visa, Master Card, or Amex only, and include account number, expiration date, and your billing address), along with your name, shipping information, and a signed statement that you are 18 years of age or older to:

Circlet Press, Dept. SXT
1770 Mass Ave #278
Cambridge, MA 02140

Include $4 shipping for the first book,
$2 for the second book, and $1 for each book thereafter,
for shipping within the US and Canada.
Massachusetts Residents Add 5% Sales Tax.